MARINE PAINTING

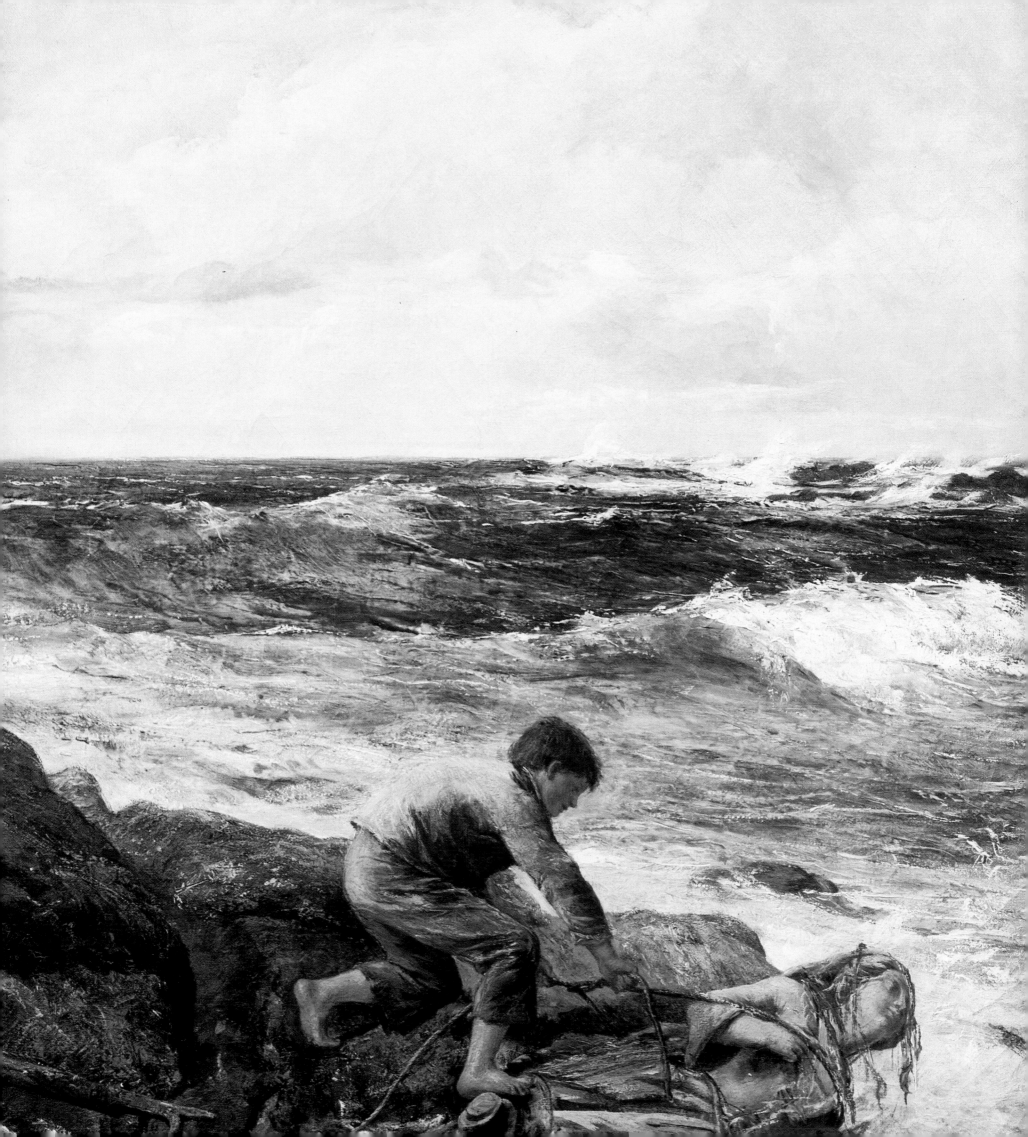

MARINE PAINTING

Images of Sail, Sea and Shore

JAMES TAYLOR

SMITHMARK

For Stefania and Joshua

FRONTISPIECE*: **'Catching a Mermaid'**, detail,* James Clarke Hook. *After discovering a ship's fig-urehead the Victorian boy attempts to rescue it. Hook studied at the Royal Academy Schools and was encouraged by Ruskin to paint coastal scenes and seascapes. His seashore compositions enjoyed great popularity throughout the Victorian era. William Collins and the Shayer family were among the earliest and finest English practitioners to specialise in coastal views focusing on human activity. The Scottish artist William McTaggart (1835-1910) painted similar scenes to Hook in an equally vigorous style.*

ACKNOWLEDGEMENTS

I am indebted to Richard Newbury for helping me to organise my thoughts and the format of the book itself; Dr Pieter van der Merwe for his editing of the text and constructive contributions. Also to the following who have contributed their expertise and enthusiasm: Susan Bennett, Dr D.G.C. Allan, Patricia Kattenhorn, Richard Wyber, Sarah Jameson, Alastair Laing, Matthew Steggle, B.C. Pratt, Dr Colin Shrimpton, Verney Lovett-Campbell, The Marquess of Zetland, Lord Derby, Miss M.M. Brooks, Michael Steed, F.B. Cockett, Philip Jago, Charles Russell, Michael Trayler, Karen Peart, David Spence, Roger Quarm, Lindsey MacFarlane, Teddy Archibald, Oliver Swann, the Federation of British Artists, Lisa Royce, Annie Madet, Joseph Vallejo, William Davis, Don Demers, Geoff Hunt, Colin Verity, David Cobb, David Cross, Maren Petersen, Peter Hagenah, John Morton Barber and Laura Brandon.

This edition published in 1995 by Smithmark Publishers, Inc.,
16 East 32nd Street, New York, NY 10016.

SMITHMARK books are available for bulk purchase for sales promotion and premium use. For details write or call the manager of special sales, SMITHMARK Publishers Inc., 16 East 32nd Street, New York, NY 10016;(212) 532-6600.

First produced in 1995 by Studio Editions Limited
Princess House
50 Eastcastle Street
London W1N 7AP
England

ISBN 0-8317-1572-3

Printed and bound in Singapore

10 9 8 7 6 5 4 3 2 1

CONTENTS

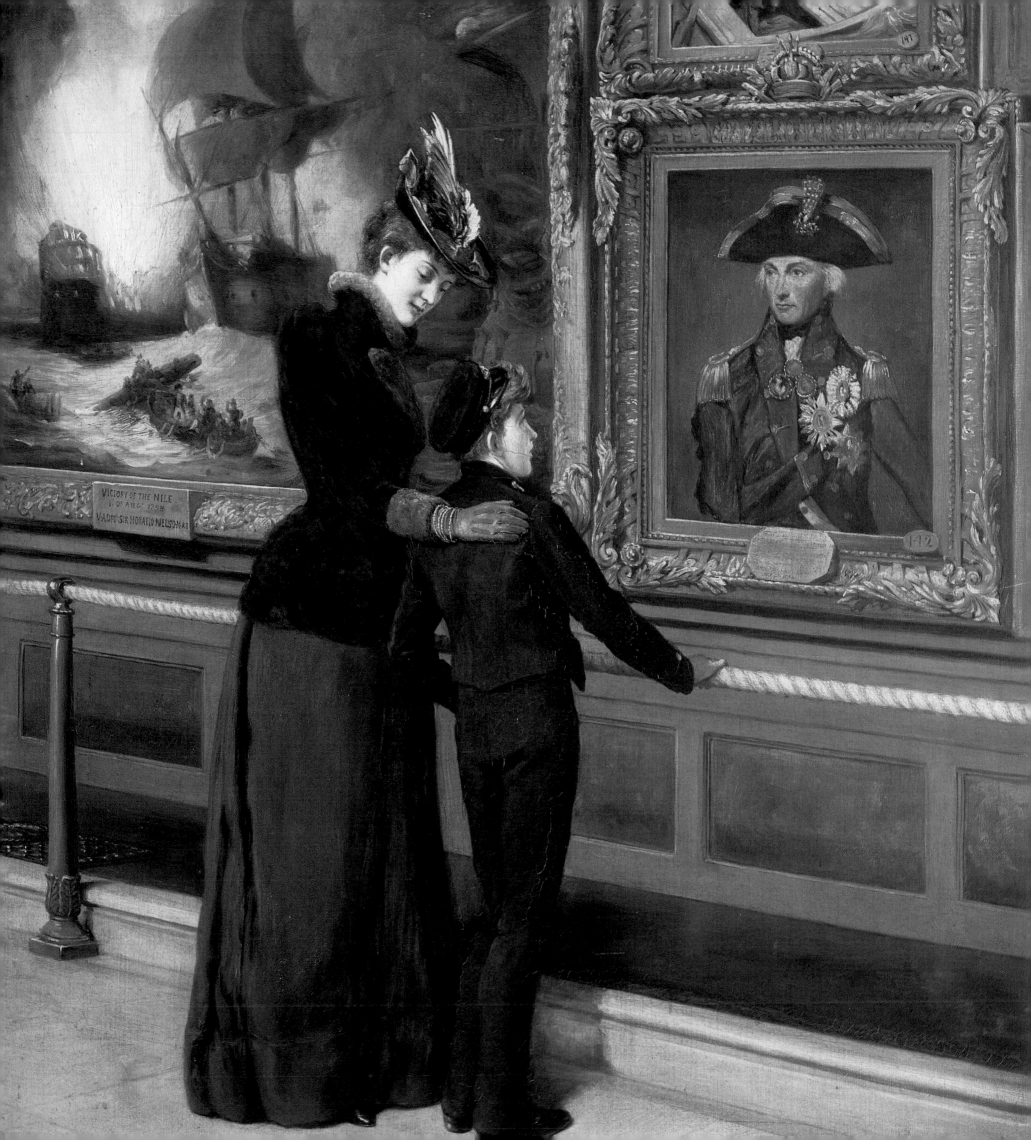

VICTORY OF THE NILE
1st of AUGt. 1798.
V. ADMl. SIR HORATIO NELSON KB.

FOREWORD

James Taylor's *Marine Painting - Images of Sail, Sea and Shore* is a most welcome addition to the rather limited literature devoted to marine painting. Through its coverage, and the sheer volume of its images, it is a truly magnificent tome for general art-lovers, connoisseurs of the genre and all enthusiasts of maritime life.

Apart from books on individual marine painters, the first general book on marine painting was Admiral Sir Lionel Preston's accomplished *Sea and River Painters of the Netherlands* of 1937. Sir Lionel, on retirement, set up an art gallery specialising in marine subjects. Then after the War came Oliver Warner's *British Marine Paintings* in 1948. There was then a lull, followed by a spate of books in the seventies. David Cordingly's two useful works, *Painters of the Sea, a Survey of British and Dutch Marine Paintings*, 1979 and *Marine Painting in England 1700-1900*, were published in 1974. Also in 1974 was Denys Brook-Hart's *British 19th Century Marine Painting*, followed by *British 20th Century Marine Painting*, both part an account and part dictionary. In 1975 came William Gaunt's *Marine Painting*, a very wide ranging, rather idiosyncratic work, embracing both the Ancient World and the Orient, more interested in movements than in men. Rupert Preston, a son of Lionel, produced *The Seventeenth Century Marine Painters of the Netherlands* (1974), which was mostly the work of his assistant, Sheila Horlick. It takes the artists separately and concentrates on where their works may be found; there is also a section on reproduced signatures. In 1973 Laurens J. Bol published a large book, *Die Hollandische Marine Malerei des 17 Jahrhunderts*.

As well as histories, there are dictionaries. The first was Arnold Wilson's *Dictionary of British Marine Painters*, 1967, then my *Dictionary of Sea Painters*, 1981, second and enlarged edition 1989 and a third, enlarged again, in 1995. Finally, Dorothy Brewington's *Dictionary of Marine Painters*, 1982, which is international, but does not cover the living or recently dead.

In *Marine Painting - Images of Sail, Sea and Shore*, James Taylor addresses the surviving scenes and maritime objects from ancient times, but the main theme of the book concerns the enduring influence of the Protestant painters of the Netherlands in the sixteenth and seventeenth centuries down to the present day. The post Reformation released these artists from the constraints of the old religious establishment, and allowed them to develop landscape and seascape themes, as well as genre scenes and portraits. Indeed the current schools find that today's tankers, bulk carriers, ferries and cruise liners have a limited appeal, and therefore tend to turn out beautifully crafted historical subjects, especially late nineteenth and early twentieth century yachting scenes, populated by the heroically proportioned racing machines to the designs of Watson and Fyffe.

Two areas not covered elsewhere are addressed here: patronage and the origins of the societies formed to hold exhibitions, without which the artist might not get known and both vital to the survival of the schools. There is also a welcome section on American marine painting.

E.H.H. Archibald, 1995

OPPOSITE: **England's Pride and Glory**, detail, Thomas Davidson . A Victorian portrayal of the magnificent Painted Hall of Greenwich Hospital. A National Gallery of Marine Paintings, with sea battles, genre scenes and portraits, was created in 1823, the first in the world. It is now in the National Maritime Museum collection.

INTRODUCTION

MARINE PAINTING spans more than three thousand years, from some of the earliest images found in ancient Egyptian mural painting to depictions of sailing ships and beach scenes, including modern subjects such as oil-rigs and tankers. The dominant influence of the seventeenth-century Dutch Masters is traced through successive generations of painters in Europe, especially in England, and in America.

The focus is on artists working in oils who portrayed accurate and recognisable marine imagery and on those who responded to the influence of Romanticism and other modern movements without losing sight of their subject matter - ships and the sea.

Marine painting encompasses a wide range of subjects and styles. Towards the end of the eighteenth century, newspaper reviewers used the term to describe depictions of sea battles, shipping subjects, ship portraits, harbour views, coastal and beach scenes. Before 1795 marine pictures were usually called 'sea pieces'. Artists painted in a realistic style, according to the tastes and instructions of their patrons, who were usually professionally associated with the sea and expected accuracy above all. Their concern was for the subject rather than the technique of painting. A ship had to look seaworthy and, better still, be recognisable as a particular vessel. Marine painters therefore required a wide range of skills and especially a knowledge of seamanship, either acquired at first hand or through detailed study of other artists' work or ship models. Pictures were normally commissioned to commemorate a specific maritime event such as the return of a trading fleet or a successful naval action.

From about 1800, artists started to break away from the documentary tradition of marine painting. P.J. de Loutherbourg and J.M.W. Turner practised a more personal and expressive form of painting, and inspired other artists to follow their example, sacrificing nautical accuracy and detail in favour of experiments in artistic expression and emotive effects. Turner's early work was indebted to the seventeenth-century Dutch masters, but his later marines are primarily concerned with the expressive potential of paint. His bold brushwork, vibrant colours and dramatic use of light encouraged painters of all artistic persuasions to explore imaginative avenues in the creation of maritime subjects thus raising the standard of marine painting to new heights.

Detailed portraits of merchant ships and naval vessels by artists such as Willem van de Velde the Elder (1611-1693) and his son, Willem van de Velde the Younger (1633-1707), semi-abstract visions of the sea in pictures such as *Slavers throwing overboard the Dead and Dying, Typhoon coming on* by Turner (1775-1851), and impressionistic beach scenes with fashionable promenaders by Eugène Boudin (1824-1898) may all be justifiably described as marine paintings.

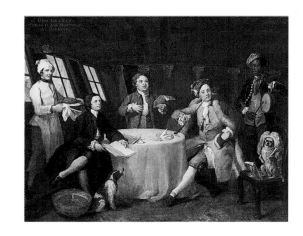

OPPOSITE: ***Song of the Sea -The 'Cutty Sark'***, *detail, Montague Dawson. 'Cutty Sark', the mercantile equivalent to Nelson's 'Victory', is the most famous merchant ship in the world. She was designed to win the coveted annual China Tea Race.*
ABOVE: ***Captain Lord George Graham in his Cabin****, William Hogarth. A rare view of life at sea. Hogarth's pug Trump mocks the more conventional officers, keeping the roast duck waiting while they sang a catch. Uniform for officers was not introduced until 1748.*

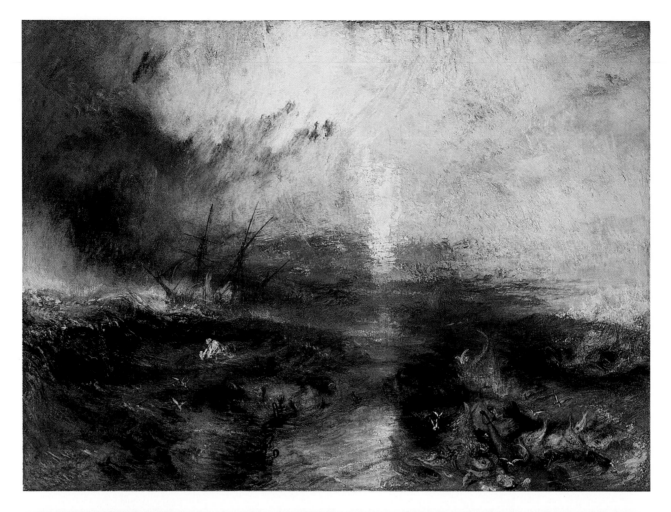

Perhaps surprisingly some of the finest marine pictures were painted by artists not normally associated with the genre and with limited first-hand experience of the sea, notably Benjamin West's *Battle of La Hogue, 1692* painted in 1778 and Théodore Géricault's Romantic image of the *Raft of the Medusa*, painted in 1819.

Two of the best-known categories of marine painting are ship portraits, either depicting a vessel in full sail or battling against the elements on the high seas, sometimes painted at the request of a ship's master or owner; and dramatic naval battles, often commissioned by naval officers involved in the action. But there is no clear dividing line between marine and landscape art, and pictures that show more land than sea or have buildings rather than ships as their focal point, such as a dockyard or harbour views, may still be classed as marine paintings. Indeed, some artists, including Henry Moore (1831-1895) and David James (fl.1885-1900) made the sea itself the main subject of their work.

During the late eighteenth century in England, the otherwise obscure artist/draughtsman Joseph Marshall (fl.1770s) painted for King George III a series of portraits of ship models, showing bow and stern perspective views. The larger part of this commission is now in the Science Museum in London and provides invaluable technical information on the ships, making them unique marine subjects.

Familiar subjects are yachting and boating, beach scenes, fishing and whaling. Less familiar depictions include royal fleet reviews, shipbuilding, ceremonies such as slip launches and State occasions, and also life afloat. There are storms and shipwrecks, often derived from biblical stories or myths and legends; and depictions of new lands executed by the official artists who accompanied explorers such as Captain James Cook during the 1770s. In addition, portraits of people associated with the sea sometimes contain maritime scenes in the background, or in the foreground, as is the case in Sir Peter Lely's maritime masterpiece *Peter Pett and the 'Sovereign of the Seas'*.

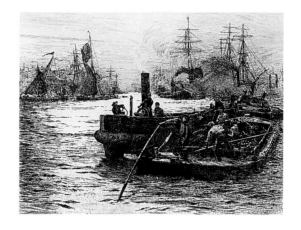

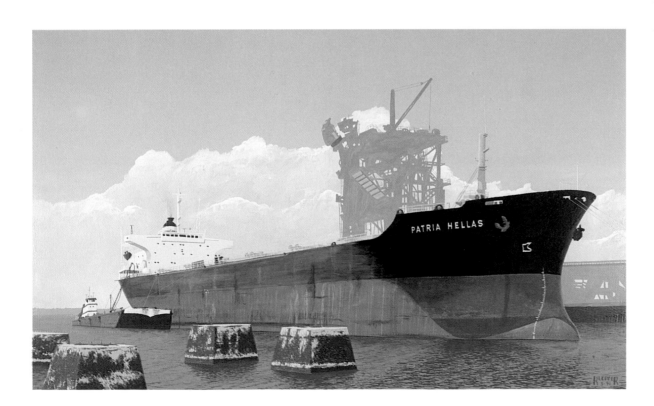

OPPOSITE ABOVE: ***Slavers throwing overboard the Dead and Dying -Typhoon coming on***, J.M.W.Turner, *also known as **The Slave Ship**. Exhibited with the lines from the artist's fragmented epic poem 'Fallacies of Hope'. Turner's champion Ruskin owned this picture for twenty-eight years, but sold it because of the disturbing nature of the subject. He believed the sea to be 'the noblest..ever painted by man'. The subject derives from James Thomson's 'Seasons', and also, as Prof. Boase has discovered, the story of the slave ship 'Zong'. In 1783 an epidemic broke out on board the ship and the Captain ordered slaves to be thrown overboard as insurance could only be claimed for those drowned at sea.*
OPPOSITE BELOW: ***Battle of the Nile,1 August 1798***, George Arnald. *This is the finest depiction of 'L'Orient' at the Battle of the Nile, one of Nelson's most dramatic naval encounters. The French flagship blew up killing the admiral and most of the ship's company.*
LEFT: ***'Patria Hellas' taking on Bunkers at Norfolk***, Rick Klepfer. *When fully loaded the red bottom of this collier will be below the waterline. She is docked in Norfolk, Virginia, awaiting coal.*
ABOVE: ***Toil, Glitter, Grime and Wealth on a Flowing Tide***, William Lionel Wyllie. *Etching published by Robert Dunthorne. Wyllie excelled at realistic images of river life, especially on the Thames. In this print after the artist's celebrated oil painting, the physical labour necessary to move cargo on the river is highlighted in uncompromising close-up detail.*

THE FIRST MARINE PAINTERS

One of the earliest paintings of a marine subject is on a wall in the tomb of Huy in Thebes dating from about 1360 BC. It represents the vice-regal barge, a boat used on the Nile. Modern viewers might consider it a work of art, but it was in fact designed to preserve the object for its owner's use in the afterlife. And yet there is no attempt to create the illusion of an actual barge in a realistic setting.

Earlier examples of ships and the sea exist in various media. Crude, schematic images of boats and sailors appear in Scandinavian Bronze Age rock carvings of about 1500 BC. Greek pottery, Roman mosaics and medieval seals, tapestries and ecclesiastical furniture such as fonts and misericords were used to convey maritime scenes for ceremonial or decorative purposes.

Marine painting as an independent genre evolved slowly, after religious, historical, portrait and landscape art. In the sixteenth century, the portrayal of maritime subjects was linked to biblical stories, parables, legends and mythology. But the Renaissance brought to Northern Europe a growing freedom to paint new subjects, and the development of new skills, especially three-dimensional perspective, which permitted the portrayal of objects with greater realism on a two-dimensional surface such as a panel or canvas. One of the best known of the Renaissance artists, Leonardo da Vinci, made extensive notes on the nature of water, and graphic drawings of the sea, storms and floods.

Until the end of the seventeenth century, marine painters drew extensively upon literary sources. Classical mythology was the source of such themes as the voyages of Ulysses and the fall of Icarus. Biblical stories inspired images of Christ preaching on the Sea of Galilee, the miraculous draught of fishes, the shipwreck of St. Paul, and Jonah and the whale. The medieval legends of St. Ursula and St. Catherine involving ships and voyages became popular. St. Nicholas, patron saint of sailors, inspired artists to paint raging seas, ships in distress, and shipwrecks.

The portrayal of named ships in distress was normally avoided. A notable exception is the *Wreck of the Amsterdam*, tentatively attributed to Cornelis Claesz van Wieringen (c.1580-1633). This large-scale theatrical presentation of a shipwreck in a storm predates, by almost two hundred years, one of the most popular themes of Romantic art. During the seventeenth century ships and wrecks conveyed both literal and metaphorical messages emphasising the frailty, and sometimes strength, of man's physical, spiritual and moral condition. Stormy seas and shipwrecks represented hardships and transience. Rocks could symbolise Christ or the Church, human courage or even the dangers of sin. An inventory of paintings from a seventeenth-century poorhouse describes a picture now attributed to Jan Peeters (1624-c.1679), as 'depicting a shipwreck and thus the origin of poverty which is encountered in this house'.

OPPOSITE: *The Fall of Icarus*, detail, Pieter Bruegel the Elder. *Icarus has fallen from the sky and is disappearing into the sea but the main focus of the picture is not this dramatic incident but the sailing vessel, which is highly detailed, and the careful delineation of wave forms.*
ABOVE: *The vice-regal Barge from the Tomb of Huy in Thebes. Nina de Garis Davies spent over thirty years, copying Theban tombs, using egg tempera to achieve colours remarkably faithful to the originals.*
BELOW: *Dionysos sailing, mid 6th century BC. Interior of a Greek bowl (kylix) painted in the Attic black-figure style on a red-glazed ground. Signed by Exekias.*

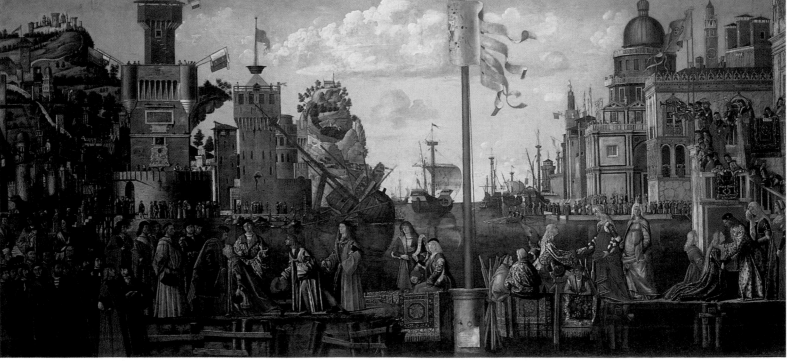

Most maritime subjects found in frescoes, and altar-pieces of the early Italian Renaissance and in medieval illuminated manuscripts derived from literary sources, although some commemorate specific maritime events. An English bestiary dating from the late twelfth century contains a highly-stylised version of Jonah and the whale. The illuminator had clearly never seen a whale and the sea is represented by a series of crude undulating lines. Another English manuscript known as *Le Livre du Grand Caam*, of about 1400, illustrates the travels of Marco Polo and includes a charming scene of the seafarer's departure from Venice, with waterside activity, and portraits of vessels with sailors aboard. The representational technique is naive but the ship in the foreground is recognisable as a cog, a trading vessel of north European origin which had been absorbed and modified in the Mediterranean since 1300.

A cog also features in Bicci di Lorenzo's *St. Nicholas rebuking the Tempest*, one of the earliest marine subjects in oils. Painted on panel, this biblical image formed part of an altarpiece from the Florentine church of San Nicolo in Cafaggio. The focus is the ship in distress, its mainsail torn in the swirling, sombre, dark green water that occupies almost three-quarters of the picture. The ominous dark shapes below the water, representing fish or perhaps sea monsters, reaffirm the threatening nature of the storm.

Vittore Carpaccio (c.1455-1526) painted a remarkably detailed cycle of paintings of the Legend of St. Ursula for the Scuola di Sant'Orsola in Venice, with ships and costumed figures of his own time. Carpaccio was the first of the *vedutisti*, or view painters, who delighted in vivid and colourful impressions of city life and harbour activity, including excellent and archaeologically important representations of ships' masts, rigging and sails. Here are the beginnings of the lively quayside and seashore scenes that have continued to attract artists today.

The Fall of Icarus by the Flemish artist Pieter Bruegel the Elder (c.1520-1569) is another authentic image of contemporary shipping: in this case a four-masted carrack, with sailors climbing the shrouds and working the sails. But the sea is less convincingly portrayed as a largely flat, opaque surface. Bruegel is better known as a painter of rustic peasant scenes, but many of his pictures contain maritime elements.

During the 1560s Bruegel made drawings for a series of ship types, etched by Franz Huys, and published in about 1565. In this series, the earliest recorded of its type, Bruegel has not only created accurate portraits of sailing vessels, but also attempted to integrate ships with seas, skies and land into realistic and animated compositions. Bruegel infuses atmosphere with naturalistic cloud formations and, less successfully, light and shadow. In his finest examples he created a sophisticated relationship between the ship and the wind acting against the sails, masts and rigging, and a creditable portrayal of realistic wave forms.

Marine painting benefited significantly from the development of navigational charts, pioneered in southern Europe during the thirteenth century, and later refined by the Portuguese and Dutch. Some elaborate examples were enlivened with colourful images of ships and sea monsters. During the fifteenth and sixteenth centuries, printmakers and some painters produced charts, maps, and aerial views of European cities, including Antwerp, Venice and Lisbon, which were instrumental in the development of the compositional and representational techniques of marine painting. One of the many notable woodcuts by Erhard Reuwich, from Bernhard von Breydenbach's *Peregrinatio in Terram Sanctam*, Mainz, 1486, the first printed travel book, portrays a bird's-eye view of Venice in 1481 with ships under construction,

*OPPOSITE ABOVE: **The Wreck of the 'Amsterdam'**. Traditionally believed to be by Cornelis Claesz van Wieringen. But the style does not relate to any other known picture by him. The arms on the stern are those of the City of Amsterdam.*
*OPPOSITE BELOW: **The Legend of St.Ursula**, Vittore Carpaccio. As a test to her suitor, the King of England's son Conon, Ursula demanded that he send her eleven thousand virgins. God commanded her to escort them to the holy shrines of Rome. At Cologne, she learned of God's desire that they all be martyrs for the faith. The legend provides an opportunity for scenes of embarkation, departure and arrival by sea, and harbour scenes. The earliest painting in this cycle is dated 1490.*
*ABOVE: **Armed Ship putting to Sea**, Frans Huys after Pieter Bruegel the Elder. A 16th-century type, with raised platforms at each end of the ship - called fore and after castles - from which sailors and soldiers fought.*
*BELOW: **First Seal of the City of Paris**, c.1200. A 13th century double-ended clinker-built hull of the Viking period. In the Middle Ages the Seine Transport Association was the most important of the Paris Guilds and so its seal served as the City seal.*

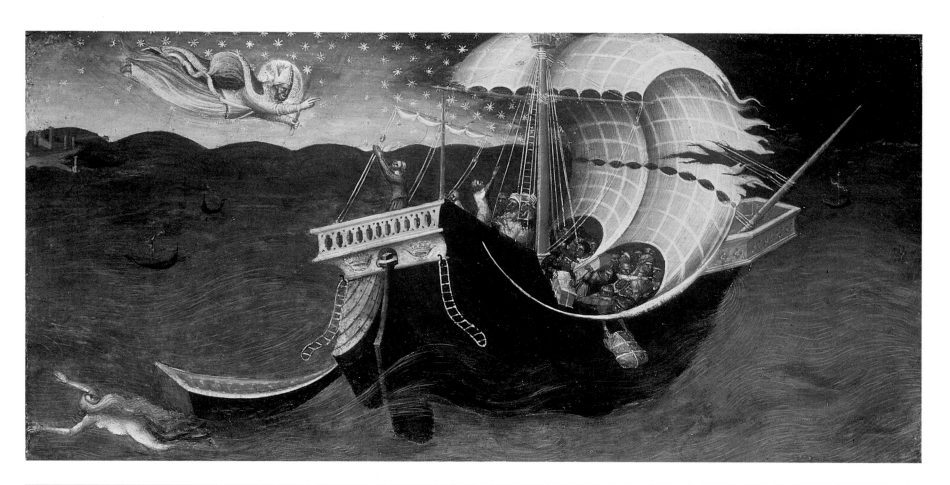

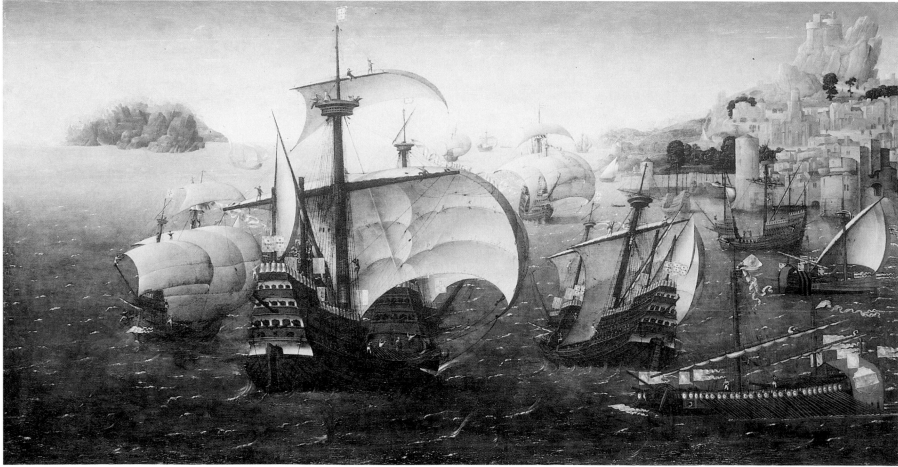

and gondolas and trading vessels moored along the waterfront. These cartographical sources encouraged marine artists to paint pictures using a panoramic viewpoint, or bird's-eye perspective, which enabled them to portray a naval battle or shipping scene in its entirety, and to re-arrange the action and individual ships intelligibly for the viewer. Pieter Bruegel the Elder and Cornelis Anthonisz. Theunissen were also map makers.

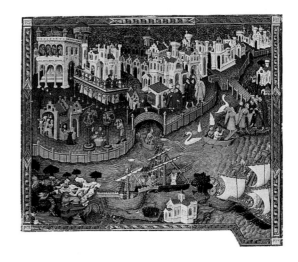

Portuguese Carracks off a Rocky Coast, attributed to the Amsterdam artist Cornelis Anthonisz. Theunissen (c.1499-1553), is probably the first marine painting to adopt bird's-eye perspective, and also one of the earliest recorded in oils. It is thought that it commemorates the arrival at Villefranche of the Portuguese Infanta Beatriz, daughter of King Manuel, aboard the *Santa Caterina de Monte Sinai*, on her way to marry Charles III, Duke of Savoy, in 1521. If the subject of the picture is correct, then it is the first true marine painting independent of a literary or religious metaphorical association. It is also important as the earliest representation of armed carracks, ships used on the early voyages of discovery and trade. However, little attempt has been made to create convincing cloud or wave forms, and the harbour and the looming rocks and fortress above, all have an ethereal quality.

Another early example of bird's-eye perspective, attributed to Cornelis Anthonisz. Theunissen and Jan Vermeyen (1500-1559), shows *Henry VIII's Embarkation at Dover in 1520* for the fabulous peace celebrations at the Field of the Cloth of Gold near Calais. The artists have adopted a raised panoramic viewpoint to good effect, representing the King's ships in a processional line to impress upon the spectator the pageantry and grandeur of the occasion. The largest of the ships depicted is the *Great Bark* at 500 tons, although Henry actually sailed on the *Katherine Pleasaunce*. The sea is rendered with less conviction.

Henry VIII transformed the small navy inherited from his father, and during the thirty-eight years of his reign built forty-six ships and thirteen small galleys, or row-barges, as well as purchasing other vessels and winning prizes. Many of these vessels have survived in the colourful visual records compiled in 1546 by Anthony Anthony, the Master of the King's Ordnance. These broadside depictions include famous ships of the Tudor navy such as the *Mary Rose* and the *Great Harry*, and lesser known vessels such as the diminutive row-barge *Rose Slype*. They were never intended to be works of art, but visual records, albeit inaccurate in their detail. The designer's emphasis on the elongated pennants and flat perspective link them to the practice of heraldic and sign painting.

Pieter Bruegel the Elder's *View of the Harbour at Naples* (c.1558), now in the Palazzo Doria Pamphili, Rome, depicts sailing ships fighting at close quarters and many galleys manoeuvring into position. Not only is this picture an impressive aerial view, but it is also the first marine painting to depict ships in a realistic setting where sea, sky and land are integrated in an atmospheric and coherent composition. It foreshadows the later achievements of the seventeenth-century Dutch masters and the gradual development of a more sophisticated realism.

Less realistic but instantly engaging is *The Battle of Lepanto, 7 October 1571*, signed H. Letter. It has been suggested that this painting is an early work by Hendrik Cornelisz Vroom. A related drawing ascribed to Vroom is in the Stichting Teylers in Haarlem. This close-up view is not an eye-witness account of the last large-scale oared galley action, which resulted in the victory of the combined fleets of Spain, the Papal States and Venice over the Turks. It is in fact an amalgamation of various contemporary Venetian engravings, primarily by Martino

*OPPOSITE ABOVE: **St.Nicholas Rebuking the Tempest**, Bicci di Lorenzo, a Florentine painter and sculptor painting in a style indebted to Gentile da Fabriano and Fra Angelico. St.Nicholas, in bishop's vestments and holding a crozier, abates the storm causing the pagan mermaid to flee. The merchants on board throw their worldly goods overboard, in a gesture of gratitude.*
*OPPOSITE BELOW: **Portuguese Carracks off a Rocky Coast**. This painting has been attributed to various artists including Joachim Patinir, Jan Brueghel, Jan and Mathys Cock, Pieter Bruegel, the Portuguese artist Gregorio Lopez, and Cornelis Anthonisz Theunissen.*
*ABOVE: **The Travels of Marco Polo** (Le Livre du Grand Caam). Marco Polo arrived in Venice in 1295. Three years later Venice was at war with Genoa and in the great galley battle of Curzola he was among the 7,000 prisoners taken to Genoa.*

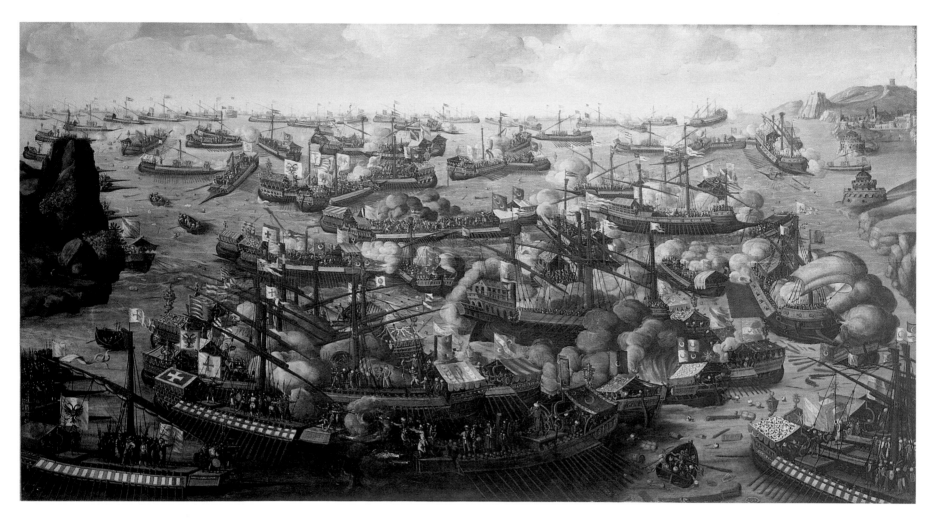

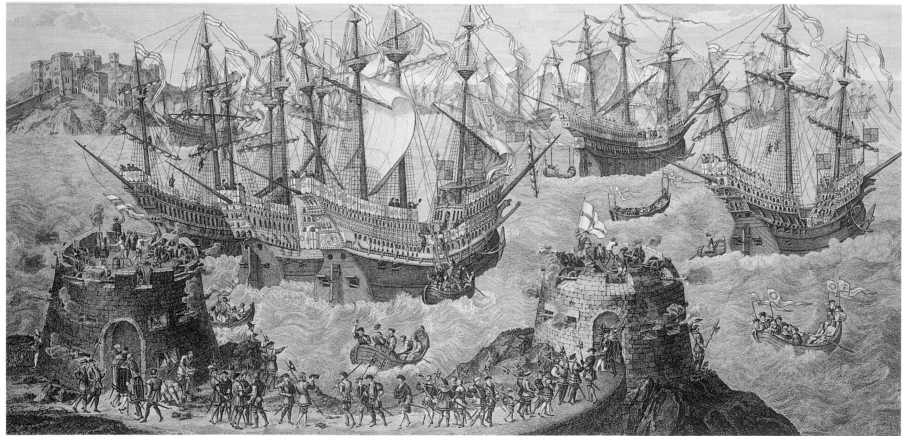

Rota (c.1520-1583). The rock formations are largely fanciful and the sea lacks animation. If this painting is by Vroom, it is a remarkably early example, displaying very little evidence of the increasing realism that is evident in his later pictures.

Panoramic viewpoints and aerial views continued as an important artistic convention during the next three centuries. Vroom was followed by Andries van Eertvelt, the Willem van de Veldes, and Nicholas Pocock. It is still used to good effect today.

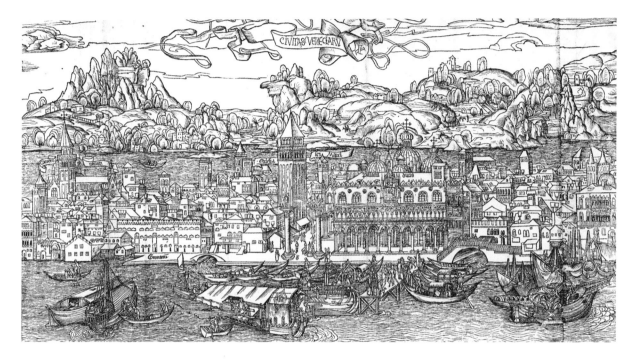

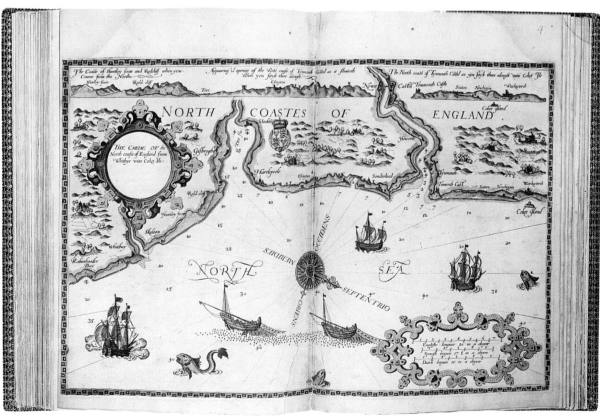

OPPOSITE ABOVE: ***Battle of Lepanto, 7 October 1571***, 'H. Letter', 16th-century. Following the proclamation of the Holy League to check the Ottoman Empire, over two hundred galleys under the command of Don Juan of Austria attacked a slightly larger Turkish fleet near its base at Lepanto in Greece. It was the last large-scale sea battle to be fought between galleys propelled by oars.

OPPOSITE BELOW: ***Henry VIII's Embarkation at Dover, 1520***, drawn by S.H.Grimm, engraved by James Basire, after the oil painting attributed to Cornelis Anthonisz Theunissen and Jan Vermeyen.

LEFT ABOVE: ***The City of Venice, 1483*** (detail) from Bernhard von Breydenbach's 'Peregrinatio in Terram Sanctam', Mainz. Woodcut by Erhard Reuwich. Venice was the greatest European sea power of the late Middle Ages. A native of Utrecht, Erhard Reuwich was both a painter and printmaker.

LEFT BELOW: ***Dutch Chart of the north east Coast of England***, Lucas Jansz Waghenaer, 1583. The Dutch master pilot Waghenaer produced the first comprehensive atlas of charts of the coasts of Europe from the Baltic to Gibraltar called 'De Spieghel der Zeevaerdt' (the Mariner's Mirror).

ABOVE: ***'Henri Grace à Dieu'***, or ***'Great Harry'***. Engraving by Newton, based on Anthony Anthony's design of 1546. His designs are now in the Pepys Library, Magdalen College, Cambridge. The 'Great Harry' of 1500 tons, carried 86 guns on several decks, and was the largest of Henry VIII's ships.

THE DUTCH AND FLEMISH MASTERS

Hendrik Cornelisz. Vroom (1566-1640) is now acknowledged as the founding father of marine painting. The reason for its development in Holland during the seventeenth century may never be satisfactorily explained. Portugal and Spain were certainly more likely locations. Throughout the fifteenth century they were the pioneers of navigation and exploration and their achievements were recorded in later engravings and paintings.

During the fifteenth century the art of painting was in its infancy, but it is not clear why marine painting did not evolve in the Mediterranean at a later time. Perhaps the notion of painting maritime images celebrating man's achievements at sea was perceived as being at odds with the existing tradition of religious painting which reaffirmed the primacy of God. However, marine backgrounds do appear in some Spanish religious art. Juan del Corte (1597-1660) and Juan de Toledo (1611-1665), called *El Capitán*, were among the earliest exponents of Spanish marines. Corte studied under Velazquez and benefited from royal patronage. *El Capitán* served in the army in Naples and painted predominantly military subjects.

The Dutch East India Company was established by the States-General in 1602, and the overseas trade with India and China brought new wealth. By the mid-seventeenth century Holland possessed many painters of superlative talent catering for the increasing demand for marine subjects. From 1609 when the Southern Netherlands was freed from Spanish control, there was less preoccupation with religious imagery in this Protestant country. Merchants whose income derived from the sea, ship owners, and naval officers, all commissioned ship portraits and commemorations of notable achievements, such as the return of a lucrative cargo or a successful sea battle. Vroom pioneered many of the subject categories of maritime art, including naval battles and everyday marine views with small sailing craft, such as *A View of Delft from the Northwest*, one of a pair painted in 1617, now in the Stedelijk Museum, Delft. He excelled at lively harbour scenes such as *Ships Trading in the East*, using the high-viewpoint. He also painted complementary and contrasting pairs of pictures of the same size.

Carel van Mander, Vroom's friend, fellow painter and biographer, published an amusing account of the artist's life in *Het Schilder-Boeck* (Haarlem, 1604). Vroom was from an artistic family and apparently loved playing practical jokes. His father was a sculptor and potter, and, like his father, he became a proficient painter of pots and ceramics. Vroom continued this profession as he travelled in Europe, where he experienced the sea at first hand and survived being shipwrecked. He received tuition in oil painting from the Flemish artist Paul Bril (1554-1625), and painted a wide range of subjects including religious works, but on his return to Holland he discovered a market for marine pictures. Current thinking is that he actually

OPPOSITE: **The Arrival of Frederick V, Elector Palatine, with his wife Elizabeth, at Flushing in May 1613**, *detail,* Hendrik Vroom. *Probably completed in time for the visit to Haarlem in June 1623 of the defeated King of Bohemia, who was in exile in The Hague .*

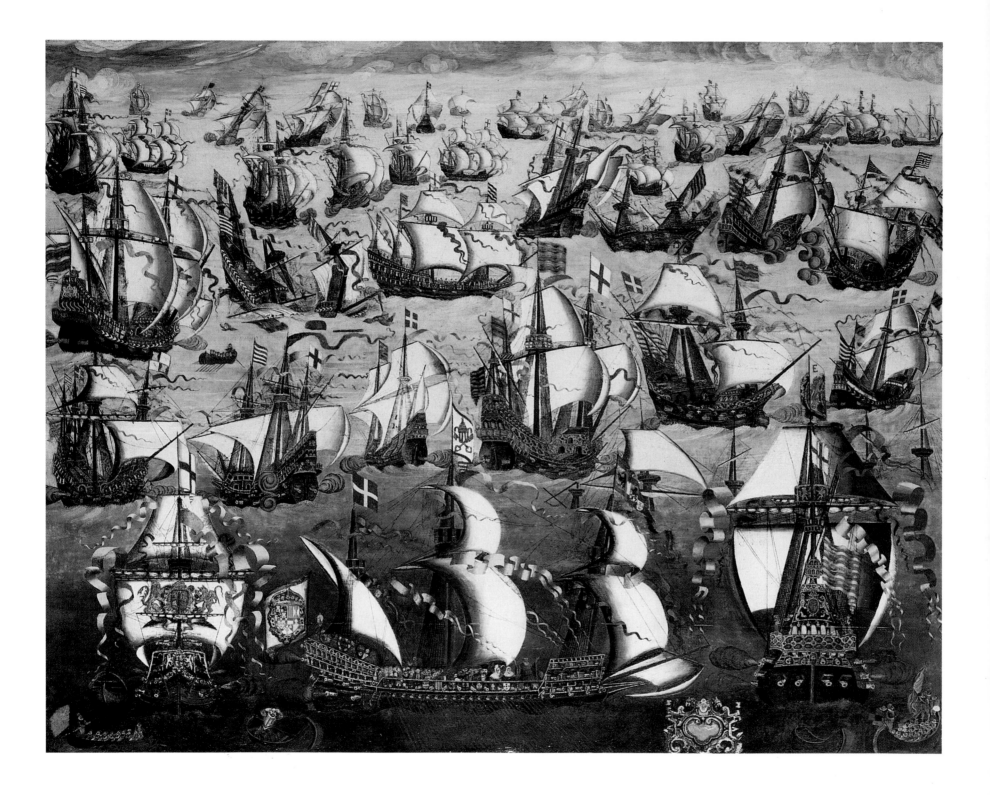

created the demand for ship painting significantly before the establishment of the Dutch Republic as a major maritime power.

Vroom also designed tapestries, and it was perhaps in this medium that he applied the high-viewpoint to its best effect. During the first half of the seventeenth century tapestries were more highly prized than paintings and literally fortunes were spent on them. Royal palaces were filled with them. After the execution of King Charles I of England, his celebrated art collection was sold at auction in 1649, and, according to a contemporary observer, there were '..tapestries.....one only piece of many valued at 12,000 pounds'.

Vroom's most famous tapestries are a series of ten designs depicting the major incidents of the *Spanish Armada*. They were woven by the Brussels weaver Francis Aertsz. Spierincx and commissioned by the Lord Howard of Effingham in 1592 to commemorate the English success under his overall command. The general arrangement of the ships was inspired by the set of charts of the engagements drawn by Robert Adams, a royal surveyor. Vroom's designs made no attempt to create a naturalistic setting but adapted Adams' cartographic images to create bold and striking patterns out of the formations of the ships and land.

The tapestries were delivered to Howard in 1595 at a cost of £1,582, but Vroom later received an additional sum of money as a gift. The tapestries originally hung in his private residences. In 1650 they were installed in the House of Lords, where they remained until destroyed by the great fire of 1834. The original cartoons, or designs, are now lost but fortunately Vroom's long-faded tapestries were engraved by the London printmaker and publisher John Pine in 1739 '...because Time, or Accident, or Moths may deface these valuable Shadows..'.

There are few contemporary oil paintings showing the Armada. In one notable panel, by an unknown artist of the English School, now in the National Maritime Museum, Greenwich, the vessels fill the entire composition leaving little space for sky. The stylised manner of portraying the ships, the wayward perspective, scale, and emphasis on colourful pennants and flags indicate a heraldic or sign painter conversant with coats of arms and trade signs rather than with the ships of the Elizabethan Navy.

Vroom painted storms and shipwrecks, some of them inspired by his own experience, and excelled at maritime genre subjects such as beach and fishing scenes, arrivals and departures. The greatest is *The Arrival of Frederick V, Elector Palatine, with his wife Elizabeth, at Flushing in May 1613*. This lively large-scale panoramic painting captures the grandeur of the occasion - the Elector's bride was Princess Elizabeth, daughter of James I of England - and accurately portrays various named vessels. It is Vroom's masterpiece and full of authentic detail. He demonstrates that..'not only does [he] understand the construction of the ships, their ropes and rigging, the direction of the winds, the sails and other relevant matters, but he also excels in all other aspects, such as backgrounds, landscapes..waves, towns, small figures, fish and the subjects which enliven and enhance his ships.' [Mander]

However, Vroom's attention to nautical detail was often diminished by his preference for stylised compositions, mannered brushwork and an artificial and theatrical use of colour.

'Old Vroom', as he was known in England, pioneered new marine subjects, but it was left to one of his pupils, Jan Porcellis, and later followers, notably Simon de Vlieger and Willem van de Velde the Younger, to develop representational techniques and a palette of colours that reflected local subjects and climate with greater fidelity.

OPPOSITE: ***English Ships and the Spanish Armada, August 1588***, *English School. Probably a tapestry design. The treatment is heraldic. In the foreground, two English warships flank a Spanish galleasse. On the right, stern view, is Lord Howard of Effingham's flagship, 'Ark Royal'. On the left, bow view, is probably Sir Francis Drake's 'Revenge'.*
ABOVE: ***The English pursue the Spanish Fleet east of Plymouth (31 July-1 August)***, *from Expeditionis Hispanorum in Angliam vera descriptio Anno Do: MDLXXXVIII, Augustine Ryther after Robert Adams; engraving with contemporary colouring. The Armada is pursued through the night at culverin range by Howard in the 'Ark Royal', with the 'Bear' and 'Mary Rose' (four ships are shown, apparently in error). The English fleet, lacking Drake's light to follow, hangs back. Drake's capture of the 'Rosario' is to the south.*
BELOW: ***The English pursue the Spanish Fleet east of Plymouth (31 July-1 August)***, *engraved and published by John Pine in London. The names of the English commanders are inscribed in the borders. Drake's capture of the 'Rosario' is shown in the lower left-hand corner, and is depicted as a desperate boarding action. In reality, the ship surrendered without firing a shot.*

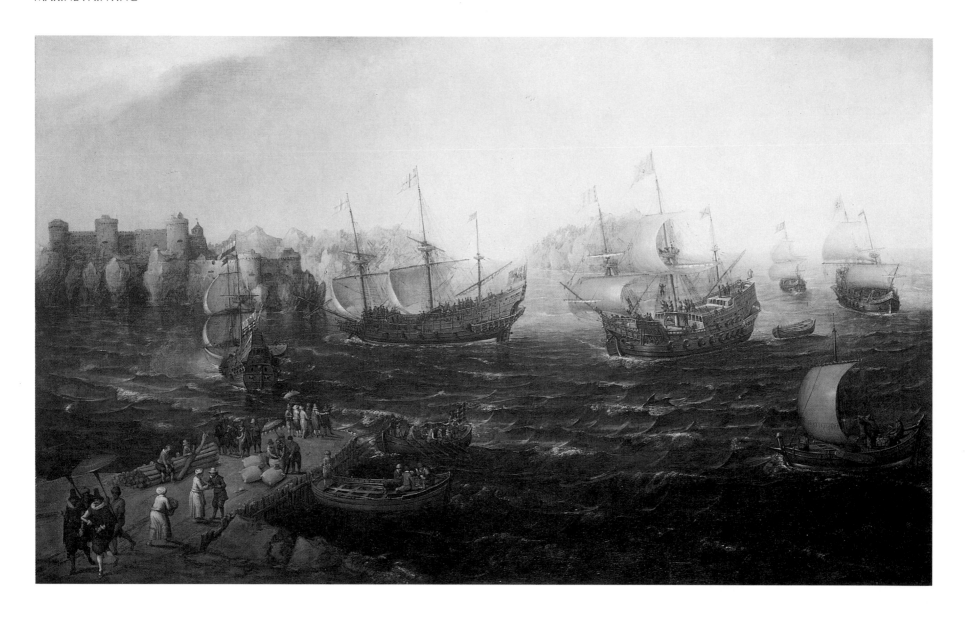

ABOVE: ***Ships trading in the East***, Hendrik Cornelisz Vroom. *This peaceful image of trading may well be an allegory illustrating the benefits of peace between sea-faring nations of the world. A twelve years' truce between Holland and Spain was signed in 1609. Ships from Holland, Spain, England and France are included.*

Vroom's success attracted an increasing number of commissions from the Dutch Admiralties, the States-General, town magistrates, merchants, and the East India Company. He could not have painted them all single-handedly. His son Cornelis Hendriksz, who painted in a similar but inferior style to his father, and several prominent artists are associated with his studio, and many more were influenced by his work.

Cornelis Claesz van Wieringen, also from Haarlem, was clearly indebted to Vroom. *An English Privateer off La Rochelle* (1616), now in the National Maritime Museum, shows a similar interest in nautical detail and colours, and his seas are invariably dark greens. He painted a wide variety of subjects but, like Vroom, is generally less successful at representing naturalistic effects. One of his most important commissions, from the City of Amsterdam, was a large picture of the *Battle of Gibraltar, 25 April 1607*, painted in the same year. It is probably the picture now attributed to him in the Rijksmuseum, Amsterdam, once attributed to Vroom.

Cornelisz Verbeecq (c.1590-c.1635), who was also from Haarlem, was almost certainly a pupil of Vroom, although his later work also has a greater affinity with the realism pioneered by Jan Porcellis. Verbeecq was capable of superlative work on a minute scale, producing masterpieces of atmosphere and accurate detail.

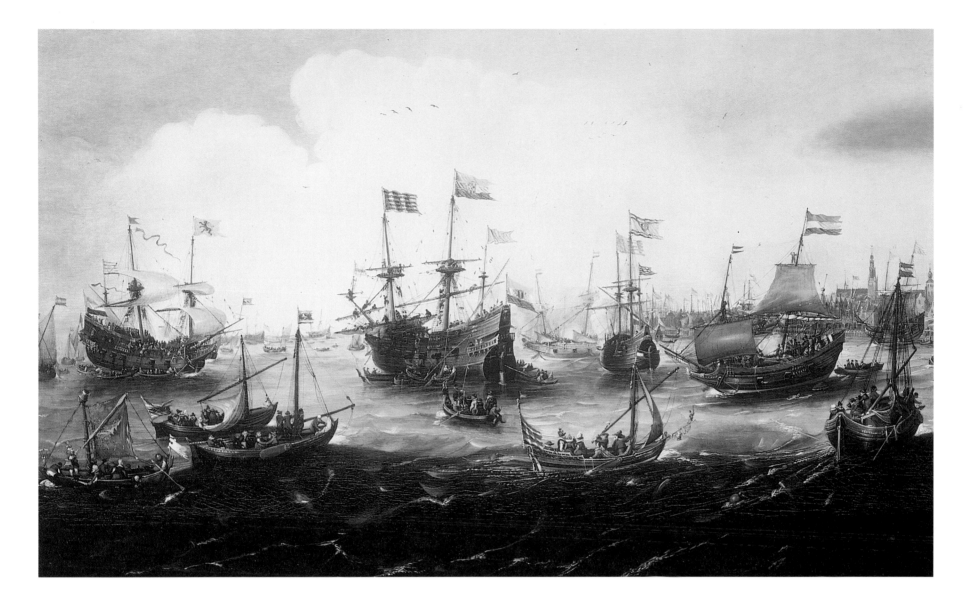

Aert Anthonisz (c.1579-1620), formerly called Aert van Antum, was a native of Antwerp, but settled in Amsterdam. He copied Vroom's work and may have studied under him. Most of his lively and atmospheric pictures were painted on small wooden panels. His ships are carefully drawn revealing a sound grasp of seamanship. His seas are less convincing in their representation and invariably dark green.

Andries van Eertvelt (1590-1652) also copied Vroom's pictures. The best known of these is the *Return of the Dutch East India Fleet, 1599*. Eertvelt, also from Antwerp, painted a broad range of subjects including ship portraits, but was less concerned with nautical accuracy. His preference for metallic colours made his work distinctive and less realistic. *Dutch Yachts Racing* of about 1620 is typical of his theatrical style, generally known as Flemish mannerism. It is also one of the earliest depictions of a yacht race. Although his early work is indebted to Vroom, he later demonstrated a fondness for fanciful stormy seas with ships, and delighted in contrasting the rigging and brightly coloured flags against a dark background.

Eertvelt's studio trained the next generation of marine artists, which included Mathieu van Plattenberg (c.1608-1660), who left Antwerp for Paris and changed his name to Plattemontagne, Hendrik van Minderhout (1632-1696), and Sebastian Castro (fl.1650-

ABOVE: *The Return to Amsterdam of the Dutch East India Fleet in 1599*, Andries van Eertvelt. *The 'Hollandia' is in the centre and the 'Mauritius' on the left. The flute, stern on, to the right of the 'Hollandia' is the 'Amsterdam', while the ship to her right is identifiable by her figurehead as the 'Duyfhen' (Pigeon). Eertvelt has copied Hendrik Cornelisz. Vroom's masterpiece 'Return of the Dutch East India Fleet'.*

ABOVE: *A Dismasted Ship in a Rough Sea*, Bonaventura Peeters the Elder. *It is possible that this scene, painted in a broad, atmospheric and realistic style is an allusion to the shipwreck of St. Paul.*

1690s). His most gifted pupil was Bonaventura Peeters the Elder (1614-1652), head of a family of painters, who at twenty became a master of the Guild of Antwerp. He painted some of the most dramatic of all marines, with an eye for nautical detail. His windswept coastal scenes with ships in distress and forlorn figures are direct precursors of the themes and compositions of Rosa, Magnasco, Ricci, Vernet and de Loutherbourg.

Adam Willaerts (1577-1664) left Antwerp at an early age to settle in Utrecht, which probably explains his individual and distinctive style. He was originally a painter of rustic genre in the manner of Pieter Bruegel the Elder, but later turned almost exclusively to colourful and animated scenes of embarkation and arrival, another subject category pioneered by Vroom. One of his favourite subjects, of which he did a series of pictures, was the voyage of the Elector Palatine and his English bride, the Princess Elizabeth, from England to Bohemia, to which he attributed a sea-coast that it does not have. He favoured imaginary compositions, although in his later pictures his seas became a realistic grey. His sons, Abraham and Isaac, also painted similar subjects in a similar but less accomplished style.

Jan Porcellis (c.1584-1632) married Hendrick Cornelisz. Vroom's daughter in 1605, and was probably one of his pupils. But he developed his own style, now described as 'realistic'.

Porcellis gradually abandoned Vroom's vivid artificial colours in favour of a limited tonal range of greys and sometimes ochres. He also helped to popularise views observed from a lower view-point, evident in pictures such as *Dutch Ships in a Gale* (c.1620), and experimented with new atmospheric effects. This new balance of colour and compositional viewpoint characterised the emergence of a talented group of marine artists, informally led by Porcellis, and encouraged by sympathetic patrons willing to commission their work.

Paintings by Porcellis and Vroom were exported and it is almost certain that in 1610 a storm scene by Porcellis and a naval battle by Vroom formed part of a diplomatic gift from the States General of the Dutch Republic to Henry, Prince of Wales, eldest son of King James I as a reward for English political support of the Dutch Republic. A similar gift was given to the French.

The English royal family were not the only collectors of marine painting. George Villiers, 1st Duke of Buckingham (1592-1628), favourite of both James I and Charles I, was a prominent art collector who purchased 'pictures, hangings, arras, tapistry, plate, jewells' including 'a sea piece' by Porcellis, and 'a ship, the fleet, when our king out of Spain', by Old Vroom. Buckingham's extensive art collection, comprising about two hundred paintings, was sold in Antwerp during the English Civil War to raise money for the Commonwealth.

ABOVE: ***The 'Prince Royal' and other Shipping in an Estuary***, Adam Willaerts. *The 'Prince Royal' was launched in 1611, and named for Henry, Prince of Wales, eldest son of King James I of England. It was the pride of the fleet and decorated with the feathers of the Prince of Wales, who died in 1612.*

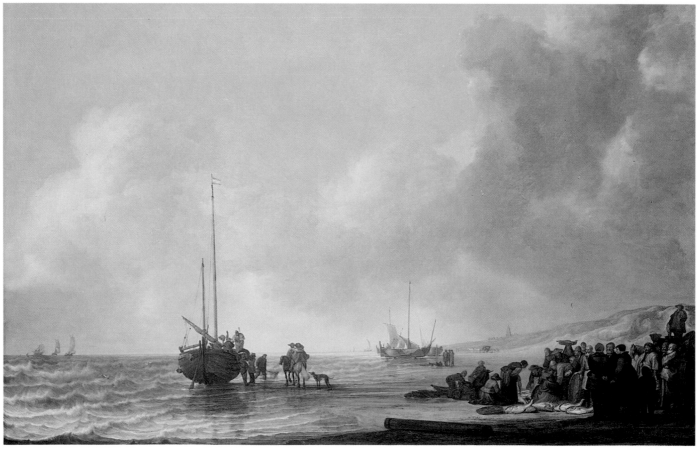

Among Jan Porcellis's pupils were his son Julius (c.1609-1645) and the Haarlem artist Pieter Mulier the Elder (1615-1670) who sometimes arranged his ships and seas in rhythmic patterns. The most important was the Rotterdam artist Simon de Vlieger (c.1600-1653) who was probably taught by Willem van de Velde the Elder, and later taught van de Velde the Younger. He is an accomplished marine painter. One of his many pictures of the beach at Scheveningen is a highly atmospheric beach scene of everyday life, showing the long stretch of coastline near the Hague, the beached fishing pinks, the unloaded catch and the fish auction in progress. It is a remarkably early depiction of landscape and skyscape - more than two-thirds of the composition is sky - and a reminder of the difficulty in classifying marine subjects.

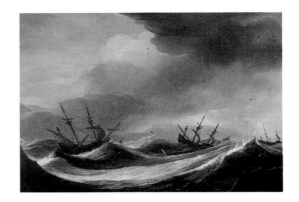

Marine painting in Holland benefited from a broader artistic interest in river and estuary scenes. Jan van de Capelle (1624-1679), probably a pupil of de Vlieger, generally avoided shipping, preferring to paint small sailing craft becalmed. Jan van Goyen (1596-1666), from Leiden, painted small-scale panel pictures such as *Fishing boats in an Estuary at Dusk*, of great delicacy and charm in their portrayal of naturalistic and atmospheric effects. Aelbert Cuyp (1620-1691) Salomon van Ruysdael (c.1600-1670) and Jacob van Ruisdael (c.1628-1682), better known for their landscape pictures, also produced exceptional river and estuary views.

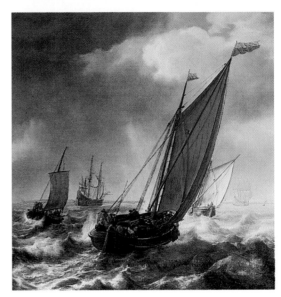

Cuyp's *The Passage Boat*, now in the British Royal Collection, and *View of Dordrecht* reveal his ability to arrange a complex variety of small craft, shipping, and maritime people into visually striking and superbly balanced compositions. His rendering of cloud formations, their reflection in the water, and controlled infusion of warm golden light remain unsurpassed.

The Willem van de Veldes, a father and son, generally referred to as the Elder (1611-1693) and the Younger (1633-1707), were born in Leiden and are widely acknowledged as two of the finest of all marine artists. Their popularity lies in their ability to create accurate, animated and harmonious compositions, with expert handling of naturalistic and atmospheric effects. They worked individually and sometimes in partnership, the Elder providing sketches and drawings, often annotated, for his son to work up into finished oil paintings.

Willem van de Velde the Elder's father was master of a transport vessel. When the family moved to Amsterdam in about 1633, they lived in the harbour area near the Montelbaanstoren, where the Elder had the opportunity to observe and record shipping and other aspects of maritime life. After a brief career at sea, he decided to become an artist. His ability as a draughtsman led to his specialisation in a unique form of painting known as *penschildering*, or pen-painting, often called *grisaille*. He used quill pens to create sharp, carefully constructed lines on specially prepared panel and canvas, sometimes highlighted with wash. The ends of the lines were pointed to resemble their engraved equivalent. Although it took months rather than weeks for a picture, greater detail and overall clarity were possible. Not surprisingly they became popular with seafaring patrons, and were the maritime equivalent of the exquisitely detailed Dutch still-lifes. Adriaen van Salm (c.1660-1720), his son Roelof, and Adam Silo (1674-1766) also specialised in pen-painting. It is not known if van de Velde the Elder pioneered this technique, but he was certainly one of its finest exponents.

He was an expert draughtsman and a skilful recorder of maritime detail, as is clearly evident in the large body of his extant sketches and drawings, sometimes annotated with descriptive notes. He possessed new recording skills derived from his precarious experiences accompanying the Dutch naval fleet at sea, although he also painted a wide variety of merchant

OPPOSITE ABOVE: ***Dutch Ships in a Gale***, Jan Porcellis. *Porcellis' pictures were less concerned with detailed portraits of vessels and coastal craft than with creating atmospheric effects.*
OPPOSITE BELOW: ***The Beach at Scheveningen***, Simon de Vlieger. *The artist has carefully positioned the fishing pinks in this early work so that their masts break up the skyline, and lead the eye to the horizon.*
ABOVE: ***Dutch Ships in a Heavy Sea running before a Storm***, Pieter Mulier the Elder. *Although Mulier is associated with the movement towards realism, here he arranges the ships and sea in a stylised rhythmic pattern.*
BELOW: ***A Dutch Ferry Boat***, Simon de Vlieger. *The prominence given to the kaag, a common type of ferry boat, is unusual. On the left is a fishing pink, with a fluyt beyond. To the right is a smalschip or wijdschip.*

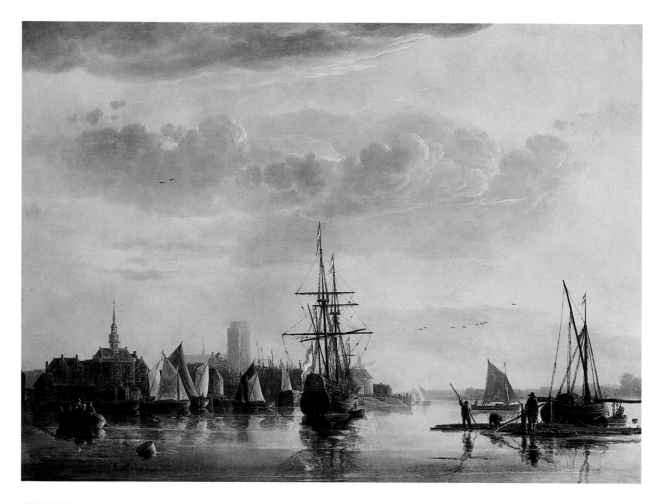

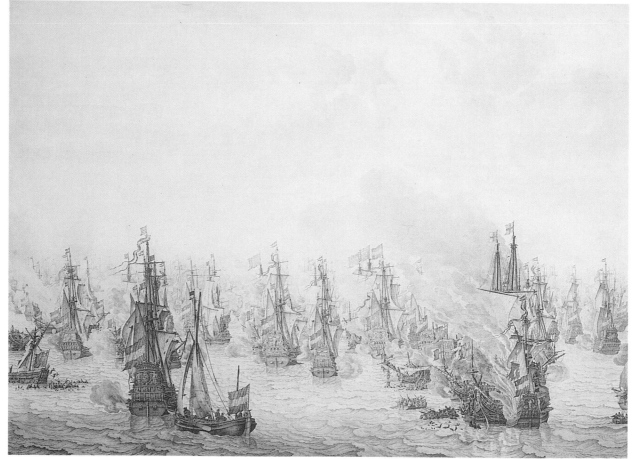

subjects such as harbour and coastal scenes with small craft, and fishermen on the beach. To assist him in his work, the Admiralty provided him with a galliot but were concerned that he kept at a safe distance from the action. He sketched key subjects and made detailed notes of the ships' positions and the sequence of events. He also made use of ship models to improve his draughtsmanship. Writing in 1706, the translator of Roger de Pile's *Art of Painting* mentions that van de Velde the Elder 'for his better information in this way of Painting had a Model of the Mast and Tackle of the Ship always before him'.

During the First Anglo-Dutch war, van de Velde the Elder operated as an official war artist. One of his drawings bears the revealing inscription: *View of the fleet, ready to sail, before the harbour, when I put to sea in the galliot with letters for Admiral Tromp on Friday afternoon at 2 o'clock, 8 August 1653.* Two days later he was also present at the Battle of Scheveningen and in the subsequent painting depicted himself perilously close to the action.

Van de Velde the Younger is poorly documented as are almost all painters of the period. His younger brother, Adriaen, probably worked in their father's studio and assisted with the pen-paintings. Both sons would have been instructed in the rudiments of drawing by their father, but both appear to have lacked the confidence to undertake *penschildering* under their own names. As a painter in oils van de Velde the Younger quickly surpassed his brother, and eventually his father. It is now believed that it was he who taught his father to paint in oils. Sir Joshua Reynolds later described him as 'the Raphael of ship painters'.

He was influenced by Simon de Vlieger but later developed his own style and his mature work shows a preference for broader brushwork and warmer colours. In paintings such as *The Dutch Coast with a Weyschuit being launched*, painted in about 1690, he demonstrates an exceptional talent for scenes of day-to-day maritime activities.

The Amsterdam-born artist Reinier Nooms (c.1623-1667), also painted in the Realist manner. He had an intimate knowledge of the sea from first-hand experience; his nickname was *Zeeman*, meaning sailor. He painted new subjects including ship-building, evident in panel pictures such as *Shipbuilding at Porto San Stefano, Italy*. *Zeeman* worked for a time at the Brandenburg Court in Berlin. Today he is better known as a printmaker.

Ludolf Bakhuizen (1631-1708) was German by birth but belongs to the Dutch school. He studied under Allaert van Everdingen (1621-1675), a practitioner of the realist style. His pen-painting indicates that he received some training from van de Velde the Elder. His knowledge of oils derived from a period in the studio of Hendrik Dubbels (1621-1707), a painter with whom he has since been confused. Bakhuizen's palette developed slowly and at first he produced a series of pictures in blue-greys and blue-blacks, but later brightened his palette to produce masterpieces like *The 'Royal Charles' carried into Dutch Waters, 1667*, following Lieutenant-Admiral de Ruyter's daring and successful raid on the Medway during the Second Anglo-Dutch War. Bakhuizen's pupils and followers include Pieter Coopse (1668-1677) and Hendrik Rietschoeff (c.1678-1746).

Abraham Storck (c.1644-1710) of Amsterdam, painted similar subjects in a similar style. He was a contemporary of the van de Veldes and may have worked in one of their studios. He had a good knowledge of nautical detail which he incorporated into visually exciting compositions, many of them imaginary, inspired by a contemporary fashion for Italianate subjects. Storck's speciality was busy local harbour scenes, with a profusion of craft, larger vessels, and

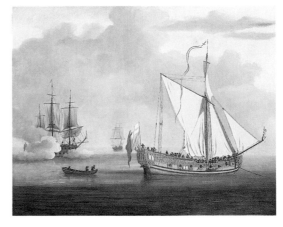

OPPOSITE ABOVE: ***View of Dordrecht***, Aelbert Cuyp. *A golden summer evening on the river de Oude Maas at Dordrecht, with the customs house and Grootekerk to the left. The two-masted schooner flying the Dutch colours contrasts with the humble fishermen on rafts to the right and the fishing boats at their moorings.*
OPPOSITE BELOW: ***The Battle of Scheveningen (Ter Heide), 10 August 1653***, Willem van de Velde the Elder. *This painstakingly detailed grisaille panel picture portrays the last battle of the first Anglo-Dutch War. The ship on fire is the 'Andrew', flagship of the rear-admiral of the white squadron, Robert Graves. The Dutch commander-in-chief, Marteen Tromp, died in the battle.*
ABOVE: ***The English Yacht 'Portsmouth'***, William van de Velde the Elder. *Built at Woolwich by Sir Phineas Pett in 1674, she was named after the Duchess of Portsmouth.*
BELOW: ***Studies of a Ship and a Boat pitching and sending***, Willem van de Velde the Younger. *The inscription reads: 'To be noted: a ship or small vessel in pitching nearly always throws up spray, as shown here'.*

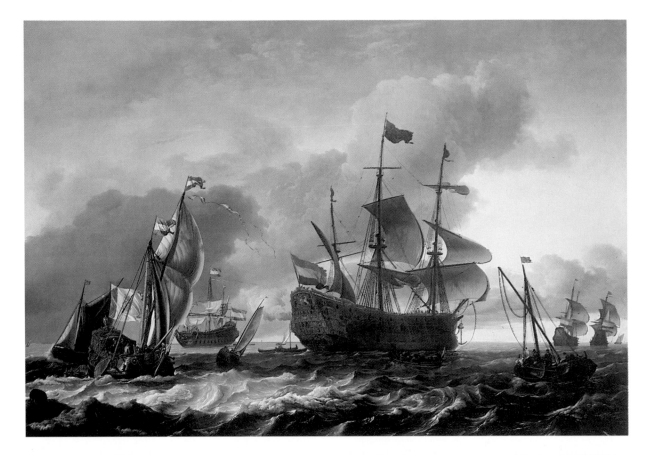

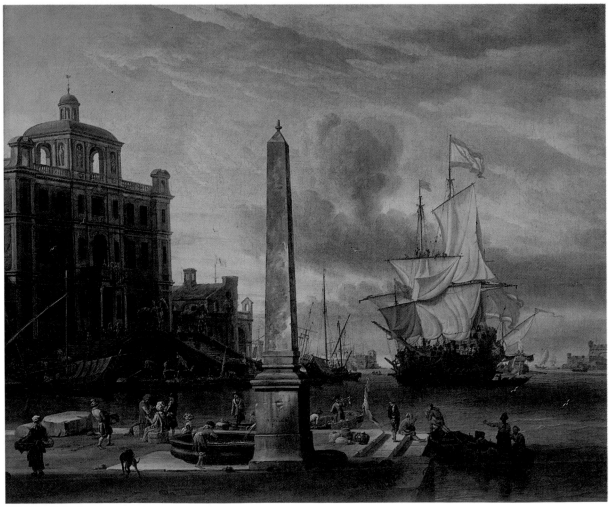

people going about their daily business on the quayside, usually near Amsterdam. The Dutch artist Gaspar Adriaansz van Wittel (c.1647-1736), changed his name to Vanvitelli because of his love of Italy, where he settled. He painted some marines such as *The Castello Nuovo and Naples Harbour*, now in the National Maritime Museum, with a ship under repair, which is a direct precursor of Claude-Joseph Vernet's series of eighteenth-century port scenes.

The French artist Claude Lorraine (1600-1682), was established in Rome by 1613. He developed a reputation as a painter of landscapes, and port and harbour scenes, such as *The Embarkation of St. Ursula*. These subjects are not accurate in terms of nautical detail and his ships are unsailable but the bold use of perspective, brilliant handling of light, and overall sense of drama made them original and influential. Claude influenced Dutch painters Nicholaes Berchem (1620-1683), Adam Pijnacker (1621-1673), and Jan Baptiste Weenix (1621-c.1660).

Storck's *A Venetian Pilgrim Ship in an imaginary Italian Harbour* reveals the influence of Claude. The fanciful architectural setting, the ruined columns breaking up the picture to create an exaggerated illusion of spatial recession akin to a theatrical backdrop, and the quayside strollers, all derive from Claude. Turner acknowledged Claude as a major influence on his work, and painted *Palestrina* as a pendant to a Claude owned by the English art collector Lord Egremont.

By the 1670s marine painting had emerged as a distinct genre. The Dutch, Flemish, French, Germans and Italians had all contributed. England's contribution was through the patronage of foreign marine artists. It was not until the eighteenth century that talented native marine painters began to emerge, as a direct result of the Dutch marine artists who settled in England.

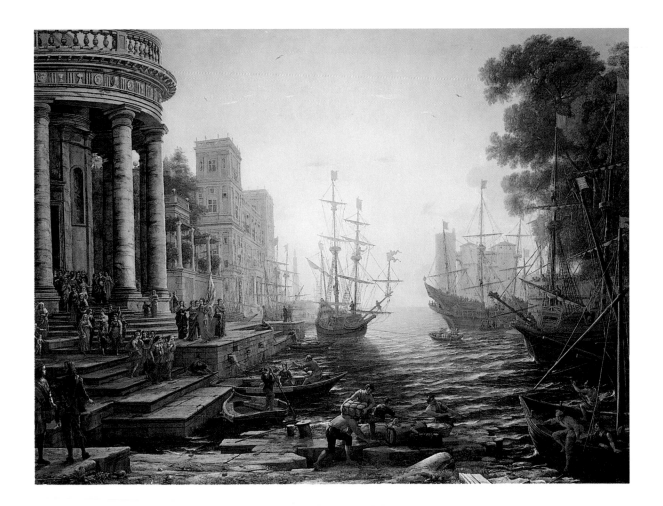

OPPOSITE ABOVE: *Dutch Attack on the Medway: the 'Royal Charles' carried into Dutch Waters, 1667*, Ludolf Bakhuizen. *The smaller craft and the vibrant light convey the impression that her voyage to the Netherlands is almost complete.*
OPPOSITE BELOW: *A Venetian Pilgrim Ship in an imaginary Italian Harbour*, Abraham Storck. *A fine example of the imaginary port scenes in which Storck excelled. The two-decker warship lies at anchor flying the flag of Jerusalem.*
LEFT: *The Embarkation of St.Ursula*, Claude Lorraine. *Claude's harbour scenes enjoyed immense popularity during the 18th and 19th centuries and influenced contemporary marine artists.*
ABOVE: *Calm: the Dutch Coast with a Weyschuit being launched*, Willem van de Velde the Younger. *The main focus of the foreground activity is a weyschuit, a small type of Dutch fishing vessel, that is being hauled down to the water's edge with the aid of rollers.*
BELOW: *Shipbuilding at Porto San Stefano, Italy*, Reinier Nooms, *called Zeeman (Sailor). A rare subject for the 17th century. Woodworking tools are clearly visible in the foreground. The largest vessel has a plant placed at her stem in continuance of an ancient and superstitious shipbuilding tradition.*

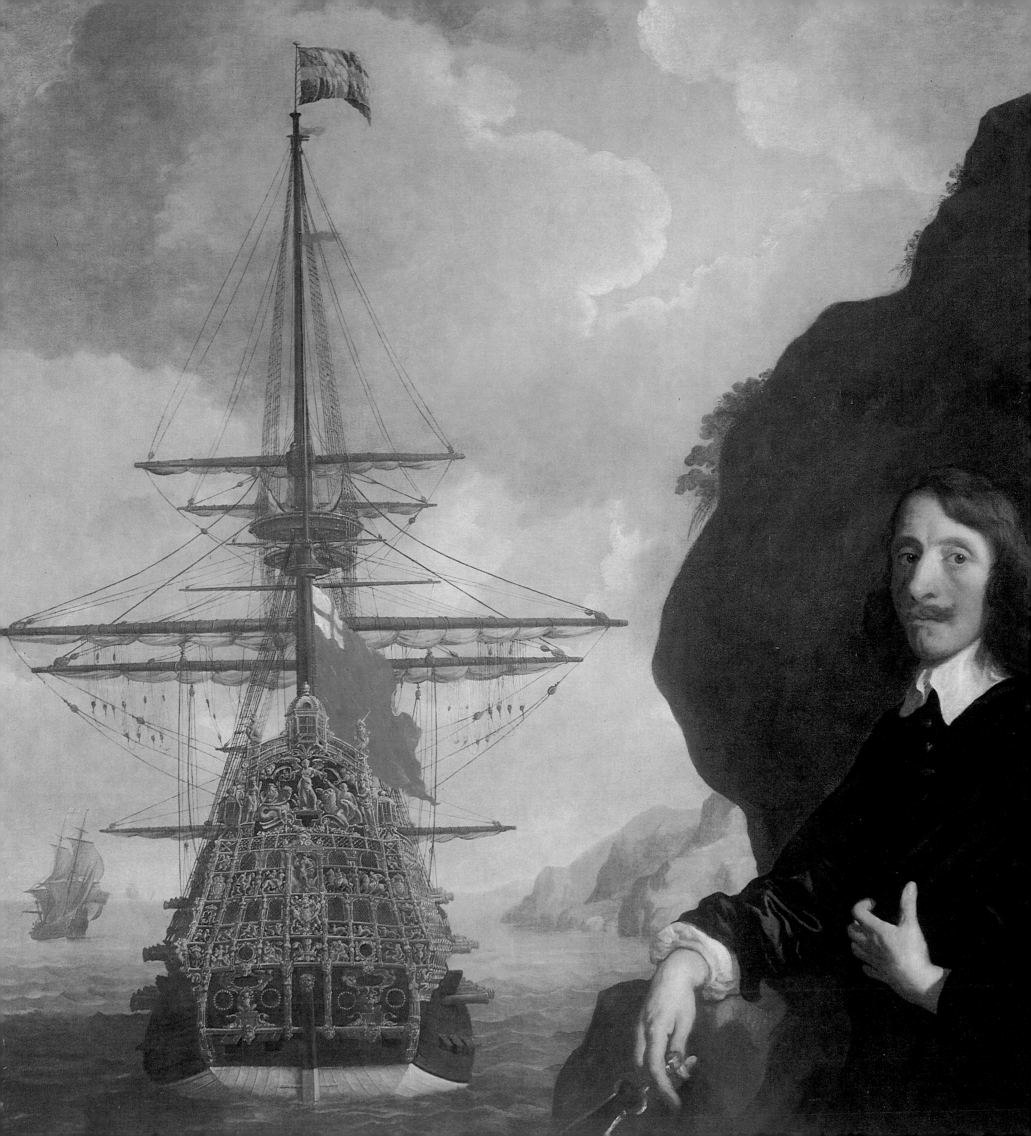

MARINE PAINTING IN SEVENTEENTH-CENTURY ENGLAND

For most of the seventeenth century, England was an artistic backwater, with the exception of portraiture. Many of the leading portraitists including Sir Peter Paul Rubens, Daniel Mytens, Sir Anthony van Dyck, Sir Peter Lely and Sir Godfrey Kneller worked in England but none was an Englishman. Lely painted a celebrated series of sea officers, known as the *Flagmen of Lowestoft*. In his maritime masterpiece *Peter Pett and the 'Sovereign of the Seas'* he painted the portrait of the shipwright and the landscape setting, but the ship itself, previously believed to have been painted by Sailmaker, may have been painted by Lely himself. Although the painter remains enigmatic, it is a good example of the versatility of marine artists, who often collaborated with portrait and landscape painters.

At this time marine pictures were produced mainly by non-specialists, who had little knowledge of ships and seafaring, and limited artistic talent. They also painted landscapes, or 'prospects', a view combining landscape, architecture, often a stream or river, and occasionally the sea, naively painted and invariably viewed from a high viewpoint, or bird's-eye perspective. The most accomplished were by Dutch and Flemish émigré artists. Claude de Jonge (d.1663) and Jan Griffier the Elder (c.1651-1718) are two of the finest exponents and their views in and around London often include maritime elements, evident in *Old London Bridge* and *View from One Tree Hill at Greenwich*. Griffier occasionally painted marine subjects. His portrayal of *Royal Yachts off Greenwich*, painted in a naive style, is now in the National Maritime Museum, Greenwich.

A contemporary inventory reveals that Charles II's art collection included 'a series of prospects by Danckerts of Portsmouth'. Prospect pictures derived from the topographical tradition where the primary concern was an accurate record, allying them to cartography. Johan Danckerts (c.1615-c.1687) was commissioned by the King to paint a series of views of royal palaces and seaports. His brother Hendrik (1625-1679) painted similar subjects.

The earliest recorded marine painter working in England was the Dutch émigré artist Isaac Sailmaker (c.1633-1721). According to George Vertue, a contemporary engraver and writer, Sailmaker left Scheveningen when young and painted a picture of the fleet of Mardyke for Oliver Cromwell in 1657. Vertue also informs us that 'This little man imploy'd himself always in painting views small & great of many sea Ports & Shipps about England, he was a constant labourer in that way tho' not very excellent. His contemporaries the Vande Veldes were too mighty for him to cope with but he out livd them & painted to his last'.

The dearth of signed work by Sailmaker has resulted in the misattribution of some of his work to Jacob Knyff (1638-1681), a contemporary Dutch painter who also worked in England.

OPPOSITE: ***Peter Pett and the 'Sovereign of the Seas'***, detail, Sir Peter Lely. *This painting is Lely's masterpiece of marine portraiture. The ship, built by Peter Pett in 1637, was the most powerful ship of her day. Her name was changed to 'Royal Sovereign'; she was rebuilt several times before being accidentally destroyed by fire in 1696. Peter Pett is identified by one of the tools of his trade, a pair of dividers. He was the Commissioner at Chatham dockyard.*
ABOVE: ***Wreck of the 'Gloucester' off Yarmouth, 6 May 1682***, Johan Danckerts. *While carrying the Duke of York to Leith, the 'Gloucester' was wrecked by the negligence of the pilot. Most passengers were saved.*

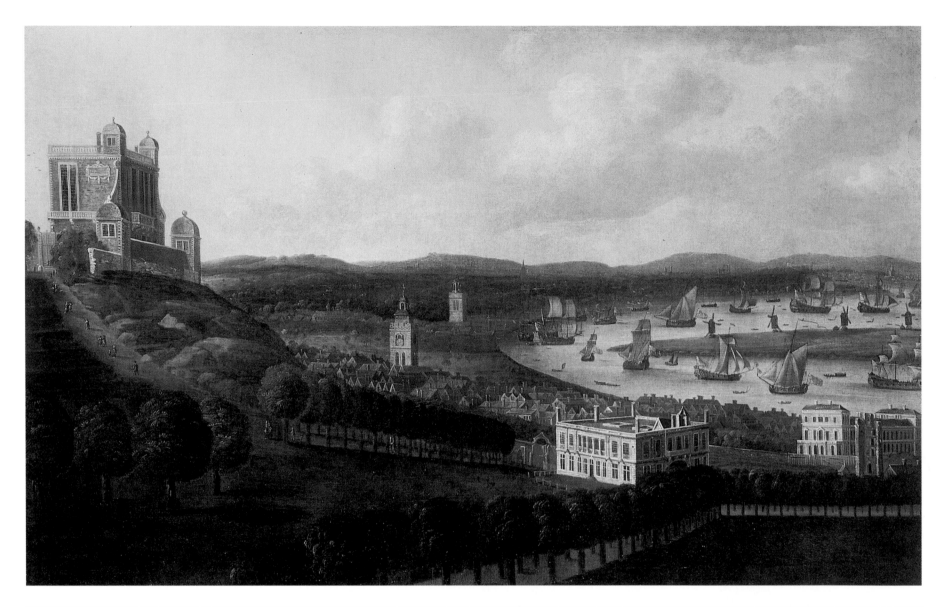

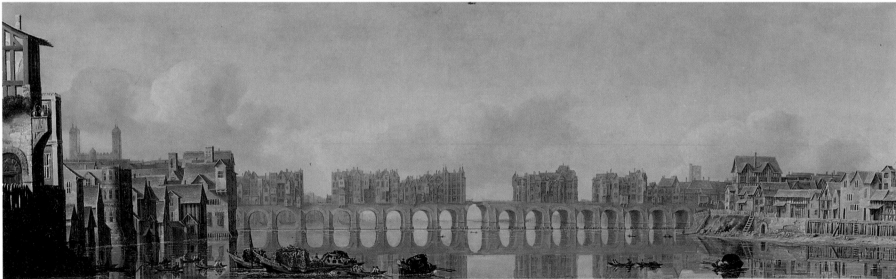

It is now believed that in 1708 Sailmaker painted several views of the second Eddystone Lighthouse. One was for John Verney, Viscount Fermanaugh, another for the Lovett family residence in Dublin, Co. Meath, a third for Queen Anne's husband Prince George, the Lord High Admiral, and a fourth for Trinity House, London, the authority responsible for navigational aids such as lighthouses. The painting still in the hands of the Lovett family closely relates to an extant signed engraving and reveals Sailmaker as the likely creator of the oils.

This painting is characterised by certain common attributes: a naive quality resulting from the artist's lack of understanding of perspective; a preference for placing ships on water in awkward and unrealistic positions; and an inability to integrate ships with sea, sky and land, into harmoniously balanced compositions. The artist also favoured a particular technique of applying several layers of gold paint in short strokes, or daubs, to create the stern decoration of ships.

Lorenzo A. Castro (fl. 1670s), a Flemish artist of Spanish descent, was also associated with patrons in England, although it is not known if he ever visited the country. He favoured Mediterranean scenes in a style close to the Willaerts family, but his portrait of the 'Sovereign of the Seas' at Great Parham, copied from John Payne's engraving and painted in about 1637, was almost certainly an English commission.

Two other painters in the same style are the obscure artists H. and R. Vale. The former is probably the earliest recorded English marine painter, although nothing is known of his life. There is one signed oil painting by him in the National Maritime Museum, the *Relief of Barcelona, 27 April 1706*, with the title in an elaborate cartouche placed in the sky. Another painting incorporating a similar cartouche inscribed '*Royal Katherine*', once believed to be by H. Vale, is probably the work of Sailmaker. The colourful pennants flying from the mastheads suggest that the artist practised as a sign and heraldic painter. R. Vale painted *A Man o'war flying the Royal Standard* in a similar style to H. Vale but it is not known if the artists were related.

At the time of Sailmaker's residence in England, there was only one active artistic association, the Painter-Stainers' Company, established in 1268. From 1532 the Company had its own Hall in the City of London, in Little Trinity Lane, and in 1581 it received a royal charter. Each member paid a membership fee called 'quarterage'. As an émigré artist Sailmaker was barred from acquiring full membership but an inventory of the Company's Property, dated 18 October 1766, mentions 'A sea-storm painted and given by (Isaac) Sailmaker'. This is surprising as the aim of the Company was to advance the interests of British artists and craftsmen against the influx of foreigners but it is probable that the artist benefited from his gift through some kind of honorary association.

Sailmaker also painted, in about 1680, a pair of ship portraits on wooden panels depicting the *Sovereign of the Seas* and the *Prince Royal*. The latter was designed by the Pett family and was built in 1637 on the Thames at Woolwich. Both now hang in Trinity House, London and form part of a larger collection of marine paintings.

The van de Veldes moved to England in 1672 or 1673 settling initially in Greenwich. It seems a curious defection as Holland and England had fought bitterly over the right to trade in the East Indies leading to the protracted Anglo-Dutch wars. But when Louis XIV of France invaded Holland in 1672 the ensuing unrest and civil disturbances made artistic patrons increasingly rare. Van de Velde the Elder's personal life also took a turn for the worse. He had been consistently unfaithful to his wife, Judith, and had two illegitimate children. There was no

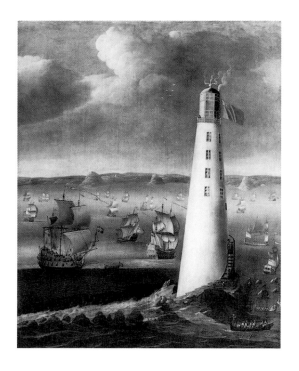

OPPOSITE ABOVE: ***View from One Tree Hill at Greenwich***, Jan Griffier the Elder. *The Royal Observatory, on the hill on the far left, was completed in 1675 to the designs of Sir Christopher Wren. The square shaped building below is the Queen's House, designed by Inigo Jones, and the earliest classical design in England. All these buildings now form part of the National Maritime Museum.*

OPPOSITE BELOW: ***Old London Bridge***, Claude de Jonge. *De Jonge visited England on sketching tours between 1615 and 1628. He has made the houses on the bridge more elegant for picturesque effect. This is one of the most important and early views of this famous London landmark, completed in 1209 and demolished in 1831.*

ABOVE: ***Eddystone Lighthouse***, Isaac Sailmaker. *The first Eddystone lighthouse was destroyed in the Great Storm of 1703. The new lighthouse was completed in 1708, and was secured to the rock by iron bolts. The lantern was supplied with twenty-four candles, and the whole structure destroyed by fire in 1755. In spite of the apparent attention to detail the shipping in the background is sailing against contrary winds.*

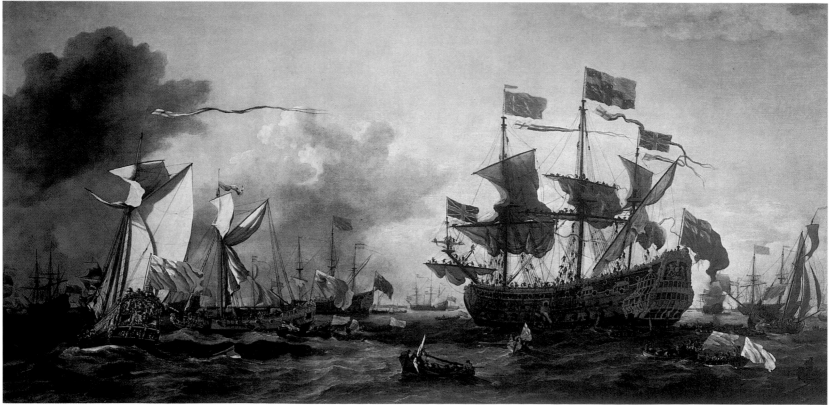

hope of patching up his marital difficulties and so, spurred on by King Charles II's invitation to Dutch artists to settle in England and hopeful of finding new patrons, he emigrated.

Charles II, who introduced yachting into England, commissioned the van de Veldes to paint his yachts. On his restoration to the throne in 1660, the States General of Holland presented him with a miniature warship, the *Mary*, for recreation. He had shown considerable interest in yachting while in exile and, after his defeat at the Battle of Worcester in 1651, escaped to France in a coasting collier called the *Surprise* which he later bought and converted to a smack-rigged yacht, renamed *Royal Escape*, painted by van de Velde the Younger.

The van de Veldes' skills were appreciated in England by a wide circle of patrons, including the King, his brother, James, Duke of York, and his intimates the Duke and Duchess of Lauderdale who employed van de Velde the Younger, together with many other artists and craftsmen, for the enlargement and elaborate redecoration of Ham House in Richmond, Surrey. Van de Velde the Younger was commissioned to paint four sea pieces for the Duke's Bedchamber (which later became the Duchess's Bedchamber). Ham House is remarkably well preserved with much of the architectural fabric of the 1670s intact. The pictures, painted in 1673, are still in their original locations. The Younger also painted, although probably later, *An Action between an English Ship and Barbary Pirates*, now hanging below the fireplace in the Duke's Closet. Two Mediterranean marine subjects by the prospect painter Thomas Wyck (c.1616-1677) originally hung nearby.

The Younger also excelled at storm scenes, royal reviews and State occasions, as well as naval battles. *The Battle of the Texel, 11 August 1673*, one of the finest marine paintings in oils of a naval encounter, was probably commissioned by Admiral Cornelis Tromp for Trompenburg, the house he had had built not long before the painting was completed in 1687.

Both van de Veldes had a broad base of patronage. The wide circle of collectors of the Elder's work included the Dutch Admiralty and private collectors in Holland, the King of Denmark, Ferdinand II of Tuscany, Cardinal Leopoldo de Medici, as well as 'severall eminent persons in Genova and Venice'.

Not all the van de Veldes' pictures were well received. They themselves, their studio and others had a tendency to repeat their compositions with such regularity that their work often appears formulaic and sometimes dull. In addition, some naval patrons were so exacting in their requirements that the resulting pictures have become lifeless documentary records rather than artistic compositions.

George Vertue recounts an intriguing story of the Younger's *Royal Visit to the Fleet in the Thames Estuary, 10 September 1673*, commissioned by Charles II and previously believed to portray a royal event of 6 June 1672. The commissioners from the Admiralty went to see the artist and suggested cutting the picture in half. 'As soon as they were gone Velde took the picture off the Frame & rold it up, resolving that they never should have it.' They may have found the composition cluttered and unbalanced, and thought that by dividing it almost in half, two striking compositions would emerge. They were probably right.

King Charles II was eager to retain the services of the van de Veldes and drew up a contract in 1674, specifying their respective roles. The Treasurer of the Navy was instructed to pay 'the salary of One hundred pounds per annum unto William Vandeveld the elder for taking and making of Draughts of Sea Fights, and the like Salary of One Hundred pounds per

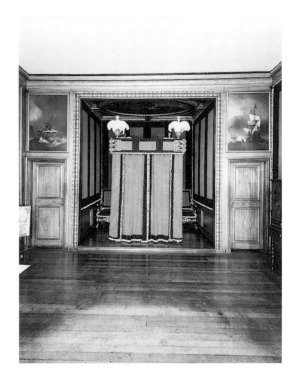

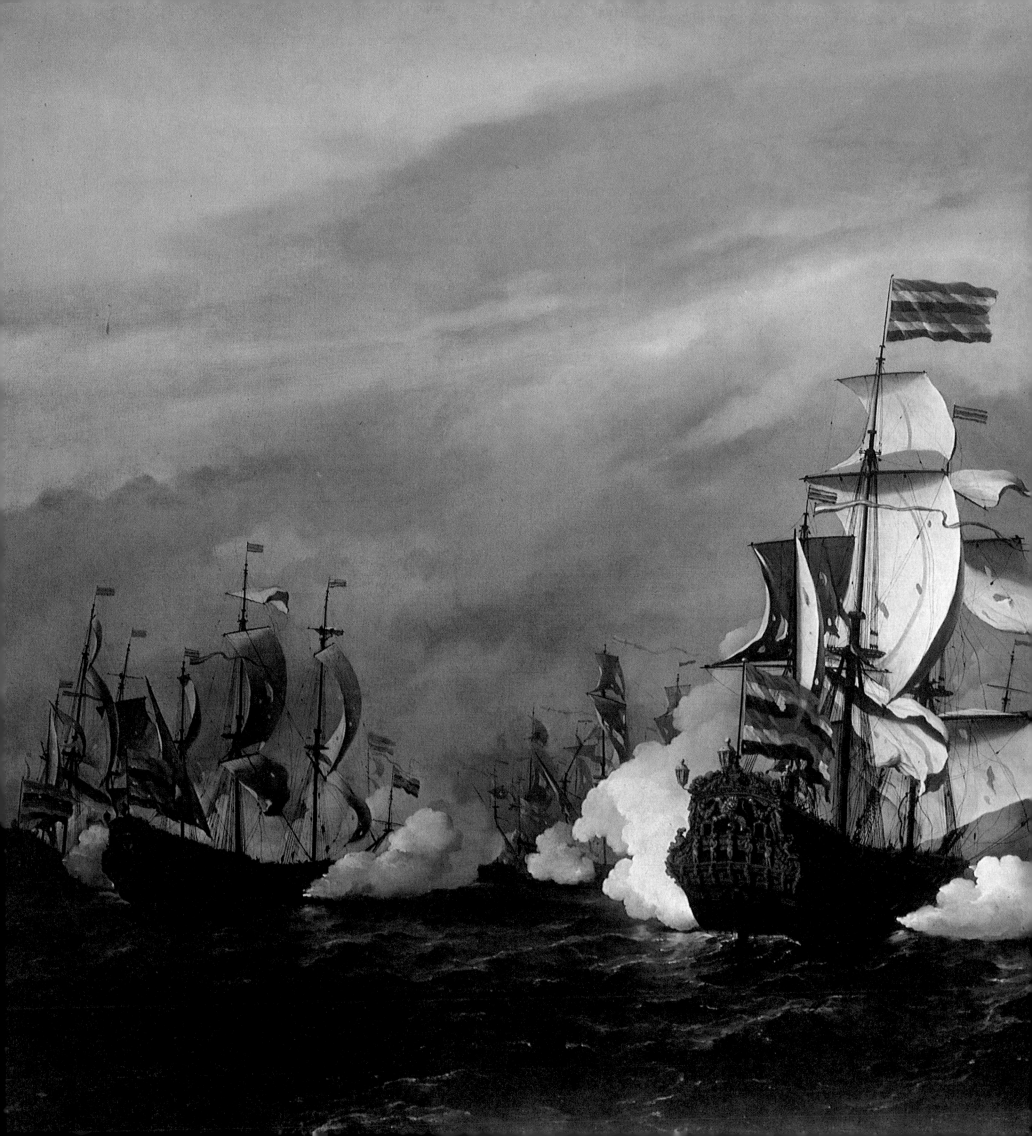

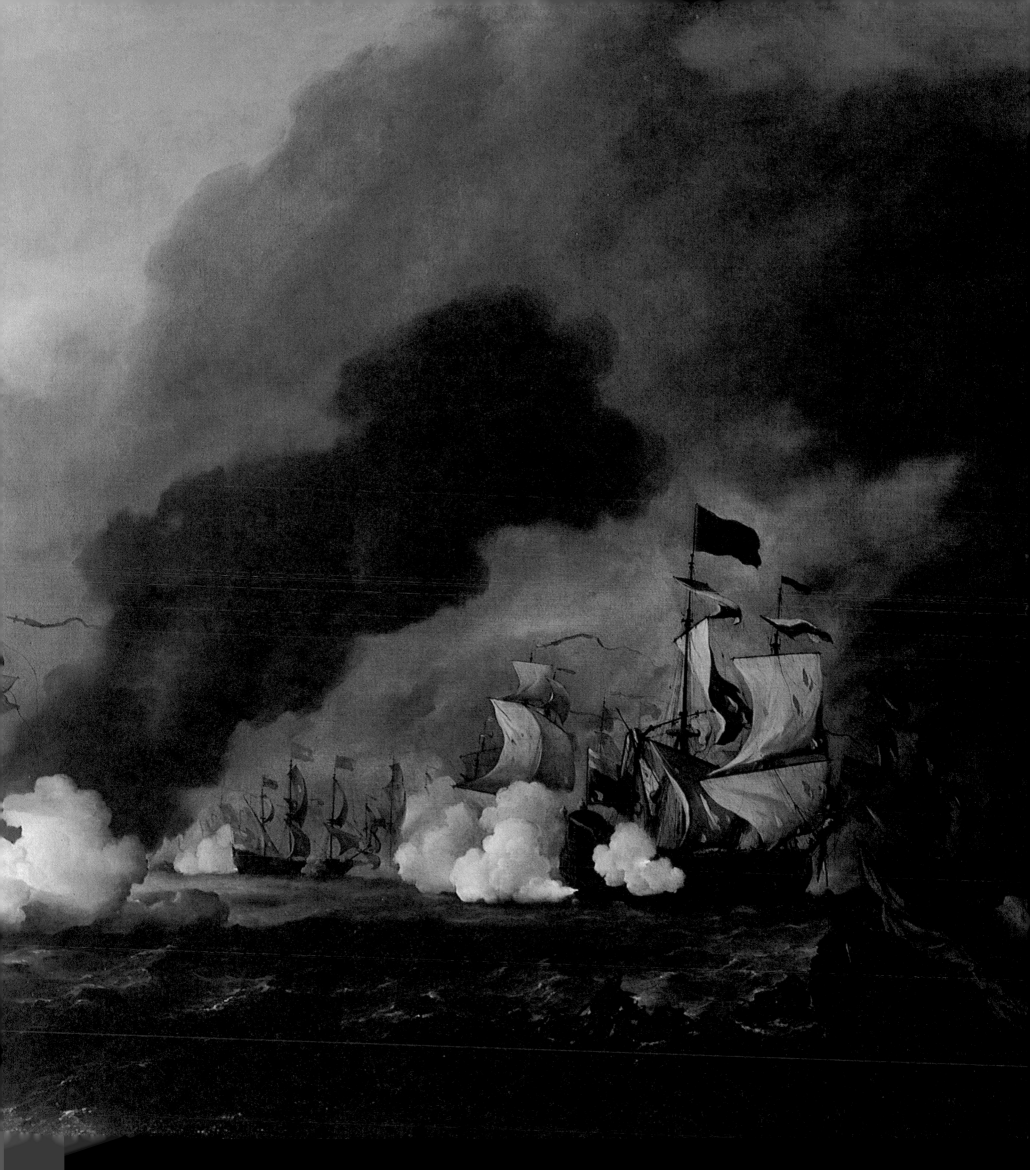

ABOVE: *The Yacht 'Royal Escape' close-hauled in a Breeze*, Willem van de Velde the Younger. *Shown here in the foreground the yacht has a red ensign, jack and the common pendant of a man-o'war at the masthead. In the left background is a two-decker almost stern view lying at anchor.*

annum unto William Vandeveld the younger for putting the said Draughts into Colours for Our particular use'. The King provided studio space for the van de Veldes in the Queen's House at Greenwich, now part of the National Maritime Museum. One of their earliest royal commissions was to provide high-horizon drawings, and later paintings, of the third Anglo-Dutch War to be used by the tapestry makers at Mortlake.

By 1675 the Queen's House was an active painting studio where mostly Dutch studio assistants learned new skills and many became professional painters. Jacob Knyff, Adriaen van Diest (1655-1704) and Johann van der Hagen (1676-c.1745) are associated with the studio through copies of the van de Veldes' work and stylistic similarities.

Adriaen van Diest was born in the Hague, and his father Willem, and brother Jeronimus, were also marine painters. His *Battle of La Hogue, 23 May 1692*, clearly demonstrates a debt to the van de Veldes although his technique is inferior. Van der Hagen's daughter, Bernada, married Cornelis van de Velde (fl.1675-1729), the son of the Younger. Cornelis was born in England and was certainly trained at Greenwich. It is thought that Sailmaker worked in the studio, and it is likely that the obscure Dutch artist L.D. Man (fl. 1725), whose spiritless compositions closely relate to those of van de Velde the Younger, also spent time there.

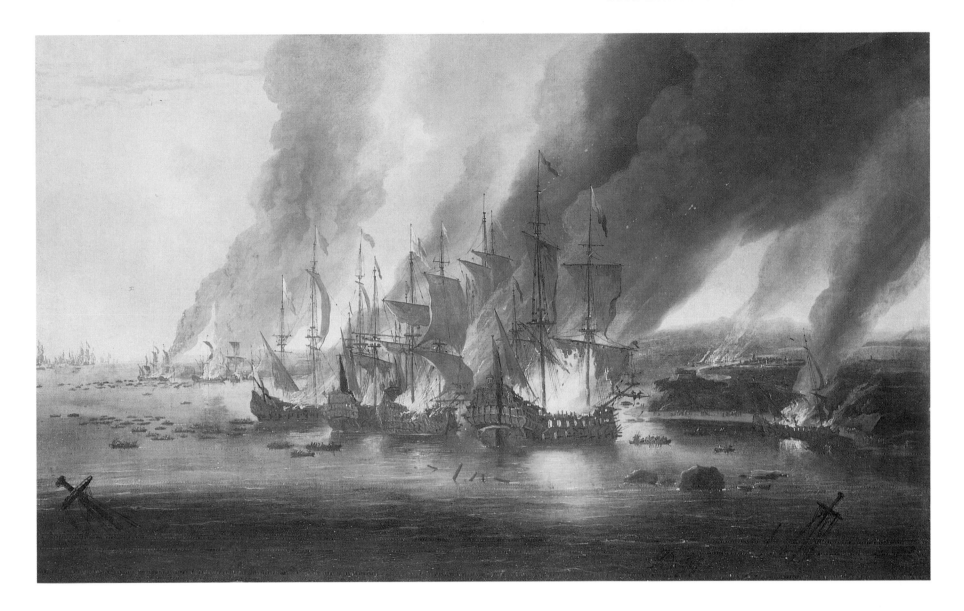

Outside London, James Stanley, 10th Earl of Derby possessed a notable collection of marines by the van de Veldes. On 23 November 1726, he proudly wrote to the engraver Elisha Kirkall, who produced a series of twelve mezzotints 'printed in sea-green' after paintings by the Younger: '...Vandervelts of which hand I verely beleeve I have as good Pictures as any in England'. Sir George Scharf compiled an authoritative catalogue of the Derby Collection in 1875, based on original inventories and bills of purchase. Dutch marines were also acquired by Scottish collectors including the Duke of Hamilton.

English marine painters studied and copied the van de Veldes' work, although it is not known if any English artists worked in the Dutch artists' studio. There is no contemporary literary evidence to throw light on this period.

The first published remarks on marine painting appeared in the *Universal Magazine of Knowledge and Pleasure*, a monthly first published in London in 1748. In his article *Art of Painting*, Pictor listed those 'who are justly esteemed eminent masters'. He named Van Diest (Adriaen van Diest), Grilfier (Jan Griffier the Elder), Monamie (Peter Monamy), and Scot (Samuel Scott). Monamy and Scott, the first professional English marine painters, were two of the most gifted European marine painters of the first half of the eighteenth century.

ABOVE: *The Battle of La Hogue, 23 May 1692*, Adriaen van Diest. *In the centre is a group of six French ships burning. A seventh is burning on shore. They have been attacked by the boats of the Anglo-Dutch fleet which are also attacking another group of ships further round the Bay of La Hogue.*

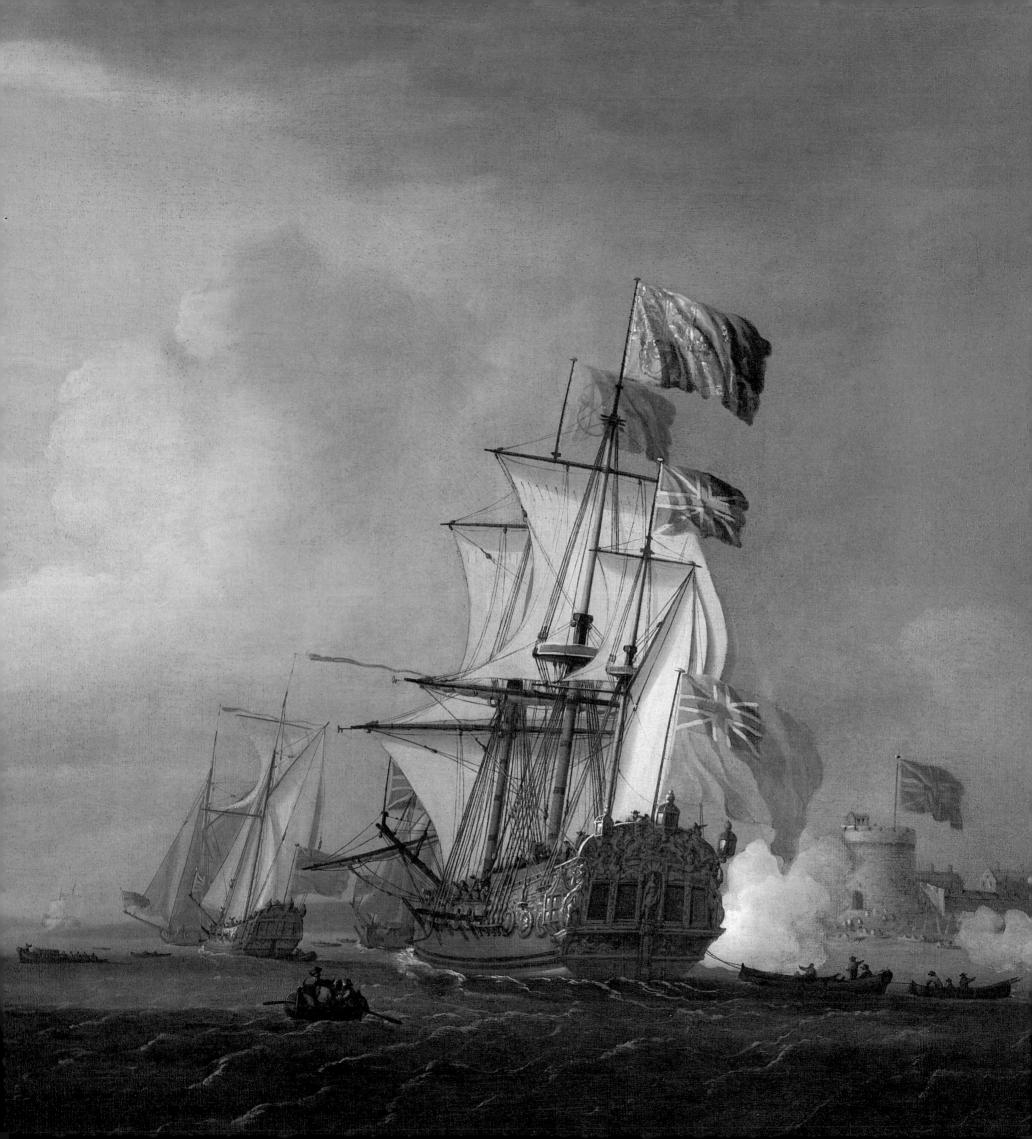

THE BIRTH OF BRITISH
MARINE PAINTING

Marine painting in Vandervelt's taste is a branch of the art in which one need not be afraid to affirm that the English excel. And yet we must not imagine that there are a great number of able artists in this, any more than in other branches. But when one or two hands become as eminent as those who are now distinguished for marine pictures in England, are not they capable of giving a character of superiority to their country?'

These words were written by the Swiss-born miniaturist André (M.) Rouquet, who arrived in London about 1722. He was certainly pro-English. He befriended William Hogarth, and lived near him in London. One of his main reasons for writing *The Present State of the Arts in England* (1755), was to demonstrate to other countries, especially France, that England's artists deserved greater acclaim. He wrote chapters on the visual arts including marine painting, as well as architecture, auction houses, music and surgery.

Rouquet did not name Peter Monamy as one of the 'hands', but he was the first English painter of any note to tackle marine subjects. He was successful in his lifetime and received commissions from both naval and merchant patrons. He painted English subjects in climatic conditions and colours appropriate to northern shores. His finest marines exhibit a flair for striking and dynamic compositions derived from the van de Veldes and Pieter Mulier the Elder.

According to Horace Walpole's *Anecdotes of Painting*, an immensely influential series of volumes on painters and engravers published between 1762 and 1771, largely based on the notebooks and manuscripts of George Vertue, Monamy was born in Jersey but although his family originated there, he was in fact born in London. Between 1696 and 1704, he was apprenticed to William Clarke, of the Painter-Stainers' Company who, according to Walpole, was a sign and house painter living on London Bridge. John Thomas Smith, author of *Nollekens and his Times* (1828), recounts a story of Monamy the 'famous Marine-Painter', who 'decorated a carriage for the gallant and unfortunate Admiral Byng, with ships and naval trophies'. Byng was executed in 1757 under No. 13 of the 'Articles of War' for 'Failing to Pursue', prompting Voltaire's lines in *Candide*: 'In this country we find it pays to kill an admiral from time to time to encourage the others'. Monamy also 'painted a portrait of Admiral Vernon's ship for a famous public-house, well-known by the sign of the 'Porto Bello', remaining until recently within a few doors north of the church in St. Martin's Lane'.

Monamy's compositions were often derived from the van de Veldes. In 1726 he presented a 'valuable Sea Piece of his own painting' to the Painter-Stainers' Company. His motives were probably not entirely selfless, as it is recorded that the Company thanked him by relieving him of his obligation to pay his 'livery fine and all those relating thereto'. His *Sea Piece* may

OPPOSITE: ***The Royal Yacht 'Peregrine' and a smack rigged Yacht on the Medway off the Coast at Gillingham, Kent, with Upnor Castle in the background***, detail, Peter Monamy. *The 'Peregrine' was converted to a royal yacht under William III and in the 18th century was the principal royal yacht and the only one that was ship-rigged. After 1716 it was renamed the 'Caroline' and in 1730 became the 'Royal Caroline'.*

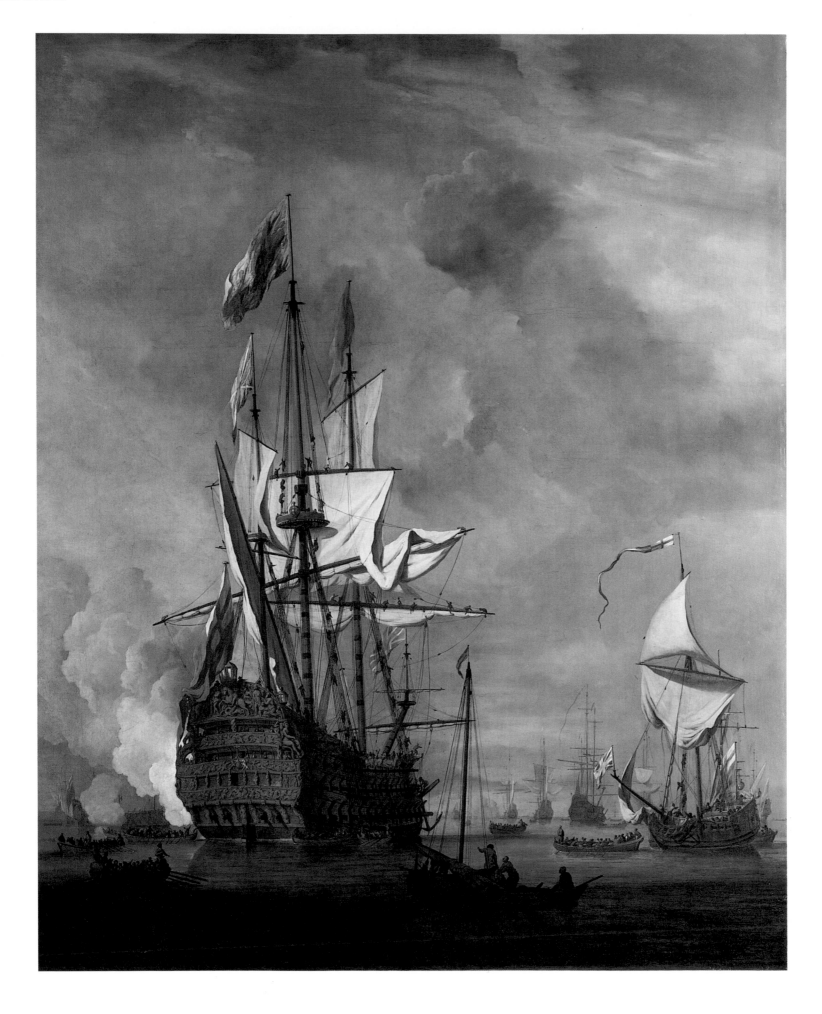

have been painted with considerable assistance from his studio, and it was certainly not an original composition. It was based on Willem van de Velde the Younger's *Royal Sovereign with a Royal Yacht in a Light Air*, painted in 1703 and now in the National Maritime Museum, Greenwich. Elisha Kirkall engraved the subject with some modification in mezzotint. It was widely available and Monamy was not alone in copying it. Robert Woodcock (1692-1728), a clerk in the Admiralty, also painted a picture based on it, in which he substituted the *Britannia* for the *Royal Sovereign*. Woodcock specialised in copying the van de Veldes and according to Walpole 'in two years copied above forty pictures'.

Monamy's *Sea Piece*, one of the largest he produced, was painted to fit the interior decorative scheme of the Company's house in Little Trinity Lane, and although no longer in its original position, can still be seen in the Company's Great Hall.

The Company's inventory of 1766 lists two pictures, a *Sea Storm*, and a *Large Piece of Shipping*, presumably the *Sea Piece*. The former was destroyed during World War II. Another marine by Monamy, presented to the Company by William Naylor, a past Master, in 1887 also remains in the Company's possession.

Monamy excelled at a wide variety of marine subjects. To mark his achievements at the age of fifty, he had his portrait painted in oils by Thomas Stubley, and this was later engraved in various versions. In 1731 John Faber junior, a leading London engraver, produced a mezzotint, bearing the inscription in Latin 'Petrus Monamy/Navium et Prospectum Marinorum Pictor:/Vandeveldo Soli Secundus'. ('Peter Monamy/Painter of ships and marine prospects/Second only to van de Velde') thus cashing in on the reputation of the Dutch artists.

Shortly after Monamy's portrait was painted and engraved, he collaborated with William Hogarth on a remarkable painting *Monamy the Painter exhibiting a Sea-Piece to Mr. Thomas Walker, His Patron*, a rare example of an interior scene featuring a marine artist and his work. On the easel is one of Monamy's typical sea pieces - he has even signed it - in a large gilt frame. It was acquired by the print collector Richard Bull. He later presented it to Horace Walpole who hung it on the staircase at Strawberry Hill. It is now part of the present Lord Derby's collection. The patron, who probably commissioned the picture, was a Commissioner of Customs and noted art collector. He owned twelve marines by the van de Veldes, probably including *The 'Royal Sovereign' with a Royal Yacht in a Light Air*.

Monamy was commissioned to paint a series of large-scale marines for Vauxhall Pleasure Gardens, a leading London attraction in the eighteenth century. Under the manager and owner Jonathan Tyers, who bought the lease in 1728, Vauxhall offered paying visitors a range of attractions including elegant formal gardens, visually exciting architecture, music, decorative arts, and a choice of 'supper boxes' in which to dine, decorated with paintings by leading contemporary painters such as William Hogarth, Francis Hayman and Peter Monamy. Rouquet's description of the decorations of the gardens is worth quoting in full: ' Every year he [Tyers] exhibits some new decoration, some new and extraordinary scene. Every year sculpture, painting and music are employed to heighten the charms of this place by the variety of their productions. Thus the opportunities of diverting the time are numberless in England, and especially in London; but music forms their principal entertainment'.

Peter Monamy painted four marines to decorate Vauxhall's supper boxes. None of the original oils has been located and their precise size is unknown but as backdrops to the boxes they

OPPOSITE: *The 'Royal Sovereign' with a Royal Yacht in a Light Air*, Willem van de Velde the Younger. *The 'Royal Sovereign' of 100 guns was a first-rate ship built in 1701. She is identified by the horse and rider on the tafferel. To right is a royal yacht.*
ABOVE: *Monamy the Painter exhibiting a Sea-Piece to Mr. Thomas Walker, His Patron*, William Hogarth and Peter Monamy. *Mr Walker stands at the extreme left in a blue coat and white wig. Behind two pictures by Monamy hang on the panelled wall.*
BELOW: *The Capture of the Spanish Galleon 'St. Joseph', 23 September 1739*, Peter Monamy. *This is a small scale version of the picture that was displayed at Vauxhall Gardens.*

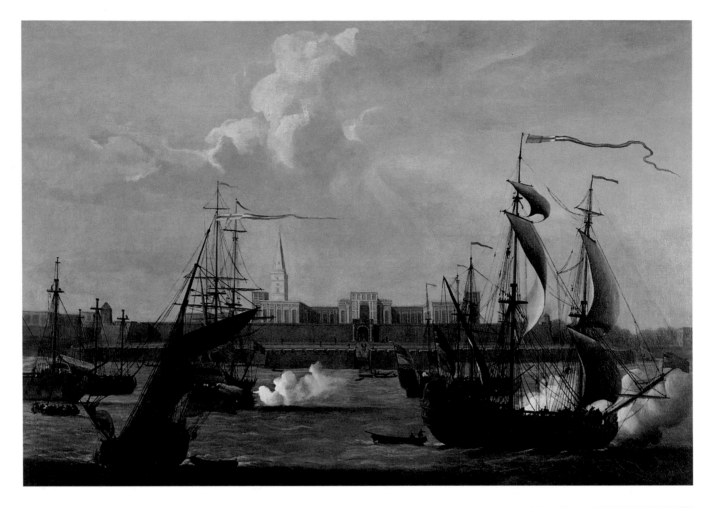

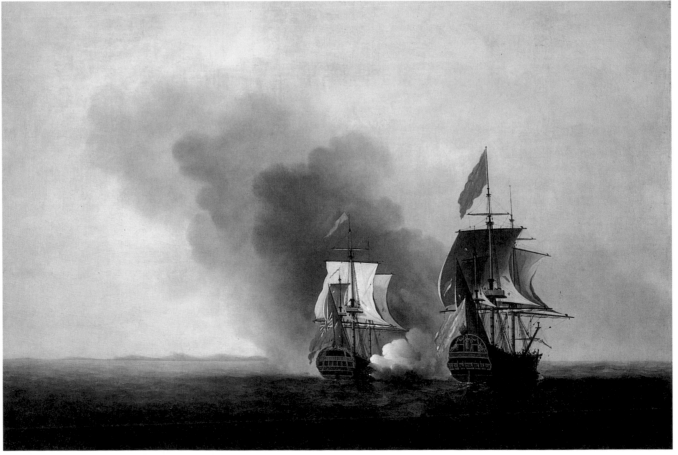

would have been about 55 inches high by 96 inches long. The pictures have been identified through contemporary engravings by Fourdrinier, and later Thomas Bowles. There is a small scale version of one of them, *The Taking of the 'St. Joseph' a Spanish Carracca Ship*, in the National Maritime Museum, Greenwich. They all portrayed naval scenes.

Tyers was eager to encourage painters to produce new work because Vauxhall Gardens had to compete with rival attractions. Francis Hayman was not a marine painter, but his contributions to Vauxhall included *The Triumph of Britannia* which treats Admiral Edward Hawkes's decisive victory over the French, at Quiberon Bay on 20 November 1759, as a grand allegorical subject. Britannia, seated in a chariot driven by Neptune, holds a portrait of King George III. Below are portraits of the victorious admirals, and in the background, two ships of the line are shown in action at close quarters. This painting is known today through S.F. Ravenet's engraving; the letterpress reveals that the original was an impressive twelve by fifteen feet.

Hayman's allegorical pictures may have been inspired by the paintings of the Neapolitan decorative artist Antonio Verrio (1639-1707). From 1699 Verrio was employed by Queen Anne at the royal palaces of Hampton Court and Windsor. He decorated the Queen's Drawing Room at Hampton Court, and painted two impressive wall paintings commemorating Britain's naval victories under Anne's husband, Prince George of Denmark, who was Lord High Admiral from 1702 to his death in 1709, and who was the focal point of each picture.

Samuel Scott (c.1702-1772) is probably better known today for his engaging topographical and Thames views of London, such as *The 'Custom House Quay'*, of which he painted several versions. He also enjoyed considerable patronage, support and friendship from the influential Walpole family. As Richard Kingzett explains in his catalogue, Sir Robert Walpole, George II's First Minister, was one of Scott's earliest patrons. Edward Walpole was accustomed 'when in London to sup every Tuesday evening at Scott's house', and he acquired four of the artist's London views and a sea piece. Horace Walpole encouraged his friends to buy Scott's paintings, of which he himself owned eight, as well as various drawings. He described Scott in the most glowing terms: '...one whose works will charm in every age. If he was but second to Vandevelde in sea pieces, he excelled him in variety, and often introduced buildings in his pictures with consummate skill'.

Details of Scott's early life are scant. According to tradition he was born in London about 1702, the date provided by his pupil William Marlow. He was certainly a popular painter and in 1771, the year before his death, an amateur art critic, Robert Baker, provided an independent assessment of Scott's work in a pamphlet *Observations on the Pictures now in Exhibition at the Royal Academy, Spring Gardens and Mr. Christie's* (the auctioneers). He described Scott's exhibit, one of his Thames architectural views as 'an admirable picture. The building and the water more especially, are incomparably well done. If the sky were equal to them, the picture would be almost beyond price'.

From 1727 until 1755, Scott held the position of Deputy Clerk in the Stamp Duty Office at Lincoln's Inn Field in London, an appointment he had obtained by purchase, which yielded one hundred pounds per annum and demanded little of his time. According to the artist and diarist Joseph Farington, Scott was 'not intended for painting - but having spare time, took it up as an amusement. He copied VandeVelde well. He never was at Sea, except once in a Yatch [yacht] which was sent to Helvotsluys to bring George 2d. from Hanover - Scott

OPPOSITE ABOVE: *Fort William, Calcutta*, c.1732, George Lambert *and* Samuel Scott. *One of a series of pictures portraying the chief settlements of the East India Company commissioned in 1731. The two lines of battlements of the fort enclose Government House.*
OPPOSITE BELOW: *The Capture of the 'Covadonga' by the 'Centurion', 20 June 1743*, Samuel Scott. *On his voyage round the world, Commodore Anson arrived at Macao in November 1742, his squadron reduced to one ship, the 'Centurion'. The 'Nuestra Señora de Covadonga', a Manila galleon carrying treasure, put up a stubborn defence before surrendering. The total booty of the voyage was £400,000.*
ABOVE: *Vauxhall Pleasure Gardens*, from Rudolph Ackermann's 'Microcosm of London', published in London, Thomas Rowlandson *and* Augustus Pugin, *hand-coloured aquatint. On both sides of the colourful stand containing the orchestra, standing figures are shown inside the 'supper boxes'. The paintings decorating them are not visible.*

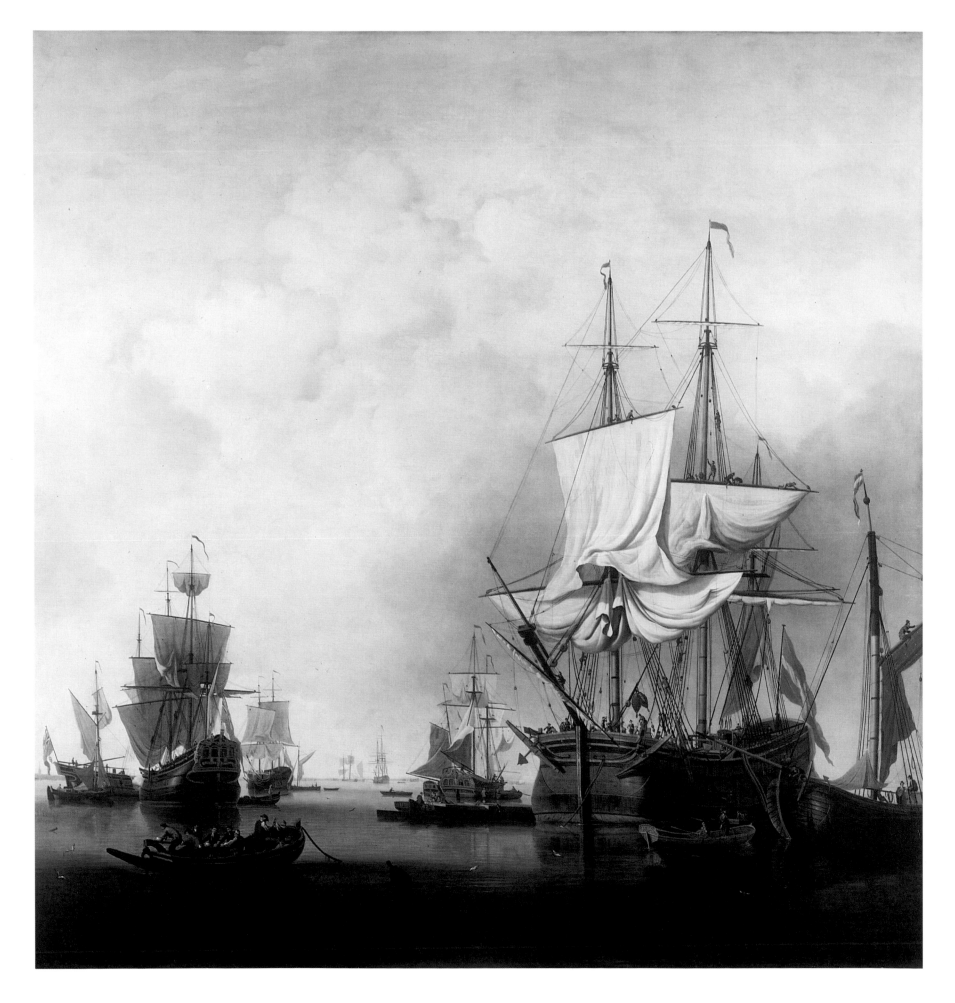

was a warm tempered man, but good natured'. Farington was mistaken with respect to Scott's sea-faring experience. In 1732 Scott accompanied four friends, including William Hogarth, on their *Five Days Peregrination* to the Thames and Medway estuaries. The group got up to all manner of pranks and practical jokes, and produced an illustrated account of the jaunt, which is now in the British Museum.

In the same year Scott completed his earliest recorded commission. He was sub-contracted to the landscape painter George Lambert (1700-1765) to supply the shipping in a series of six paintings of the English East India Company's settlements for the Company's headquarters at East India House, in Leadenhall Street, London. A water-colour by Thomas Hosmer Shepherd of about 1820 shows the pictures arranged around the walls in the Director's Court Room. It is recorded that Lambert received £94 10s 0d for his larger contribution to the set. A brief entry in one of George Vertue's notebooks reveals Scott's collaboration.

It is likely that Scott acquired his extensive collection of prints and drawings, and a smaller number of oil paintings, from the sales held after the death of Willem van de Velde the Younger. Scott's own picture collection included examples by Pieter Bruegel, Jacob Ruisdael, Jan Griffier the Elder, Claude Lorraine and Ludolf Bakhuizen, and was auctioned in Covent Garden, during a series of sales held in 1765 and 1773.

During the first half of the eighteenth century, Scott specialised in contemporary sea battles and general shipping scenes. He recorded Commodore Anson's celebrated circumnavigation in pictures such as *The Capture of the 'Covadonga', by 'Centurion', 20 June 1743*. His compositions are largely derived from the van de Veldes; one of the most obvious examples of this influence is the large-scale painting representing *Lord Anson's Victory off Cape Finisterre, 3 May 1747*, which is an adaptation of the Younger's *Battle of the Texel, 11 August 1673*.

Scott painted pictures specially designed as part of grand interior decorative schemes, notably a pair of overdoors of *A Danish Timber Bark getting under way* and *A Flagship shortening Sail*, both dated 1736, probably commissioned by William, 3rd Earl Fitzwilliam, for Wentworth Woodhouse. Scott studied and copied compositions by the van de Veldes and they remained the dominant influence throughout his life. But he has also been called the 'English Canaletto', and it is true that he was, for a time, preoccupied with this fashionable artist.

The name of Antonio Canal, called Canaletto (1697-1768) conjures up images of the waterways and campaniles of Venice. Although most celebrated for his elegant topographical views or *vedute* of this city, characterised by crystalline light and assured flicks of oil paint, some of his finest pictures were actually painted in England - in Warwick, Northumberland, and along the banks of the Thames - between 1746 and 1755. In May 1746 Canaletto made his first extended visit to England, and his presence was immensely influential in terms of the development of topographical marine art. His visit had not been designed to encourage English artists to paint architectural views; rather, Canaletto was looking for new commissions for himself. He had enjoyed immense popularity and patronage from gentlemen making the Grand Tour but by the 1740s this lucrative business was drying up.

Despite his popularity, little is known of Canaletto's early training and even less of his life. He was the son of a painter, born near the Rialto Bridge in Venice, and was known as Giovanni Antonio Canal until he adopted the name Canaletto, meaning little Canal, in about 1720. His father was a notable theatrical scene painter and was his first teacher. Not surprisingly,

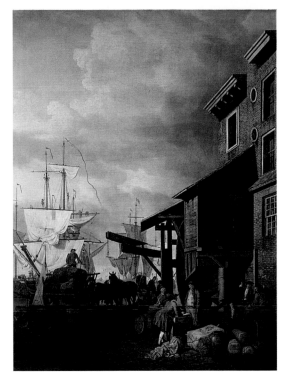

OPPOSITE: *A Danish Timber Barque*, Samuel Scott. *This large picture shows men in a boat weighing and fetching home the anchor of the timber bark. The composition relates to Elisha Kirkall's mezzotint engraving after Willem Van de Velde the Younger's 'The 'Royal Sovereign' with a Royal Yacht in a Light Air'.*
ABOVE: *East India House*, Thomas Hosmer Shepherd. *Lambert and Scott's series of paintings are arranged around the walls of the Director's Court Room in the London headquarters of the East India Company. The paintings have survived although the building itself was demolished in the 1860s.*
BELOW: *The 'Custom House Quay'*, Samuel Scott. *Almost certainly a composite image of various maritime locations close to the Thames. Scott painted several versions of this picture.*

ABOVE: **London: Westminster Bridge from the North on Lord Mayor's Day, 29 October 1746**, Canaletto. *This elaborate river scene painted from an imaginary bird's-eye viewpoint depicts the Lord Mayor's procession to Westminster to be sworn in. The Lord Mayor's barge is the largest vessel powered by eighteen oarsmen.*

Canaletto's pictures often bear some of the characteristics of scene painting. They are visually striking compositions, imbued with a dramatic atmosphere and use of light. His most accomplished work has great flair and his detailed views were assisted by optical instruments, especially the *camera obscura*. Although one of the greatest view-painters, he was not the first and his work, in common with all the *vedutisti*, was indebted to Luca Carlevaris (1665-c.1730).

Canaletto's portrayals of ships often have the appearance of ship models. The scale and perspective are somewhat wayward and there are often representational errors of shipping and craft. He used shipping, and people, as theatrical props to animate his scenes, and his paintings were largely commissioned by non-maritime people who either did not notice or did not care about the contradictory features. Some scenes were totally imaginary.

Canaletto's celebrated follower Antonio Joli (c.1700-1777) also worked in London in the 1740s as a scene painter at the King's Theatre, Haymarket. He painted *capriccios* of the Thames, and was supported by several of Canaletto's patrons, especially the Duke of Richmond.

Canaletto also exploited the expanding market for prints. It was probably before his temporary return to Venice in 1750, that he made the four drawings of Vauxhall Gardens, that were engraved by J.S. Muller and Edward Rooker and published in the following year by Robert Sayer. Canaletto's Italian pupil Francesco Guardi (1712-1793) also specialised in *vedute* which invariably included gondolas, oared craft and sailing vessels. However, Guardi's atmospherically moody style is very different from the clarity and crispness of Canaletto's. His painting technique was considerably looser and he favoured a more silvery palette.

Canaletto inspired other painters in England to seek out new marine subjects along the banks of the River Thames. He himself imported Mediterranean light and colour into his English commissions, especially those depicting the River Thames and the City of London, the various views of Westminster Bridge, and *Greenwich Hospital from the North Bank of the Thames* (c. 1750). His northern followers, however, applied local colour and lighting effects, and generally lacked the theatrical composition and the bravura of the Italian's brush strokes.

ABOVE: ***The Adelphi, London, under construction, with York Water Tower and the River Thames towards Westminster, 1771-1772***, William Marlow. *The Royal Terrace of The Adelphi was designed by the Adam brothers. It was a highly imaginative venture but financially disastrous. Marlow animates the architectural scene with workaday boats*

ABOVE: *Greenwich Hospital from the North Bank of the Thames*, Canaletto. *Greenwich Hospital was a home for old and disabled seamen founded by William and Mary in 1694 to designs by Webb, Wren, Hawksmoor and Vanbrugh. Today it is home to the Royal Naval College.*

Scott's art collection included a collection of prints and drawings by Canaletto. His painting of an arch of Westminster Bridge (c.1750) clearly derives from Canaletto's composition, painted about 1746. The so-called *Custom House Quay* of 1757 is a more original, and partly imaginary, maritime genre composition. His pupil, William Marlow (1740-1813), also painted topographical marines in a similar style, and his masterpiece *The Adelphi, London*, demonstrates that he was capable of rivalling his master. Horace Walpole patriotically, but absurdly, believed Scott and Marlow to be 'better painters than the Venetian'.

Scott also owned pictures by the French painter Claude-Joseph Vernet (1714-1789), who popularised accurate depictions of harbour views and stormy coastal scenes. Vernet was born in Avignon, into a family of artists. He received his earliest training from his father, a decorative painter. Later in Rome, where he settled from 1734 to 1753, he studied under the landscape and marine painter Adrien Manglard (1695-1760). In Rome he was impressed by Claude's harbour scenes and by the stormy and rocky coastal views of the Italian artist Salvator Rosa (1615-1673). He benefited from a broad base of patrons in Rome, many of them English, and his relationship with British customers was doubtless advanced by his marriage to Cecilia Parker, the daughter of Captain Mark Parker, the Pope's naval commander. Vernet's *Livre de*

Vérité reveals that he was prepared to brave the elements in order to paint the sea with greater fidelity. During a storm on board the ship that brought him to Rome, he exclaimed 'Give me my brushes so that I may paint these superb effects before I die!'

Rome was the international centre of art in eighteenth-century Europe. Those on the Grand Tour could see and buy a wide range of work. In 1750, Benjamin Lethieullier, who was in Rome making the Grand Tour with his brother-in-law, Sir Matthew Featherstonhaugh, commissioned Vernet to paint a contrasting series of four marines *The Four Times of Day*, all dated 1751. They hang today in the dining room of the Featherstonhaugh family at Uppark in Sussex, now owned by the National Trust.

Vernet's dramatic windswept coastal views derived in part from Marco Ricci (1676-1729) and Alessandro Magnasco (1677-1749), although he favoured a less combative relationship between his figures and the world they inhabited. Vernet shared Canaletto's love of placing carefully-drawn figures and groups in grand compositions that invariably portray vessels in harbour, or ships struggling against the elements close to the shore.

Vernet's most important and ambitious commission was a series of French port views undertaken for Louis XV of France beginning with Marseille in 1753. He was determined not

ABOVE: *Entry to the Port of Marseille*, Claude-Joseph Vernet. *One of Vernet's famous series of paintings depicting the Ports of France. This example clearly shows the artist's clever use of elegant, fashionably attired figures near the water to enliven his composition.*

to produce dull objective records and included day-to-day maritime activities such as trading, shipbuilding and repair. His ships and harbour fortifications were also enlivened by the inclusion of large groups of fashionably-attired figures on the harbour walls and shores, picnicking or resting by the water, and observing the sea-borne activity. The original inventory is vague about the precise number of pictures commissioned, implying twenty or more, but only fifteen were completed. Those of Marseille, Toulon and Rochefort are now rightly regarded as valuable historical documents of French maritime and naval life.

Vernet was not exclusively a marine painter, but was the Official Marine Painter to the French King. His pupils included Charles-François La Croix, called Lacroix of Marseille (c.1700-1782), who copied Vernet's harbour scenes, of which there are superb examples at Uppark. Jean-Baptiste Pillement (1728-1808) lived for a time in England and exhibited widely in London, although he continued to work for the French and Polish royal families. The Swedish artist Elias Martin (1739-1818) trained under Vernet in Paris. He painted mainly landscapes but some port and harbour scenes, and exhibited widely in London, where he was made an Associate of the Royal Academy. In about 1790 he returned to Stockholm where he prospered with the support of a wide circle of patrons. Louis-Philippe Crépin (1772-1851), a native of Paris, carried Vernet's influence into the nineteenth century.

John Cleveley the Elder (c.1712-1777) was the head of a remarkable family of English marine artists who painted dockyard scenes, ship launches, harbour views and sea battles. He almost certainly knew the work of Vernet and Canaletto, if not the original oil paintings, then the prints after their work. Born in Southwark, Cleveley was apprenticed to a carpenter in Deptford Dockyard, but later became a full-time marine painter, perhaps encouraged by the economies being implemented in the dockyards. By 1704 the cost of carving decorations on ships was so high that it was severely restricted and replaced by painted decoration. Cleveley was self-taught and his style distinctive. His family included twin sons, John Junior (1747-1786) and Robert (1747-1809), and a third son James, born about 1750, who was a ship's carpenter. He was on board the *Resolution* during Captain Cook's third voyage of discovery and returned with sketches which his brother, John Junior, worked up into wash drawings, later published as aquatints. Robert served as a clerk in the Navy in the 1770s, and preferred to paint sea battles. He was the only member of the family to benefit from royal patronage.

The topographical accuracy, architectural detail, the inclusion of figures on board the various ships and smaller craft, and the quayside strollers in the Cleveley's dockyard scenes have some parallels with Canaletto. This is evident in *The 'Royal George' at Deptford showing the launch of 'Cambridge'*, and *A Sixth Rate on the Stocks*. But for all their inherent charm and attention to detail these pictures lack the refinement, flair, and bold brushwork of Canaletto or Vernet. However, the Cleveleys' pictures are more convincing in their portrayal of ships and smaller craft, as many of their clients were dockyard officials and naval officers.

By the mid-eighteenth century the Dutch, Italians, French and Germans, and every major painter of maritime subjects had been instrumental in creating and shaping the English school of marine artists. British art in general was being actively encouraged and marine art was benefiting from British naval successes in the conflicts of the period. All this gave rise to a new wave of patrons and schemes, including exhibitions, societies, and competitions, which were created in order to encourage English artists to raise their standards.

OPPOSITE ABOVE: *The 'Royal George' at Deptford showing the Launch of the 'Cambridge'*, John Cleveley the Elder. *Deptford was one of the principal royal dockyards in the 17th and 18th centuries. This is a composite image as the 'Cambridge' was launched in 1755, and the 'Royal George' never went up the Thames as far as Deptford.*
OPPOSITE BELOW: *Rocky Coast in a Storm*, Alessandro Magnasco. *Magnasco's dramatic coastal scenes were influential on the Romantic artists.*
ABOVE: *A Stormy Coast Scene*. Claude-Joseph Vernet. *Vernet's coastal scenes were widely collected and admired. Some of his followers copied his work.*

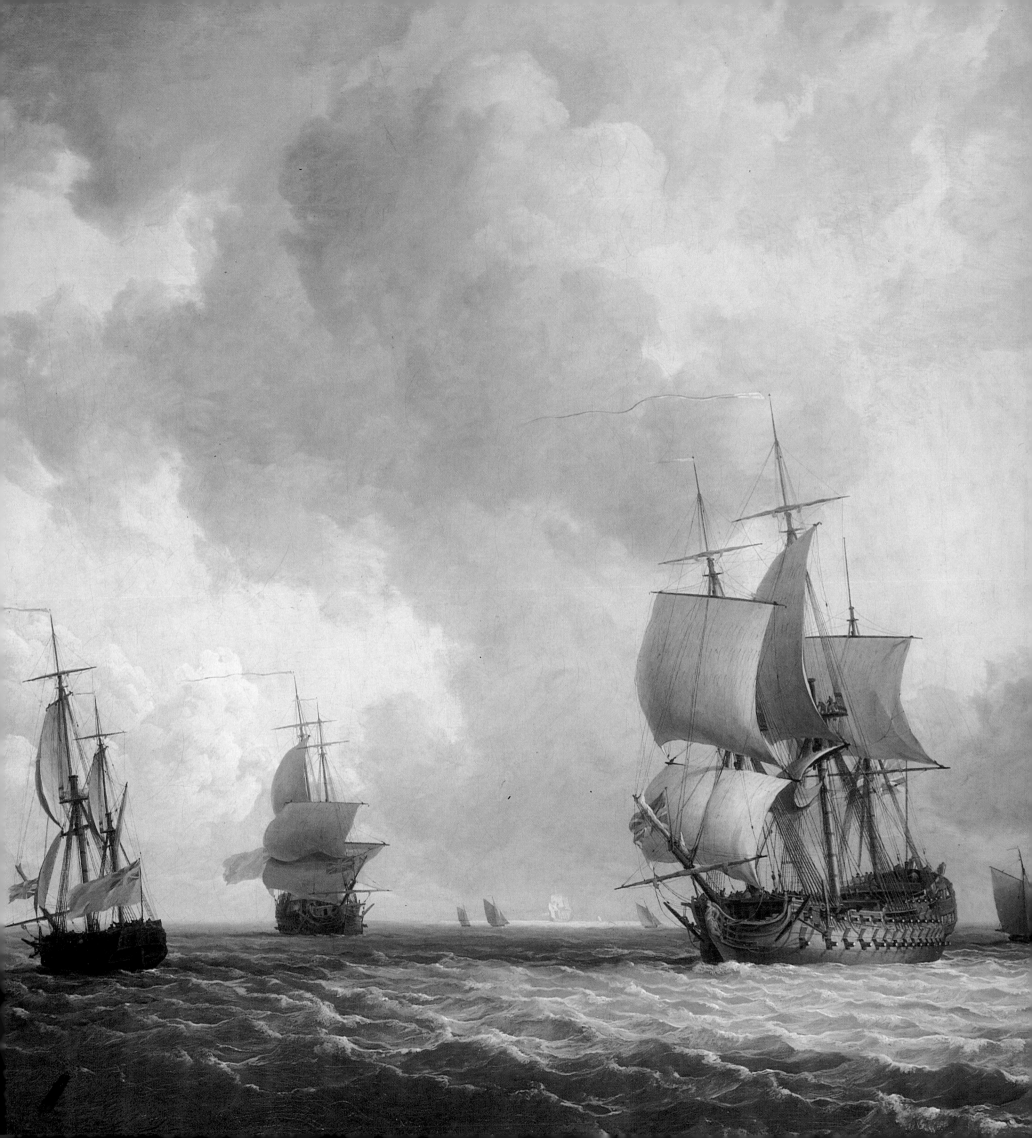

PATRONS, PREMIUMS AND EXHIBITIONS

In 1739 Captain Thomas Coram, a retired sea captain, shipbuilder and philanthropist secured a royal charter for a Foundling Hospital in London 'for the maintenance and education of exposed and deserted children'. The Hospital, the world's first incorporated charity, actively encouraged artists including Hogarth, Hayman, Lambert, Monamy and Scott, as well as sculptors, craftsmen, composers and musicians to become associated with it.

William Hogarth, a founder Governor of the Hospital, conceived the idea of adorning the walls of the Court Room and other rooms with paintings and sculpture by leading contemporary artists and was made responsible for organising a committee to 'consider what further Ornaments may be added to this hospital without any expence to the charity'. In exchange for their donations the artists benefited from the exhibition of their work making the Foundling Hospital the first non-paying public exhibition forum for the arts in England.

A remarkable series of eight roundels of the prominent London hospitals was painted to enhance the Court Room, where the Governors held their meetings. Contributors included Thomas Gainsborough (1727-1788), who depicted the Charterhouse, painted in 1748. Gainsborough was a portrait and landscape painter, but did paint coastal subjects including *Coast Scene: Selling Fish in a Storm*, now in the National Gallery of Victoria, Melbourne. It was one of a pair of maritime subjects, the other a calm, exhibited at the Royal Academy in 1781. This was Gainsborough's first attempt at marines, partly inspired by Vernet. Horace Walpole praised them for being 'so free and natural that one steps back for fear of being splashed'.

Charles Brooking (1723-1759), one of the most gifted of all eighteenth-century English marine painters, was encouraged by his patron, Taylor White, the institution's Treasurer, to paint for the hospital *An English Vice-Admiral of the Red and his Squadron at Sea*, his largest recorded painting measuring 70 x 123ins, painted as a companion to Monamy's large port scene, now missing. He was rewarded by being elected a Governor and Guardian of the hospital.

Biographical details of Brooking's life are meagre and there is little contemporary criticism of his work. Edward Edwards, the author of *Anecdotes of Painters*, published in 1808 and designed as a continuation of Horace Walpole's work, obtained information from Dominic Serres, who knew Brooking well. He states that Brooking, like the Cleveley family, was brought up in the dockyard at Deptford and 'worked for the shops'; professional picture dealers were rare, and the 'shops' were probably retailers who sold a wide range of items, and adorned their windows with 'furnishing' pictures. Brooking's pictures were sold by an unscrupulous London dealer near Leicester Fields (Leicester Square) who removed the artist's signature to maintain the monopoly on his custom. But he left one signature in place and an admirer of Brooking's work, since identified as Taylor White, immediately advertised to meet the artist.

OPPOSITE: ***Ships in a Light Breeze***, detail, Charles Brooking. *The main vessel in this carefully observed and atmospheric work is a two-decker, with a cutter astern. Left is a ketch-rigged sloop or bomb-vessel.*
ABOVE: ***An interior view of the original Foundling Hospital before its demolition in 1927***, Hanslip Fletcher. *Brooking's painting, completed in 1754, is clearly visible at the far end of the room. Taylor White's portrait in pastels by Francis Cotes hangs above another portrait in the immediate right foreground.*

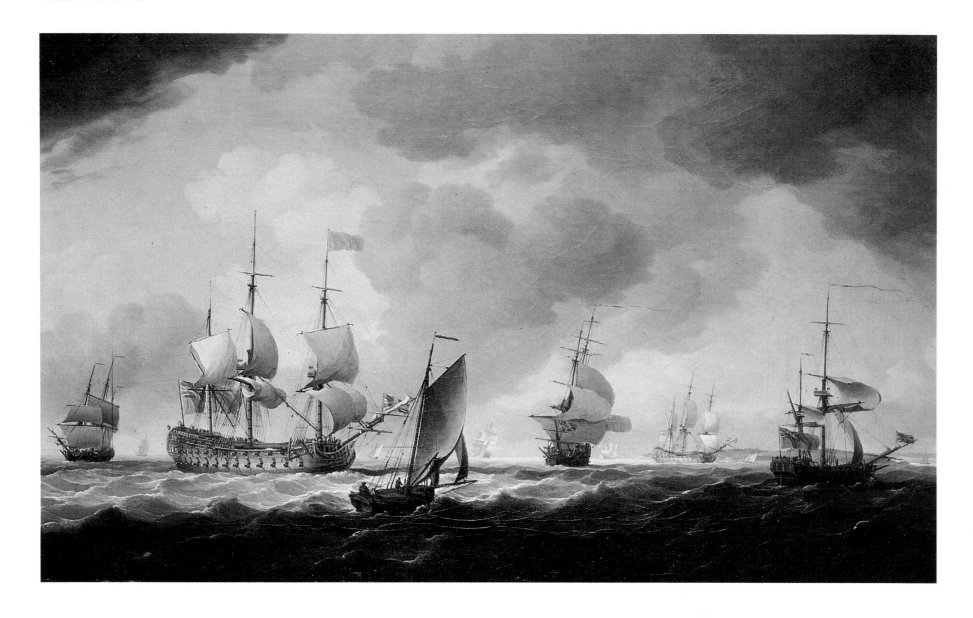

ABOVE: *An English Vice-Admiral of the Red and his Squadron at Sea*, Charles Brooking. *A small scale version of Brooking's painting presented to the Foundling Hospital demonstrates the artist's intimate knowledge of ships and shipping. The flagship may be the 'Boyne'.*

Unscrupulous dealers were a common problem during the mid-eighteenth century. Thomas Mortimer sought to provide a solution with his *Universal Director* of 1763 which listed leading contemporary artists in London, then the artistic capital of Britain. It included eight marine painters, with a reference to where they could be contacted; but ironically, the guide failed.

Brooking received an unusual commission from John Ellis to co-illustrate a book on marine biology entitled *The Natural History of the Corallines*, published by Boydell in 1753 but this did little to further his career. He was a man of 'sickly appearance' and without White's assistance may well have faded into obscurity. White's collection was sold at Christie's in December 1774 as part of a three-day sale. It included pictures by Ruisdael, van Goyen and de Vlieger, a pair of paintings by Peter Monamy, and a collection of marines by Brooking described as: 'a calm', 'a small sea piece', 'sea piece' and 'a capital sea piece, with a view of Dover'. The last-named sold for the remarkable sum of £43.1s.0d, the highest price of the sale, suggesting that it was a special commission and that there was a buoyant market for contemporary maritime art. But Brooking enjoyed only modest success in his lifetime and left his family destitute.

Brooking initially fell under the spell of the van de Veldes and Simon de Vlieger, whose compositions he copied, but developed his own unique style of painting favouring general

shipping scenes, although he did paint some whaling scenes and naval battles, notably a series of pictures depicting the exploits of the 'Royal Family' privateers, so called because each vessel was named after a member of the royal family. Like his Dutch predecessors, the artist was preoccupied with depicting shipping in accurate detail and atmospheric conditions. In *Ships in a Light Breeze*, he adopted the Dutch convention of filling two-thirds of his painting with dramatic cloud formations and a superbly rendered sea indicating wind against tide. But he used local light and colour, identifying him as a member of the English School. His finest pictures are carefully observed, full of atmosphere, and harmoniously balanced. His compositions are rarely dynamic but his shipping is arranged with subtlety and precision, making his work highly distinctive and among the finest of all eighteenth-century marines.

The Foundling Hospital not only offered artists an exhibition forum but also a place to meet and dine. In this respect England lagged well behind other European countries. Italy had a long tradition of exhibiting art, especially sculpture, in public places. In France, largely through the influence of Louis XIV and his minister Colbert, art exhibitions or *salons* were established at the Louvre in Paris from 1667. The success of the Foundling Hospital exhibitions fired the hope that British artists might exhibit on continental lines. A committee was

ABOVE: *Greenland Fishery: English Whalers in the Ice*, Charles Brooking. *Brooking's composition may derive from an earlier artist Adriaen van Salm who painted many whaling and fishing scenes.*

created, chaired by Francis Hayman, and the first organised public exhibition of art in England took place in London in April 1760. The premises, the Great Room situated in Denmark Court opposite Beaufort Buildings, were hired from the Society for the Encouragement of Arts, Manufactures and Commerce (known as the Society of Arts), an organisation founded in 1754 by William Shipley, a Northamptonshire drawing-master. Hogarth, Hayman and Reynolds were among the earliest artists to be elected members of the Society in the 1750s. Of the 130 exhibits, only two could be classed as marines, or 'sea pieces'.

The exhibition was a commercial success and attracted upwards of 20,000 visitors but the difficulties of organising it led to the creation in 1761 of two separate organisations in London: the Society of Artists and the Free Society of Artists, so called because there was no entrance fee. A third exhibition forum, the Royal Academy of Arts, was founded in 1768 and it is the only one that is still active today.

One function of the Society of Arts was to encourage native artistic skills to the benefit of commerce, manufacture and trade. But British 'goods' had to be made attractive to customers and collectors. During the 1740s Dutch art had started to flow into the country, encouraged by many prominent English collectors. These included the first minister Sir Robert Walpole, the diplomat Sir Paul Methuen, and Sir George Colebrooke, a director of the East India Company. One of the most important collections of Dutch and Flemish pictures was amassed by the politician, John Stuart, 3rd Earl of Bute and displayed in a specially-built picture gallery at Luton Hoo in Bedfordshire.

Sir Lawrence Dundas, another remarkable collector, favoured seventeenth-century Dutch art. He had made a fortune as a merchant contractor and as Commissary-General of the Army in Flanders during the Seven Years' War and used his wealth to buy houses and commission leading architects and craftsmen, and also, but to a lesser extent, contemporary painters.

Dundas owned pictures by Aert van de Neer, Jan Griffier the Elder, Thomas Wyck, Cuyp, the van de Veldes, Bakhuizen, *A Sea Port [with] Figures* by Vernet, a sea battle by Lingelbach, and a superb calm scene by Jan van de Cappelle which his agent, Boston-born artist turned picture dealer John Greenwood believed to be '..one of ye most capital pieces that is known of him, as good as any van de Velde'. In 1770 Greenwood boasted to his friend and fellow American artist, John Singleton Copley, that he had 'brought to London above fifteen hundred pictures, and have had the pleasure of adorning some of the first cabinets in England'.

Dundas's interest in English marines was limited to Samuel Scott's *An Arch of Westminster Bridge*. But he commissioned a portrait of himself and his family from Johan Zoffany (1733-1810). Zoffany portrayed Dundas with his grandson, Lawrence, in the Library, or pillar room, of his London residence at 19 Arlington Street. The arrangement of the pictures in this room, decorated by Robert Adam, might be in part fanciful; but all were recorded in the collection. Over the chimney piece is the Jan van de Cappelle, flanked by a pair of marines - *A Fresh Breeze with Shipping* and a similar companion - by Willem van de Velde the Younger.

The Society of Arts' dedication to advancing British marine painting led to the concept of a marine painting competition, for the 'best original Sea Piece on a canvas...' in oils. Conceived in 1762 it was the first of its kind in the world, although it was not launched in the London press until 1764. The competition was open to all ages and the successful entrant was required to provide proof that the picture had been painted in England.

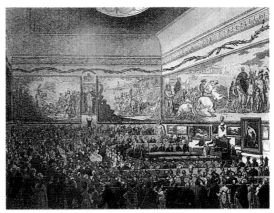

OPPOSITE ABOVE: *A Beach Scene with Man-o'war in the Distance,* Charles Brooking. *Brooking's picture is copied from a composition by Simon de Vlieger.*
OPPOSITE BELOW: *The Capture of Havana, 1762,* Dominic Serres. *The Morro Castle and the boom defence before the attack.*
ABOVE: *Sir Lawrence Dundas and his Grandson in the Pillar Room at 19 Arlington Street, 1769,* Johan Zoffany. *Dundas posed against the backdrop of his marine pictures appearing as a patron and connoisseur.*
BELOW: *The Society of Arts,* from 'Microcosm of London'. *In 1774 the Society of Arts (now the Royal Society of Arts) purchased its splendid building in John Adam Street, part of The Adelphi built by the Adam brothers. This print shows the premium or prize ceremony in the Great Room in the early 19th century.*

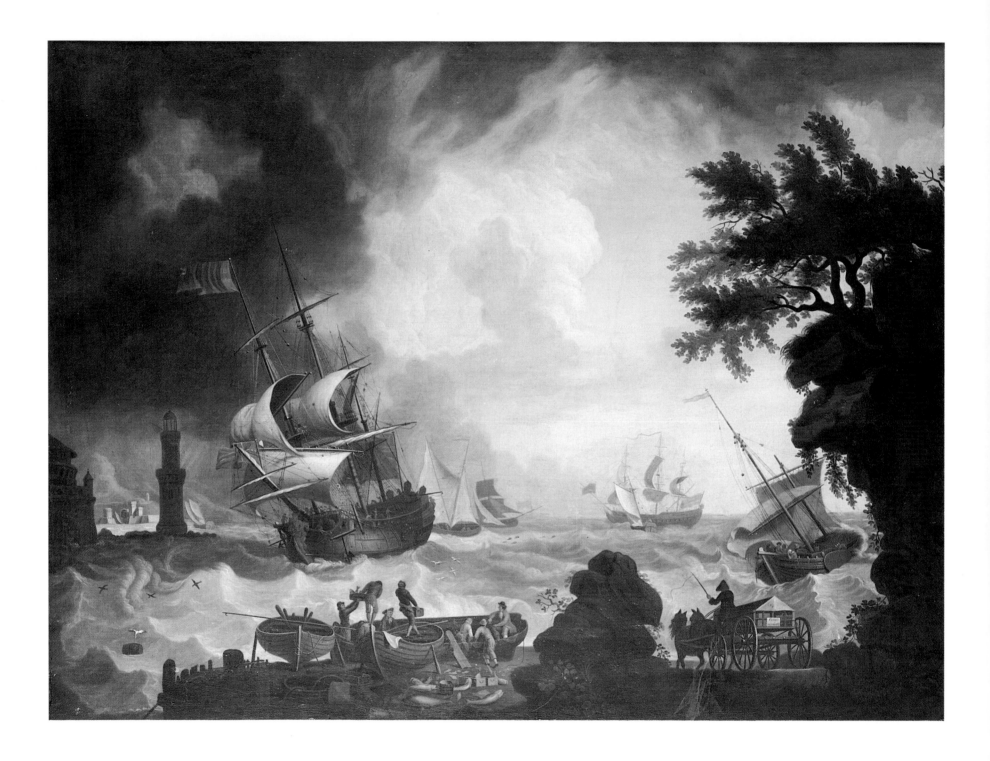

In the first year there were two 'premiums', or prizes. The competitions were repeated in 1765, 1766 and 1768, but then abruptly and somewhat mysteriously ceased. Richard Wright, a marine painter little known today, carried off the first prize in 1764, 1766 and 1768. Robert Wilkins won the first prize in 1765; second prizes were awarded to Francis Swaine (1764), Captain Francis Swain Ward (1765), and Thomas Mitchell (1766). John Cleveley (1765), and Robert Wilkins (1766) received third prizes. It is astonishing that Dominic Serres, a painter of talent and considerable charm, and Richard Paton and Francis Holman, never won a prize. It would have been surprising if they had not entered, although evidence that they did so has yet to emerge. In the year the premiums ceased, the Royal Academy of Arts was formed.

However, the Royal Academy made no attempt to encourage marine art. Of its thirty-six founder members, Dominic Serres was the only professional marine painter. But through Serres' charm, contacts and influence, English marine painting gained royal approval and entered into a new phase of development.

Richard Wright (1735-1775) was probably born in Liverpool. He was largely self-taught and, according to Edward Edwards, 'of rough manners and warm temper'. He painted a wide range of marine subjects and his artistic interests were shared by his family, some of whom received tuition in London from his friend George Stubbs, the famous animal painter. For a time Wright shared the same address and probably a studio with Stubbs. Mortimer's *Universal Director* has only a brief entry on the artist: 'Painter of Sea Pieces, Enquire at Mr. Stubbs in Somerset Street, the Upper End of North Audley-Street, Grosvenor-Square'.

Wright's popularity during the mid-eighteenth century is now difficult to comprehend. He was a competent but prosaic recorder of marine themes. However, he was an expert promoter of his work, and his subjects were carefully selected to tempt potential buyers and please competition judges. *Princess Charlotte's Passage to England*, exhibited at the Society of Artists in London in 1762, was almost certainly acquired by Queen Charlotte. It was painted from a sketch made on board the royal yacht *Fubbs*, which brought the princess to England in 1761 to marry King George III, but it is not clear if Wright made the sketch himself. He later incorporated the central section of the picture into the background of Joshua Reynolds's portrait of Mary Panton, Duchess of Ancaster, who had accompanied the princess in the *Fubbs*.

In April 1764 Wright responded to the advertisement issued by the Society of Arts for 'the best original Sea Piece on a canvas 5 feet 6ins in length and 3 feet and half in height'. The premium was to be fifty guineas although Wright was only awarded the original sum of thirty guineas. There was a second premium of fifteen guineas. According to Edwards, who believed the artist had trained as a house and ship painter, Wright 'paid a compliment to the Society, by introducing an allusion to their encouragement of the scheme for supplying the metropolis with fish by means of land-carriage'. Generally known as *The Fishery*, the title of William Woollett's 1768 print, this picture exists in several painted and engraved versions, and is also known as *A Sea Piece, with a Squall of Rain*. The many painted versions have made it difficult to identify the original.

Francis Swaine (c.1720-1783), one of the most prolific of all marine artists, was influenced by Brooking, Monamy and the van de Veldes, but never came close to rivalling them. He turned out numerous complementary pairs of pictures, general shipping subjects, moonlight scenes and naval encounters. He exhibited from an address near Avery Farm in Chelsea, London,

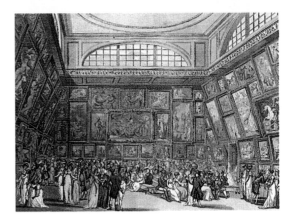

OPPOSITE: ***The Fishery***, Richard Wright. *An unusual composition by an artist little known today. Wright's image was well known through Woollett's engraving, and was widely copied.*
ABOVE: ***Princess Charlotte's Passage to England, September 1761***, Richard Wright. *Lord Anson was sent to Cuxhaven to collect Princess Charlotte of Mecklenburg-Strelitz, future wife of King George III.*
BELOW: ***The Royal Academy of Arts***, *from Rudolph Ackermann's 'Microcosm of London'. The Royal Academy, which was originally located at Somerset House, moved to Burlington House in 1866.*

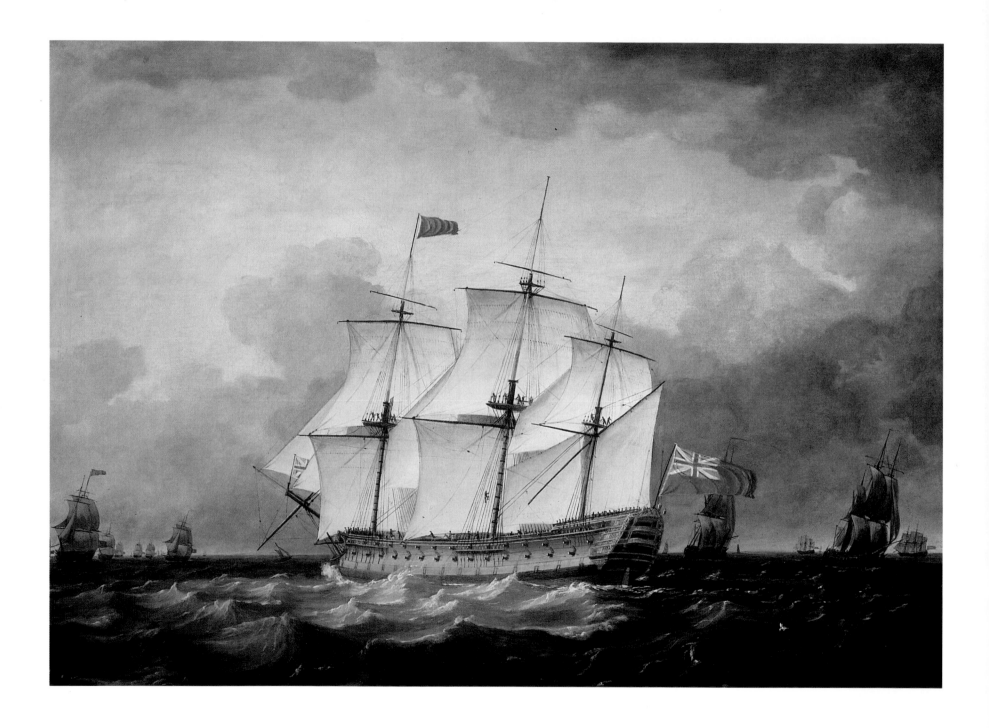

and worked mostly for 'the shops'. According to Edwards he was prepared to try his hand at various commissions including painting the 'face of a wind-dial, with sea and ships'. In 1735 he is recorded in a list of clerks and commissioners of His Majesty's Navy, as a messenger.

The author and art-lover Robert Baker was Swaine's most loyal admirer, but observed that marine painters were having difficulties selling their work. 'We have no English painter now living, whose productions are more perfect in their kind than the moonlight sea-pieces of Swaine…I am sorry to observe, by his pictures being all marked for sale that they are not in the request they deserve to be: for he is a much better painter than some, whom the distribution of prizes at the Arts and Sciences have brought into high repute. This man's works will one day or another esteem, when that esteem (alas!) will be of no benefit to their author.'

Other marine painters were finding it difficult to make ends meet. Peter Monamy enjoyed success in his lifetime, but left little spare money and his widow was awarded a share of the profits of the first exhibition of the Society of Artists at Spring Gardens, amounting to ten guineas. The three children of Charles Brooking received a similar sum.

Francis Swaine's son, Monamy Swaine, born about 1750, was also a marine painter, named after Peter Monamy. He painted a wide variety of subjects including still-lifes and marine scenes in the style of his father. One of his most accomplished marines represents the *Victory* in 1794, the first rate ship-of-the-line that was to become Nelson's flagship at the Battle of Trafalgar.

Robert Wilkins who worked in the 1760s and 1770s is largely unknown today. He painted a wide range of subjects, including dockyard scenes and naval battles, as well as landscapes, portraits and still-lifes, and for a time exhibited from an address at the Shipyard, Temple Bar. He may have learned to paint through working in the dockyards, although it is possible that the Shipyard may refer to an inn. Mrs Wilkins, Master John, aged 11 years, and Master James, aged 12, all practised as artists.

Captain Francis Swain Ward (1736-1794) is not recognised today as a marine artist but rather as a landscape and architectural painter. Born at Kingston-upon-Thames in Surrey, he was brought up as an artist, although he temporarily abandoned that career to join the Madras Army of the East India Company. He became dissatisfied with his advancement and returned to England to paint full time. He was Secretary of the Society of Artists and exhibited a series of Indian subjects there between 1770 and 1773.

No examples of his sea pieces are extant but something of his marine style can be deduced from his depiction of the peacock boat in the foreground of the *Mausoleum of Sher Shah, Sasaram*. This unusual subject is one of a series of ten paintings of India he painted in about 1770 for the East India Company, as a diplomatic manoeuvre to get himself reinstated into the army as a captain. He succeeded and his pictures were hung at the East India Company's headquarters in Leadenhall Street in London.

Thomas Mitchell (1735-1790) exhibited from an address in Chatham, and from 1771 was listed as a Builder's Assistant at His Majesty's Dockyard, Chatham. He later held the same position at Deptford and finally became Assistant Surveyor of the Navy. He was capable of competent work but his style was generally uninspiring and is found in a wide range of subjects, although he favoured battle scenes.

John Cleveley the Elder (c.1712-1777) exhibited at the Free Society of Artists in London. His exhibits for 1765 were: *A Sixty Gun Ship in her Timbers*, *An Indiaman just set up*, and *A*

OPPOSITE: *The 'Victory' underway*, Monamy Swaine. *Launched in 1765, the 'Victory' is perhaps the most celebrated of all naval ships. It was famous even before Nelson's time.*
ABOVE: *Fishing scene, with a Yacht becalmed near the Shore*, Francis Swaine. *This charming picture is a good example of Swaine's work. He was an artist of uneven talent, although some of his contemporaries were unequivocal in their support.*
OVERLEAF: *Chatham Dockyard in 1777*, Robert Wilkins. *The three-decker with a white hull prepared for launch is the 'Formidable', a 98-gun Second Rate launched on 20 August 1777. In the foreground is a mooring boat.*

View of Portsmouth with Shipping. He was awarded the third prize of ten guineas for *A Storm upon the Princess of Brunswick's Passage to Holland.*

On Wednesday, 6 April 1768, several London newspapers ran a defamatory 'advertisement' accusing the Society of Arts of rigging its competitions for marine and landscape painting. The story made the front page of the *Gazette and the New Daily Advertiser*, and the inside pages of the *Public Advertiser* and the *Daily Advertiser*. All ran the same copy, signed by 'Mr Dreadnought', calling into question the fairness and judgement of the adjudicators of the Society of Arts' competitions. The Society's response, recorded in its Minute Books, was immediate and discreet. An extraordinary meeting resolved that the 'advertisement' was 'false, scandalous, malicious and injurious as well to the Society, as to the candidates who obtained the Premiums'.

The Society interviewed various artists and officials. Richard Wright said that several years previously he had been advised by Mr Jared Leigh to paint 'only a slight picture for the second premium and that he should have the first premium another year'.

Jared Leigh was an amateur marine painter and active member of the Society. He exhibited at the Free Society from 1761 until 1767. Mortimer's Director (1763) records him as living in Wardrobe Court in Doctor's Commons, and that he was 'by profession, an Attorney', painting 'only for his own amusement'. Leigh told Wright that he could influence the outcome of the competitions and, according to Wright, had deterred many entrants. It transpired that Leigh had conspired with Robert Wilkins, and with Thomas Mitchell, whom he had persuaded to withdraw a picture without consulting the Society. In May 1768, Mitchell and Wilkins were barred from all future competitions and Leigh was expelled from the Society. His conduct was found to be 'disingenuous, disorderly and disrespectful in regard to the Society, and prejudicial to its interests and those of its candidates and consequently of the Public'. More seriously, the competitions ceased.

OPPOSITE ABOVE: ***Mausoleum of Sher Shar, Sasaram, Bihar***, Captain Francis Swain Ward. *Sher Shar, the Pathan Governor of Bahir, drove the Mughal Emperor, Humayun, from Delhi in 1540 and installed himself as ruler. The ceremonial peacock boat is in the foreground.*
OPPOSITE BELOW: ***A Sixth Rate on the Stocks***, John Cleveley the Elder. *The placement of costumed quayside strollers in this picture evokes the compositions of Canaletto and Vernet.*
LEFT: ***Forcing a Passage of the Hudson River, 9 October 1776***, Thomas Mitchell. *This representation of a small but important operation during the American war is based on a painting by Dominic Serres. Parker in the 'Phoenix' and his squadron are viewed from astern.*
ABOVE: ***Jared Leigh and his Family***, George Romney. *Leigh on the far right was exposed as a bounder by the Society of Arts. The portrait was exhibited at the Free Society in 1768.*

EIGHTEENTH-CENTURY SEA-BATTLES AND SHIPPING SCENES

Dominic (or Dominick) Serres (1722-1793) was the most prolific and remarked upon marine artist of the later eighteenth-century. He was born of a well-to-do family near Auch in Gascony and attended the English Benedictine school at Douai but, when his parents wanted him to join the priesthood, he ran away to the West Indies.

After a few years in Havana, he became a merchant shipmaster and enlisted on a Spanish ship that was captured by the English. He was brought to England as a prisoner of war, probably during the Seven Years' War in 1756. On his release he settled in London, where he sold pictures from a small shop in Piccadilly. He befriended Charles Brooking, who probably helped him understand the market for marine paintings and may have given him some tuition.

Serres painted a wide variety of marine subjects, including ship portraits, general shipping scenes and landscapes but he preferred naval actions painted from the English viewpoint. This was a lucrative and expanding market as English victories encouraged naval officers to commission paintings of their actions. Officers were fastidious in their demands for factual accuracy and wanted documentary records unobscured by artistic expression.

In *Present State of the Arts in England*, Rouquet highlights the constraints placed on marine artists and they are clearly revealed in a letter from Sir Richard Strachan, who commanded a squadron that captured four French ships off Cape Ortegal on the north-western coast of Spain in November 1805, to the marine painter Nicholas Pocock: 'Sir Richard Strachan compliments to Mr Pocock and inform him he just recollects that the French Admirals mizzen topmast should be shot away at the time the picture is meant to represent - the French admiral is that ship engaged by *Namur* - the ship with the main topsail aback - and the main yard carried away. The French adml should have his ensign hanging as if fallen over the stern, and the flag & mizzen topmast hanging after. The *Courageux* stern should be like a frigate'. A rough pen-and-ink sketch of two damaged ships and a stern, now in the National Maritime Museum collection, accompanied the text. The painting referred to is probably *Sir Richard Strachan's Action off Ferrol, 1805*, now in the British Royal Collection.

The auction of Serres' Valuable and Genuine collection of Pictures, Drawings, Prints, Book of Prints, Beautiful Models at Christie's in 1795 reveals that he owned marines by Claude, van de Velde, de Vlieger, Zeeman, van Goyen, van de Cappelle, Storck, van Diest, Scott and Monamy, six pictures by Brooking, nine sea-ports by Vernet (probably prints), and shipping views by his friend Paul Sandby. Unfortunately the ship models are not itemised separately.

A commentator in the *London Courant* of 6 May 1780 observed that Serres' exhibits of naval engagements at the Royal Academy, 'are very capital paintings; the events represented in them

OPPOSITE: *Princess Charlotte arriving at Harwich, 6 September 1761*, detail, Dominic Serres. *The principal royal yacht became the 'Royal Charlotte', and was sumptuously fitted out for the occasion.*
ABOVE: *A Lieutenant with his Cutter in the Background*, Dominic Serres. *One of a series of six prints illustrating officers' and seamen's uniform, published in November 1777.*

are rendered highly interesting: the shipping very highly finished and the sea expressed with that accuracy of colouring which distinguishes the works of Brooken and Monamy'.

Serres was an admirer of the van de Veldes and owned almost two hundred of their pictures and sketch books. He 'improved' their drawings and copied their work and also shared van de Velde the Younger's interest in painting for interior schemes.

Not all commentaries on his work were favourable. In 1783, he exhibited four works at the Royal Academy, including three representing the heroic action of the English 44-gun *Mediator* against a superior French fleet of five ships and substantially greater fire-power. The *Painter's Mirror* noted: '...it is fair to remark, that as the *Mediator* is English built, it is not quite so national to give her a Dutch stern and a heavy hull. In the representation of the action with *La Ménagère*, the land should be kept more distant; and though Mr. Serres had succeeded very well in preserving the different lights produced by the morn, and the first of the ships while engaging; a scene of night is no excuse for leaving the other parts of the picture in so unfinished a state..'.

The influence of Vernet is evident in much of Serres' work including the careful arrangement of quayside activity in the foreground of his harbour and dockyard pictures and in some of the Havana series. Serres clearly thought highly of Vernet. Paintings like *The Return of a Fleet into Plymouth Harbour*, and *Ships at the Gun Wharf at Portsmouth*, executed in the 1760s and 1770s, reveal Vernet's influence with echoes of his celebrated series of French ports. Although Serres lacked the technical skills and artistic flair of his compatriot, he produced competent work and excellent records of naval actions. Like Vernet he was not exclusively a marine painter, and *Mortimer's Director* (1763) lists him as 'Serres, Dominick, Painter of Landscapes and Sea Pieces, Opposite the Black Bear, Piccadilly'. He also designed, etched and published a series of six prints illustrating naval officers' and seamen's dress in 1777.

Serres got on well with his patrons despite being described as 'a very honest and inoffensive man, though in his manners *un peu du Gascon*'. He rarely missed a chance to advance his career: he was marine painter to George III and later Librarian of the Royal Academy. He was the only documentary marine painter to receive full membership of the Royal Academy that century. His sons, Dominic Jnr (c.1761-c.1804) and John Thomas followed his profession.

John Thomas Serres (1759-1825) was taught by his father and influenced by de Loutherbourg. His success was largely due to his father's influence. A privately-printed publication *A Liberal Critique on the Present Exhibition of the Royal Academy* (1794) summed up his talent and offered him advice: '...not as good as his father. If this gentleman would condescend to copy one of the fine pictures, by van de Velde, I am persuaded he would forego his turgidity of finishing'.

He succeeded his father as marine painter to George III and to the Duke of Clarence, later William IV. In 1793 he was appointed marine draughtsman to the Admiralty, and was instructed to make drawings of coastlines to assist with navigation and the location of enemy installations. More than one hundred hand-coloured aquatints of coastal profiles, lighthouses, plans of the principal harbours and charts were published in *The Little Sea Torch, or True Guide for Coasting Pilots* (1801). His counterparts in France were the Ozannes, Nicolas-Marie (1728-1811), and Pierre (1737-1813). Pierre was draughtsman to the French navy, and produced a set of sixty engravings of vessel types called *Vaisseaux et autres Batiments de Mer* (1813).

John Thomas Serres collaborated with his father on an ambitious publication called the *Liber Nauticus, and Instructor in the Art of Marine Drawing*, published by Edward Orme in two

OPPOSITE ABOVE: ***The British Fleet entering Havana, 21 August 1762***, Dominic Serres. *One of a series of paintings describing the six-week siege, bombardment and capture of Havana, the last major operation of the Seven Years' War. Here, the British fleet enters the harbour to take possession of the Spanish ships.*
OPPOSITE BELOW: ***The Thames at Shillingford, near Oxford***, John Thomas Serres. *In the foreground is a Peter boat used for fishing. The spritsail barges are typical of those which traded in London.*
ABOVE: ***Captain Philip Affleck (1726-1799)***, Edward Penny. *Affleck rose to become Admiral of the White. Behind him on the wall of his apartment is an oil painting of an unidentified ship, although almost certainly one that he had commanded.*

parts, in 1805 and 1806. John's introduction sums up the difficulties facing marine painters: 'Many are the obstacles to attaining a proficiency in drawing Marine subjects, particularly as it is not only requisite that a person desirous of excelling in this Art, should possess a knowledge of the construction of a Ship, or what is denominated Naval Architecture together with the proportion of masts & yards, the width depth & cut of the sails, &; but he should likewise be acquainted with Seamanship.'

The first part provides illustrations of masts, rigging and sails, and bow and stern views of various ships. It demonstrates the effects of weather on the sea, and gives examples of ships' fittings and equipment, including anchors, capstans, cables, and cannon. The second part contains ship portraits, and depictions of smaller vessels and craft. There is an explanatory text to improve the skills of draughtsmen and the technical knowledge of amateur artists.

In about 1817 John Thomas Serres purchased an interest in the Coburg Theatre in Lambeth, London (now the Old Vic) and became its scenic director. One of his junior painters was Clarkson Stanfield who was to become a dominant force in marine painting.

Few French painters specialised in naval battles during the second half of the century as a direct result of the limited success of the French navy. During the American War of Independence the French fared better, holding off the British in five actions off the east coast of Ceylon in 1782-1783. This encouraged the French Navy Ministry to commission commemorative pictures from the naval officer Capitaine le Marquis de Rossel de Cercy (1736-1804) but the results were disappointing. *The Battle of Cuddalore* (Gondelour), the last of the actions between Admirals de Suffren and Hughes, is a static, spiritless composition, naively executed.

Painting in Holland also suffered a decline as a result of economic recession. Some Dutch and Flemish artists followed in the footsteps of the van de Veldes and exhibited in England. Jan Verbruggen (1712-1780) painted marine and landscape subjects. He was Master Founder to His Majesty at Woolwich Arsenal, and exhibited *A View of a Town in Holland*, at the Society of Artists in London in 1772. He also did a remarkable series of water-colours, of almost photographic realism, illustrating the process of gun founding at Woolwich. The Rotterdam-born artist Hendrik Kobell (1751-1779) exhibited *A Sea Fight* at the Free Society in 1770, but later returned to Amsterdam. He worked mainly in water-colour.

Towards the end of the eighteenth century marine painters turned to an earlier age for inspiration, and Jan van Os (1744-1808), who remained in Holland, was one of a growing number of artists painting marines in the style of the seventeenth-century Dutch masters.

Johan Tietrich Schoultz (c.1750-1807) is a rare example of a Swedish marine painter. He was an officer in the Swedish naval artillery battalion and a talented artist who recorded the principal actions between Sweden and Russia. His marines are normally panoramic compositions favouring bird's-eye perspective. In terms of colour and treatment of sea and sky, they echo the earliest marines by Bruegel and Vroom. Schoultz's battle scenes are strong on atmosphere but weak on detail, and much of his work is of a stylised nature. He enjoyed the patronage of the Swedish royal family, and fifteen of his paintings are now in the Sjohistoriska Museum.

During the last quarter of the century a revival of interest in marine art in Holland was pioneered by the Dordrecht-born artist Martinus Schouman (1770-1838). He painted dramatic seascapes and naval actions and taught Johannes Christiaan Schotel (1787-1838), also resident in Dordrecht, who encouraged his son Petrus Johannes (1808-1865) to paint marines.

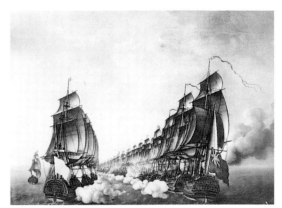

OPPOSITE ABOVE: *Dutch Boats in a Calm*, William Anderson. *A fine example of the artist's 'Dutch style'. At first sight this image could be mistaken for a Dutch marine of the 17th century.*
OPPOSITE BELOW: *Swedish and Russian Fleets engaging in 1789*, Johan Tietrich Schoultz. *A Russian ship is seen exploding. In 1790 Sweden gained the upper hand against the Russians and ended the protracted war at the battle of Svensunnd, 9 July 1790.*
ABOVE: Plate XVII from Vol.1 of *Liber Nauticus*, *drawn by* John Thomas Serres *and aquatinted by Swain and Harraden. It represents a broad-side view of a first rate man-of-war.*
BELOW: *The Battle of Cuddalore*, Capitaine le Marquis de Rossel de Cercy. *This battle (which the French call Gondelour) was the last of the five actions between Admirals de Suffren and Hughes off the east coast of India in the years 1782-1783.*

The Belgian painter Franz Balthazar Solvyns (1760-1824) is an underrated painter of marine subjects, little known today. In 1789, he went to India and sketched, painted and etched Indian subjects. His prints failed to sell and he was forced to return home and find work in the Antwerp docks. A small number of exquisite panel pictures survive, among them the ship portrait of *Charlotte of Chittagong*. Solvyns was a master of light, shade and reflection, and capable of turning a general shipping scene into a visually forthright composition.

In England Serres had several rivals. Richard Paton (1717-1791) was a consistent challenger as a painter of naval actions, but lacked the Frenchman's painterly charm and personal contacts. Some contemporary patrons preferred Paton to Serres, but they were probably biased because Serres was not English. Thomas Mortimer clearly favoured the English artist and his *Director* (1763) included an enthusiastic extended entry on Paton.

Paton enjoyed royal favour, but did not receive a royal appointment. King George III granted him permission to paint the Royal Dockyards but he never finished the project. He exhibited dockyard views of Deptford and Chatham at the Royal Academy. He resigned from the Society of Artists in 1770 after a dispute over the hanging of his *Battle of Finisterre, 1747*.

By the time Paton resigned, England was the major centre for the production of marine painting. The principal painters were Francis Holman, Nicholas Pocock, Robert Dodd, Thomas Whitcombe and Thomas Luny. They all succeeded in making a good living from painting and from the prints made after their work. Art publishers in London set up galleries devoted to the sale of maritime and historic prints. The publisher Robert Bowyer ran a very successful Naval and Historic Gallery in Pall Mall, and commissioned Robert Cleveley and other artists to produce pictures specifically for engraving.

Francis Holman (1729-1784), a prominent painter of naval battles, shipping scenes, and ship portraits has been eclipsed by his famous pupil, Thomas Luny, who was certainly a more versatile and prolific artist. Holman's shipyards, ship portraits showing the vessel broadside on or sometimes in two or three positions, and his general shipping scenes and naval actions are all painted in a straightforward documentary style.

For many years Holman proved elusive to historians. It is now known that he was baptised in 1729. His father was master of the *Happy Return* and the *Anglesey*, but it is not known if his son went to sea. In the 1750s Holman probably worked as a decorative and heraldic painter. He lived in London and exhibited marine pictures at the Free Society of Artists from an address at Bell Dock, Wapping, from 1767 to 1772, and at the Royal Academy from 1774 to his death, which, according to his Will, occurred in 1784. He was a successful painter, and left to his wife Jane a life interest in all his money in public funds and stocks.

One of the best known mariners to become a professional marine painter was Nicholas Pocock (1740-1821). He was born in Bristol and sailed from there to America and elsewhere in merchant ships. He worked for the well-known merchant Richard Champion, who made Bristol porcelain, and commanded his ships *Betsey*, *Minerva* and *Lloyd*. Pocock was largely self-taught and his earliest efforts are known through ships' logs. He included small wash drawings of the ship in each day's entry, noting weather conditions, the nature of the sea, and the condition of the vessel. Some entries also include track charts and occasional drawings of fish and birds.

Pocock sent a painting to the Royal Academy in 1780, but it arrived too late. However, Sir Joshua Reynolds, the first President of the Academy, encouraged him to study the work

OPPOSITE ABOVE: ***Relief of Gibraltar by Earl Howe, 11 October 1782***, Richard Paton. *Part of the English fleet is running towards the straits, with the Franco-Spanish fleet at anchor in Algeciras Bay.*
OPPOSITE BELOW: ***A Fleet of East Indiamen at Sea*** Nicholas Pocock. *Eighteen East Indiamen, under the orders of Captain George Millet in the Hindustan given the order to wear, the sternmost and leeward ships first.*
ABOVE: ***A Dutch Frigate and a Pilot Vessel in a Rough Sea***, Petrus Johannes Schotel. *Petrus painting in a similar style to his father Johannes Christiaan.*
CENTRE: ***'Charlotte of Chittagong' and other Vessels in the River Hoogli***, Franz Balthazar Solvyns. *These snow-rigged craft, with large passenger accommodation, were used by the East India Company as despatch vessels around the coasts and up the great rivers of India.*
BELOW: ***An English Brig with captured American Vessels***, Francis Holman. *This subject has not been identified with a particular incident in the American Revolutionary War. The British vessel in the centre is surrounded by four American prizes, which fly the Union flag over the rebel striped flag.*

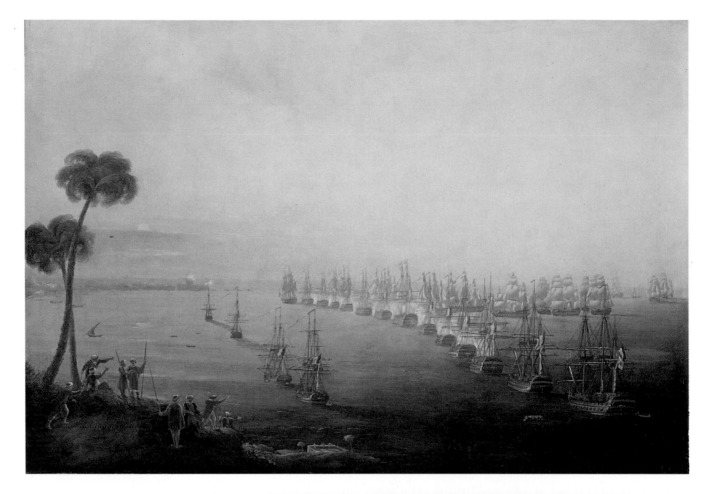

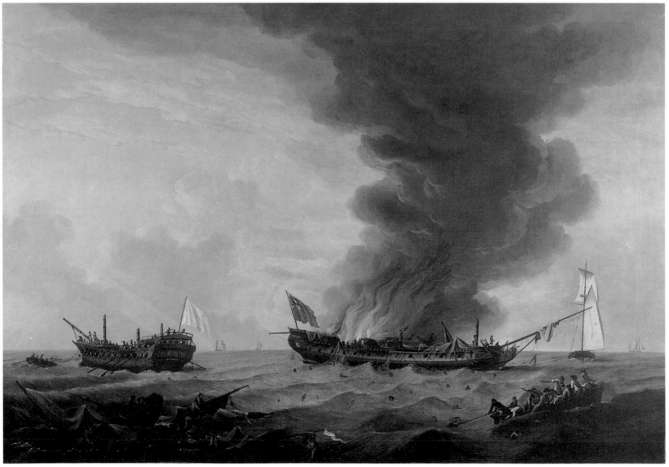

of the van de Veldes, and 'to paint from nature instead of drawing; to carry your palette and pencils to the waterside. This was the practice of Vernet whom I knew in Rome'.

Pocock's *Battle of the Saints, 12 April 1782* was mocked by 'Guido' in the *Painter's Mirror* (May 1783), who criticised the painting as not spirited enough, but fortunately this ill-informed criticism did not mar Pocock's career. He became one of the most successful painters of naval actions and general shipping scenes in oil and water-colour. He was well known in his lifetime for his six oil paintings of Nelson's triumphs for Clarke and McArthur's *Life of Nelson* (1809), including the battles of the Nile (1798), Copenhagen (1801) and Trafalgar (1805). All use a bird's-eye viewpoint in the tradition of the Dutch Masters and closely relate to the *grisailles* of *The First Battle of Schooneveld* by the van de Veldes.

Clarke and McArthur were editors of the *Naval Chronicle*, an illustrated monthly published by Joyce Gold from 1799 to 1818, offering readers naval biographies, history and topical news of the French wars and other subjects, including marine zoology. It was aimed at a naval readership but marine painters collected it. Clarkson Stanfield owned some twenty-one volumes.

Pocock provided numerous drawings of naval actions and harbour scenes for the *Naval Chronicle*, all aquatinted by the in-house team of engravers. He secured several prominent naval commissions and was present during the Battle of the Glorious First of June, 1794, on board the *Pegasus*, a 28-gun frigate. He kept a detailed notebook with pen-and-ink and wash drawings and extensive notes recording the sequence of events, the respective positions of the ships, and the weather conditions. From these records he was able to work up oil paintings. Two of Pocock's sons were artists; William Innes Pocock (1783-1836) was a Lieutenant in the Royal Navy, a prolific sketcher and a marine painter in a similar style to his father.

Naval officer artists were common. As part of their training they were encouraged to make wash drawings recording landfalls and harbours to assist with navigation and to record enemy defences. Among the marine artists who taught these skills, the most famous was the Scottish artist John Christian Schetky. British officers who painted professionally included Lt. Thomas Yates (c.1760-1796) and Lt. William Elliott (fl. 1784-1791). Both exhibited at the Royal Academy competently painted sea battles in a similar style to Dominic Serres.

Robert Dodd (1748-1815) was an uneven artist but what he lacked in artistic talent he made up for in promotional zeal. He not only painted naval actions but engraved them for publication. Much of his output comprises awkward compositions that exhibit little understanding of perspective and are naively painted. His largest picture, *The Battle of the Glorious First of June, 1794*, was painted for an inn, the Half Way House on the Commercial Road in the London docks area, near where he lived

Thomas Luny (1759-1837) is believed to have been a purser in the Royal Navy. He studied under Francis Holman, and his early efforts are sometimes mistaken for his master's work. But he developed his own style, in part derived from Vernet, and produced outstanding marines such as *The Wreck of the 'Dutton' at Plymouth, 26 January 1796*. He copied Vernet's work and painted for numerous patrons including admirals and captains. He also painted pictures after Bakhuizen, the van de Veldes, and Richard Wilson. Most of his work sold for under five pounds so he was prolific and exhibited at all major exhibitions.

Thomas Buttersworth (1768-1842) also had first-hand experience of the Navy. He became a midshipman, was wounded at Minorca and sent home in 1800. He was a full-time painter

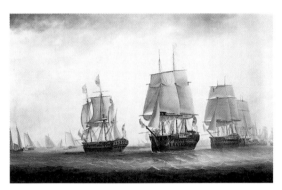

OPPOSITE ABOVE: ***The Battle of the Nile, 1 August 1798***, Nicholas Pocock. *The scene in Aboukir Bay as the British fleet sails in to attack the line of anchored French ships. The inclusion of palm trees and a group of onlookers in oriental dress imparts a picturesque feel.*
OPPOSITE BELOW: ***Action between the 'Quebec' and the 'Surveillante'***, Robert Dodd. *The British ship 'Quebec' is shown on fire; the 'Surveillante' is only marginally less damaged.*
ABOVE: ***From Leghorn towards London in the ship 'Betsey' 1770***, Nicholas Pocock. *Log book recording a voyage aboard the Betsey from Bristol to the Mediterranean.*
BELOW: ***George III in the 'Southampton' reviewing the Fleet off Plymouth, 18 August 1789***, Lieutenant William Elliott. *Royal reviews were a popular subject for marine painters and continue to attract artists today.*

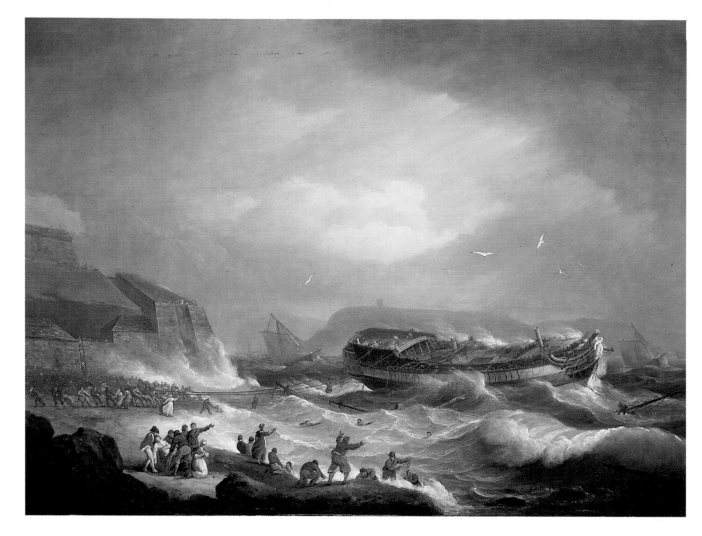

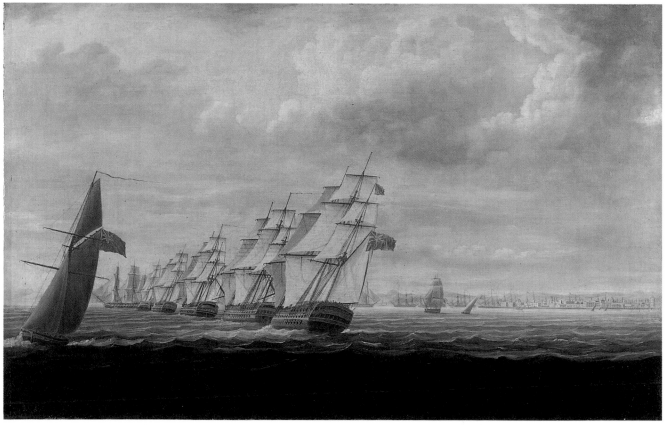

but exhibited only one painting at the Royal Academy. He had a profound understanding of ships but was never an inspired painter. He showed a preference for battle scenes and many of these were based on drawings made on the spot. *The Inshore Blockading Squadron off Cadiz, in 1797*, is a representative example of his work, showing Nelson's ship *Theseus*, the last in line of the five sailing ships, all flying the blue ensign. His son James Edward Buttersworth (1817-1894) painted in a similar style to his father.

Thomas Whitcombe (1763-1824) shared Dodd's business acumen, producing a large body of work for publication, but was a far superior painter, whose finest work has a freshness, crispness and vitality that has greatly attracted him to modern collectors. One of his finest achievements is the fifty-one pictures for Jenkin's *Naval Achievements of Great Britain, from the Year 1793 to 1817*, published in London in 1819. They range from *The Capture of 'La Cléopatre', June 18th, 1793*, to *The Bombardment of Algiers, August 27th 1816*, and were published as hand-coloured aquatints. He painted a wide variety of subjects and excelled at ship portraits, often depicting East Indiamen in two or three positions. The influence of his technically accurate and spirited compositions on ship portraiture continued into the next century.

OPPOSITE ABOVE: **The Wreck of the 'Dutton' at Plymouth, 26 January 1796**, Thomas Luny. *The 'Dutton', an East Indiaman bound for the West Indies with troops aboard, was wrecked during a gale. Thanks to the heroic efforts of Pellew in getting a line aboard all but four persons were saved. Luny's picture is based on Nicholas Pocock's engraved design published in 1796.*
OPPOSITE BELOW: **The inshore blockading Squadron off Cadiz, 17 April 1797**, Thomas Buttersworth. *After the Battle of St. Vincent, the British fleet went to Lisbon to refit and restore, and be reinforced. On the left are six ships of the line. The 'Theseus' with Nelson's blue flag at the mizzen, is the last ship of the line.*
LEFT: **The Cutter 'Mary Ann' and the 'Sylph'**, Thomas Whitcombe. *Whitcombe's marines are reliable visual records of contemporary shipping.*

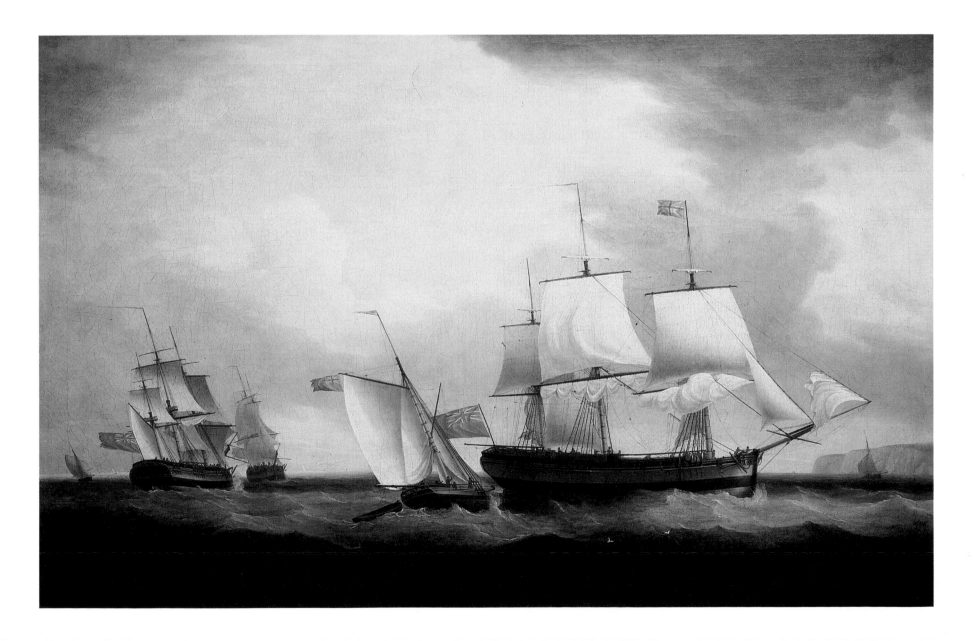

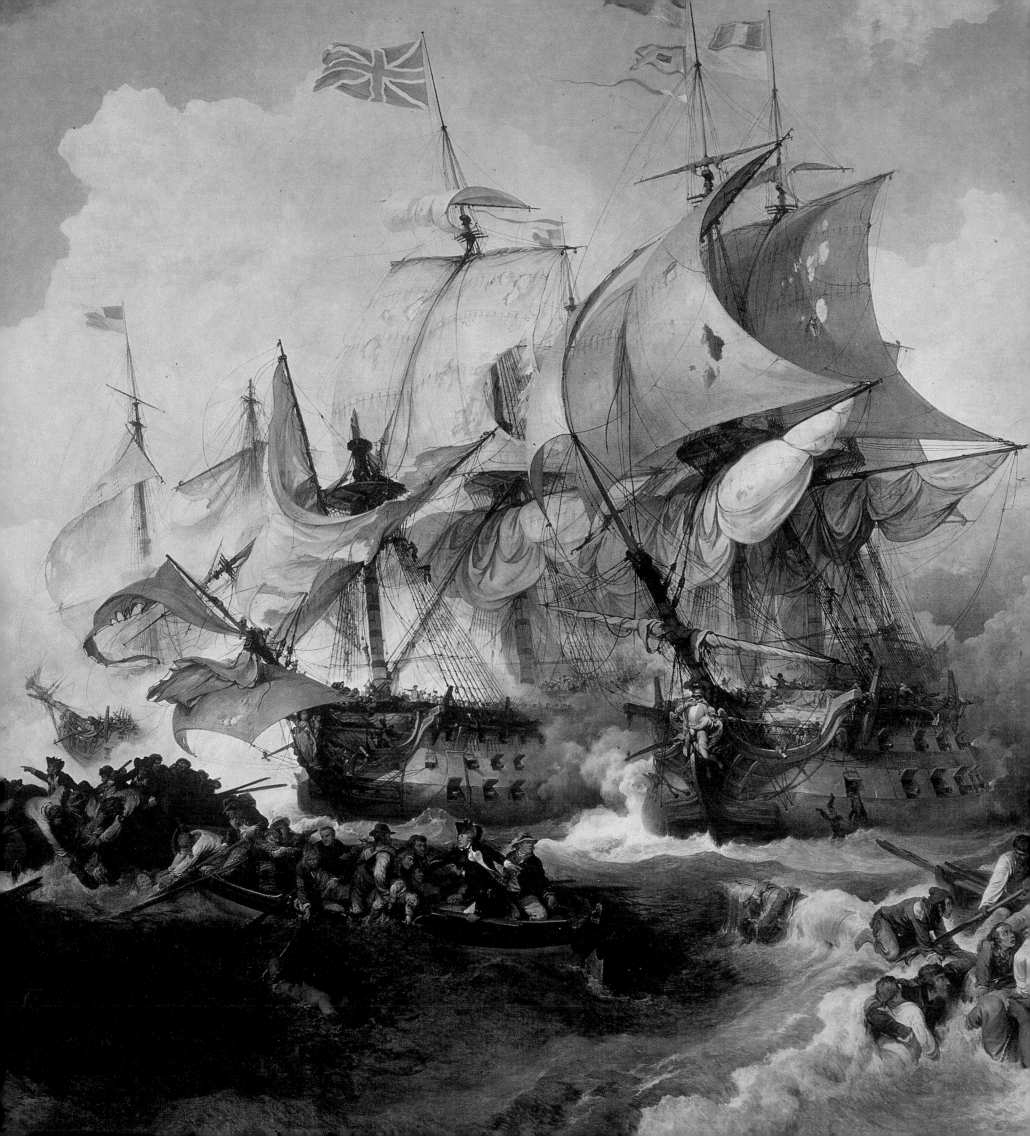

TOWARDS A NEW VISION

For almost two hundred years the seventeenth-century Dutch school of marine painting was the dominant influence on marine art. It combined accurate depictions of ships, seas and skies arranged in harmonious compositions, brought to life by the dramatic use of light and shade, and derived from a detailed study of all aspects of the subject.

This representational style dominated the genre until about 1800, when Philippe-Jacques de Loutherbourg and Joseph Mallord William Turner brought an individual and highly imaginative approach to marine and landscape subjects. An anonymous reviewer writing in the *Morning Post* of May 1797 of de Loutherbourg's *Banditti attacking and robbing Travellers in a Forest in Germany* (exhibited at the Royal Academy in that year) was aware of the emergence of a new expressive style: 'It is evident that this spirited Artist embodies in imagination, what was never seen even in the multifarious presentations of nature'.

De Loutherbourg (1740-1812) was born in Strasbourg. He studied in Paris under Carl van Loo and with Francesco Giuseppe Casanova (1727-1802), a specialist in battle scenes. When he settled in London in 1771 he was already an established artist and founder member of the French Academy, who enjoyed royal patronage. In his marine work he favoured wild coastal scenes, and dramatic and theatrical naval battles, of which the *Battle of the Glorious First of June, 1794* is his *chef-d'oeuvre*. He was invited to England by the celebrated actor-manager David Garrick who employed him as scenic director at the Theatre Royal, Drury Lane. His influence on the development of stage design was profound.

De Loutherbourg's overall artistic aims were more visionary and futuristic. On 26th February 1781, his Eidophusikon, or mechanical theatre, was exhibited at his house in Lisle Street, advertised as 'imitations of Natural Phenomena, represented by Moving Pictures'. The stage was over six feet wide and eight deep but the painted illusion suggested a 'horizon...miles distant'. Reynolds and Gainsborough were among enthusiasts who enjoyed *Storm at Sea* and *Loss of the Halswell Indiaman*, accompanied by simulated sounds of the sea, wind, rain, thunder and lightning. The beautifully modelled and correctly rigged ships were also memorable. Another popular performance was *An Italian Seaport*, notable for its dramatic lighting effects. The Eidophusikon used transparency painting, moving scenic elements and rolling panoramic sky scenes and is recognised as an early ancestor of the cinema.

Theatricality pervades much of de Loutherbourg's painting. It was a style that became immensely influential, and profoundly affected the young Turner, who was friendly with him and admired his work. Turner responded to the Frenchman's passion for dramatic lighting effects and bold handling of paint, but could not match his talent for figure drawing or his facility

OPPOSITE: *Battle of the Glorious First of June, 1794*, detail, Philippe-Jacques de Loutherbourg. *One of the most dramatic interpretations of a sea battle ever painted. The battle was fought off Ushant against a fleet escorting merchant ships bringing relief supplies to France. The British scored a tactical victory, with seven French ships captured, but the convoy escaped.*
ABOVE: *Battle of the Glorious First of June, 1794*, Philippe-Jacques de Loutherbourg. *See above.*
BELOW: *The Battle of Trafalgar, 21 October 1805*, detail, J.M.W. Turner, *see page 93*

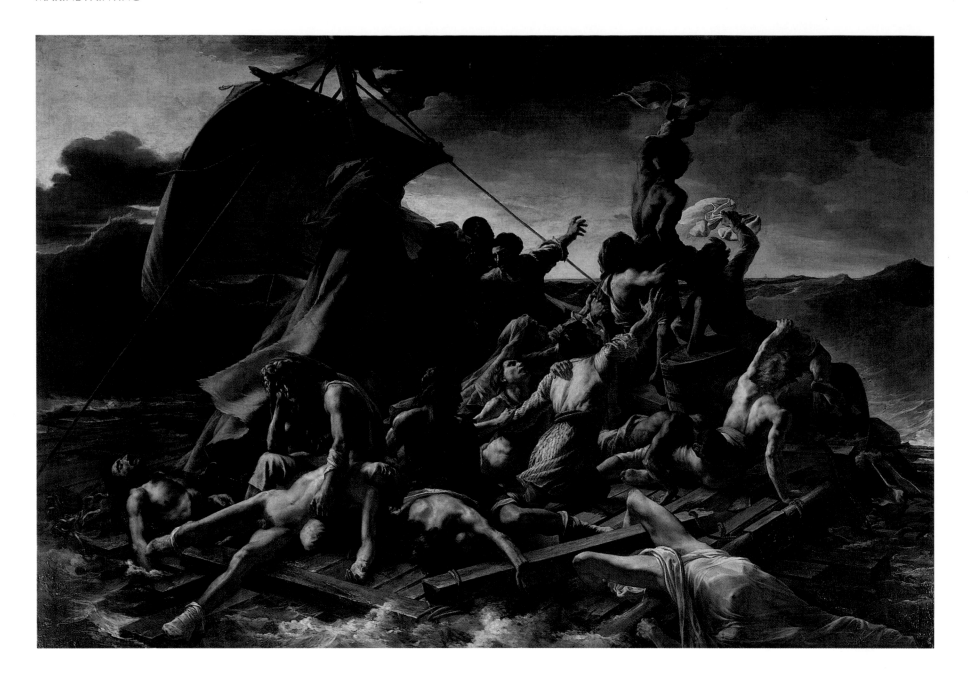

ABOVE: *The Raft of the Medusa*, Jean Louis André Théodore Géricault. *A contemporary subject in Romantic style. In 1816 the French frigate 'La Meduse' sank on her way to Senegal; the raft containing one hundred and fifty survivors was deliberately set adrift. Only fifteen remained alive when the 'Argus', seen on the horizon, came to their rescue. Géricault conveys the anguish of the survivors and the aftermath of horrific scenes of murder and cannibalism.*

for rendering distinctive facial expressions. Turner's individual figures frequently lack credibility or resemble colourful mannequins, despite the drama of his groupings.

In their different ways de Loutherbourg and Turner approached marine painting as imaginative interpreters rather than documentary recorders, placing them at the forefront of the Romantic movement. Romanticism was undeniably a liberating force, encouraging artists to express themselves and their own experiences of the world. Imagination, individuality and inventiveness were held in high esteem, and while subjects still derived from actual events, the range of painting widened to embrace literary and poetic sources. In his fragmented epic *The Fallacies of Hope*, Turner expressed in words what his work sought to achieve. Literary works also encouraged artists to pursue a more imaginative style of painting. One of the most influential was Edmund Burke's *Philosophical Enquiry into the Origin of our Ideas of the Sublime and the Beautiful* (1757). A new language developed in tandem with the movement and reviewers began describing pictures as picturesque, 'terrifick', romantic and sublime.

The demand for illustrated travel books increased rapidly at this time. The allure of visiting unknown places held a special fascination for Romantic artists. The fact that Europe was closed to British travellers during the French Wars of 1793-1815 stimulated its appeal and in parallel interest increased in the scenery of the British Isles, especially its coastline.

Printmaking techniques had improved and from the 1820s steel-engraving increased considerably the number of prints of consistent quality that could be produced, thus bringing down the cost of illustrated publications. De Loutherbourg contributed a selection of coastal views, including Conway Castle, to be aquatinted for John Clarke's *Romantic and Picturesque Scenes of England and Wales* (1805). Turner's numerous prints for publication included *The Ports of England* (1826) and *Rogers' Italy* (1830). William Daniell (1769-1837), an admirer of Turner's work, made the designs for *A Voyage Round Great Britain*, published in parts between 1814 and 1826. In addition, he collaborated with his uncle, Thomas Daniell (1749-1840) on *A Picturesque Voyage to India by way of China, 1810*, which was based on firsthand experience.

ABOVE: *A View of Cape Stephens in Cook Strait, New Zealand, with Waterspout*, William Hodges. *During Cook's second voyage, on 11 May 1773, the search vessel 'Resolution', with Hodges on board, encountered a series of waterspouts, one of which passed within fifty yards of the ship. Hodges painted it some three years later, in a composition highlighting the frailty of man against the immensity of the ocean.*

Géricault's Romantic masterpiece *The Raft of the Medusa*, painted in France in 1819 is a vast canvas portraying the agony of the survivors of the French frigate *La Méduse*, which foundered on her way to Senegal in 1816. It toured England to great critical and popular acclaim.

In Germany, Caspar David Friedrich (1774-1840) was inspired by the literary ideas of the German transcendentalists, and produced exquisitely painted, haunting, atmospheric marines including the *Stages of Life* and *Arctic Shipwreck*. They are not straightforward marine pictures but metaphors with religious, political and social meaning. Friedrich influenced the work of his close friend, Johan Christian Claussen Dahl (1788-1857), who painted stormy coasts and the fjords of his native Norway.

There was a mood of scientific and individual investigation in the second half of the century. The voyages of discovery to the South Seas, the Arctic and Antarctic, led by such famous seafarers as Captain James Cook (1728-1797), were an important focus. Cook commanded three British Admiralty expeditions that literally changed man's comprehension of the world. He discovered and charted New Zealand, charted the eastern coast of Australia, and explored more of the Pacific than anyone else. An official artist was employed on each voyage to record coastal profiles, topographical views and other subjects. Cook's violent death during his third voyage made him an instant, if temperamentally unlikely, Romantic hero.

William Hodges (1744-1797) was appointed to the second expedition. He learned to draw at William Shipley's Art School, and trained as a landscape painter under Richard Wilson (c.1713-1782). He also worked briefly as a scene-painter. Hodges made on-the-spot drawings and oil sketches from which he worked up larger oil paintings that were exhibited at the Royal Academy in 1776 and 1777. Some of his designs were engraved for Captain Cook's *A Voyage Towards the South Pole and Around the World 1772-1775*, published in 1777.

Hodges and John Webber (1752-1793), the Admiralty draughtsman on Cook's third voyage, contributed to a unique 'speaking pantomime' called *Omai, or a Trip Around the World*, based on Cook's voyages, with 'Scenery, Machines, Dresses &c' designed and invented by de Loutherbourg, performed at the Theatre Royal, Drury Lane in 1785. Webber advised on native costume and almost certainly painted some of the backdrops. Hodges' drawings, and engravings after his designs, were also consulted.

Ironically, contemporary newspaper reviews ridiculed Hodges' work comparing him to a scene-painter. One of his most powerful pictures *A View of Cape Stephens in Cook's Straits with Waterspout*, which was exhibited at the Royal Academy in 1777, was a re-working of Richard Wilson's *Ceyx and Alcyone* of 1768, in turn inspired by the stormy seascapes of Vernet and Gaspar Poussin's (1615-1675) great sea piece *Jonah and the Whale* but the critics loathed his vivid colours, and his handling of paint was described by one wit as: 'patch'd so thick, with various colours almost make one sick'. Hodges was ahead of his time in his selection of a vibrant palette, his bold handling of paint and dramatic lighting effects. A decade later Turner, and to a lesser extent de Loutherbourg, received similar abuse.

The earliest drawings of J.M.W. Turner (1775-1851) were sold from his father's barber shop in Covent Garden, an inauspicious beginning for an artist who would excel as a topographer, landscapist, and illustrator, and was the creator of some of the most original, controversial and stimulating of all marine paintings. His *Fighting Temeraire* is probably the best known of all images of maritime art and, according to Ruskin, Turner's greatest champion, the best

OPPOSITE ABOVE: ***Arctic Shipwreck***, Caspar David Friedrich. *This powerful image portraying a ship locked in the arctic ice floes was almost certainly inspired by William Parry's first arctic expedition of 1819-1820. The ships 'Hecla' and 'Griper' became locked in the ice. Friedrich captures the luminous light and the menace of the unforgiving arctic climate.*

OPPOSITE BELOW: ***A Party from the 'Resolution' shooting Sea-horses (walruses)***, John Webber. *Webber accompanied Cook on his third voyage. The 'Resolution' reached the northernmost point of latitude before the ice forced them to retreat. Fresh food was scarce and parties regularly went out to shoot walruses.*

ABOVE: ***Salcombe, Devon***. *Hand-coloured aquatint from 'A Voyage Round Great Britain', published between 1814 and 1826. The views were designed and engraved by* William Daniell *with accompanying text by Richard Ayton. Illustrated travel books focusing on the British coast and landscape enjoyed great popularity during the early 19th century.*

BELOW: ***Fishermen at Sea***, J.M.W.Turner. *Almost certainly the painting exhibited at the Royal Academy in 1796. In his treatment of the sea Turner acknowledges a debt to Claude-Joseph Vernet.*

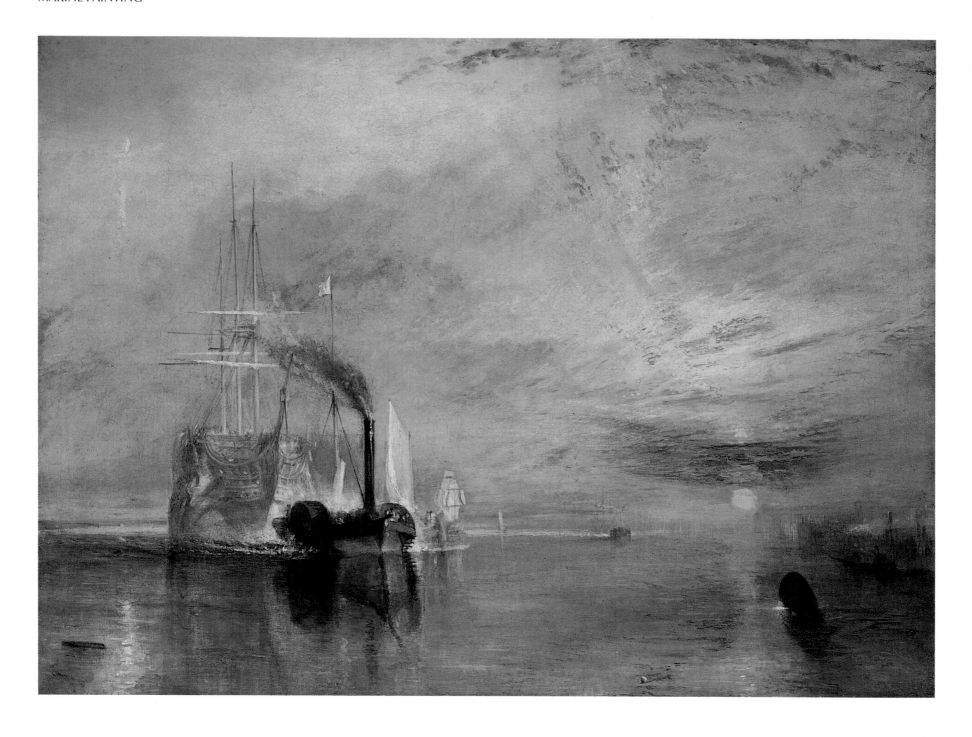

ABOVE: *The Fighting 'Temeraire', tugged to her Last Berth to be broken up, 1838*, J.M.W.Turner. *The 'Temeraire', named after a French ship, was a ship of the line of 98 guns. Ruskin thought the picture one of the most perfect of the artist's late works. Turner had made on-the-spot sketches but transposed the funnel and foremast of the tug for artistic effect.*

picture he painted. His first marine painting, *Fishermen at Sea*, exhibited at the Royal Academy in 1796, was partly indebted to Vernet, particularly in the handling of the sea, but also to Joseph Wright of Derby (1734-1797) in his portrayal of light. Turner copied compositions by Richard Wilson and Claude Lorraine, bequeathing two of his paintings, *Sun rising through Vapour; Fishermen cleaning and selling Fish* and *Dido building Carthage; or the Rise of the Carthaginian Empire* to the National Gallery, London, to hang alongside two paintings by Claude.

The seventeenth-century Dutch school was a major influence on Turner. He made five visits to Holland and filled his Dort sketchbook with studies of Dutch craft. Four of a series of Dutch historical marines he produced in the 1830s depicted subjects of Admiral van Tromp, the great Commander killed in 1653. Turner also copied and adapted the van de Veldes' designs, although he took liberties with the representation of shipping and the sea. He was

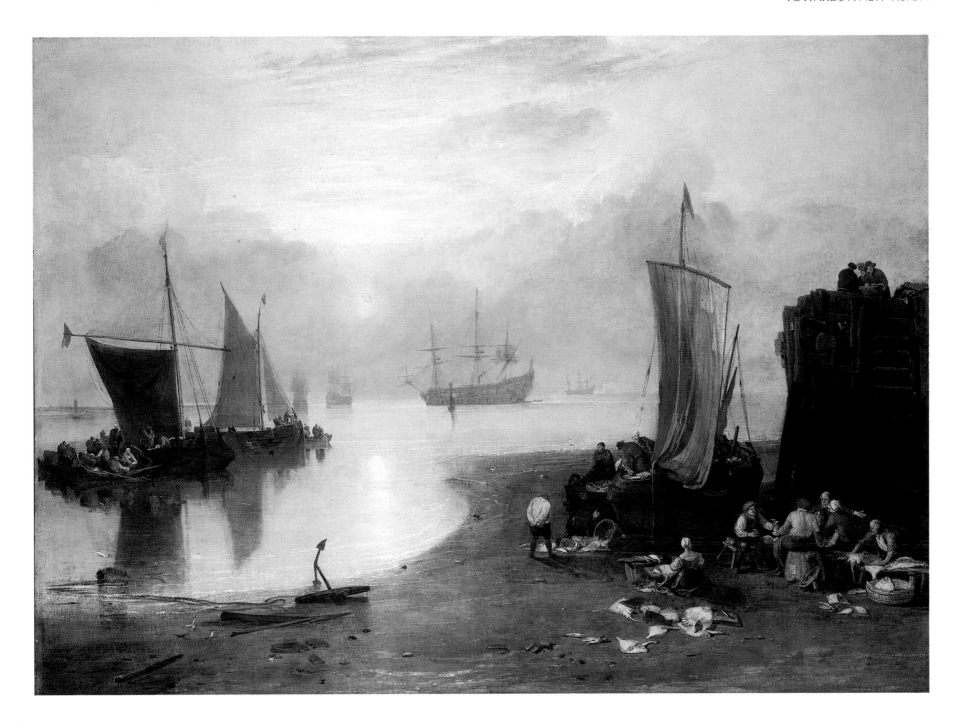

largely preoccupied with art itself as a means of expressing individual emotion and experience. Despite his traditional training at the Royal Academy Schools, and encouragement from the Society of Arts who awarded him the 'Greater Silver Pallet' for landscape drawing in 1793, his mature work was invariably metaphorical and his depictions of ships and sea largely symbolic. Contemporary critics were divided on the wisdom of his approach. Some, like A.P. of the *Morning Post* (5 May 1797) who reviewed *Fishermen coming ashore at Sunset, previous to a Gale* thought him a genius, and appreciated his original approach: '...he seems to view nature and her operations with peculiar vision, and that singularity of perception so adroit, that it enables him to give a transparency and modulation to the sea, more perfect than is usually seen on canvas - he has a grace and boldness in the disposition of his tints and handling which sweetly deceive the sense; and we are induced to approve him the more, as all our marine Painters

ABOVE: ***Sun rising through Vapour; Fishermen cleaning and selling Fish***, J.M.W.Turner. *There are preliminary studies for this picture in Turner's 'Calais Pier' sketchbook. Fred Bachrach has identified various sources. The becalmed sailing craft are reminiscent of van de Capelle; the ship of the line in the centre is a common motif of the van de Veldes. The rustic figure group on the shore derives from David Teniers or perhaps van Ostade. The light is Claudian.*

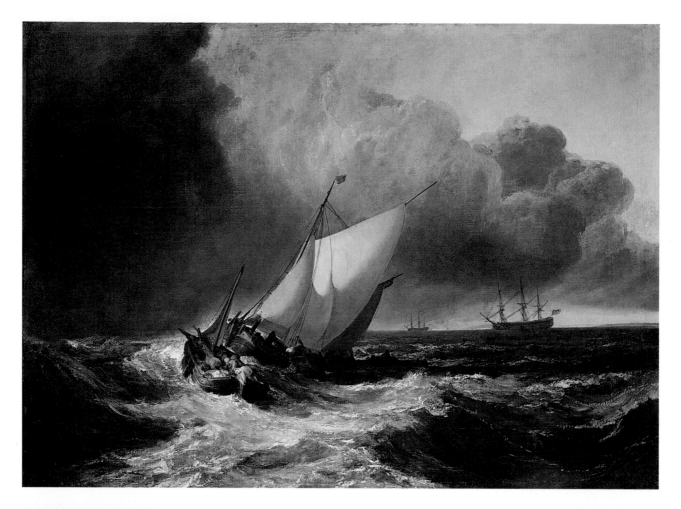

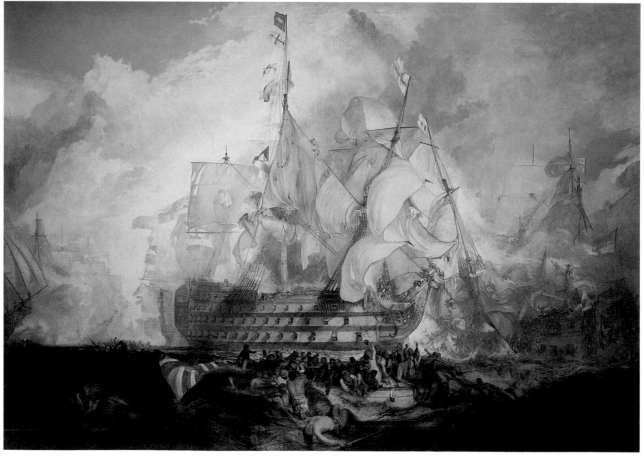

have too servilely followed the steps of each other, and given us Pictures more like japanned tea-boards, with ships and boats on a smooth and glossy surface, than adequate representation of that inconstant element'.

Others were less enthusiastic. They dismissed his draughtsmanship as carelessness and he was accused of negligence and affectation. When *Dutch boats in a Gale; Fishermen endeavouring to put their Fish on Board* was commissioned by Francis Egerton, Duke of Bridgewater, as a companion piece to Willem van de Velde the Younger's *A Rising Gale*, Turner received a scathing review from the critic of the *Porcupine* (7 May 1801).

At twenty-seven, Turner was elected a full member of the Royal Academy, still the youngest to achieve this honour, and five years later was elected its Professor of Perspective. His critics remained unrelenting. *Fishermen upon a Lee Shore in Squally Weather,* one of eight Royal Academy exhibits in 1802, was attacked by the *True Briton* of 4 May 1802 as an unrealistic representation of nature: 'He seems to be always attempting something extraordinary, bold, and sublime, and therefore, generally leaves poor Nature behind him...'.

These contemporary criticisms highlight the fundamental problem of defining marine painting. The van de Veldes and Turner represent two distinct branches of the genre, the documentary and the imaginative. Turner attempted to marry the two branches in the *Battle of Trafalgar* (1805) commissioned by King George IV to hang in St. James's Palace as a companion to de Loutherbourg's *Glorious First of June, 1794,* and to complement two other battle subjects by George Jones, who was one of Turner's closest friends. Painted in 1823-1824, this sea battle was his largest painting in oils, and one of his most controversial compositions. The commission was highly prestigious, and Turner made an effort to represent the nautical details with appropriate accuracy. He employed John Christian Schetky to make drawings of Nelson's flagship *Victory*, although he had himself already sketched the ship in Portsmouth when he witnessed her return from the battle. But despite his efforts the naval critics found the picture wanting in nautical detail and it received almost universal condemnation. In 1829 the King gave the painting and its companion to Greenwich Hospital.

In 1837 the Duke of Bridgewater lent Turner's *Dutch Boats in a Gale* and van de Velde's *A Rising Gale* to a special exhibition at the British Institution in London, allowing visitors and critics to make up their own minds on the relative merits of the companion pictures. The result was a virtual knock-out in van de Velde's favour but Turner was not without his supporters, who included the younger artists Augustus Wall Callcott and Clarkson Stanfield. His most vociferous ally, John Ruskin, was one of the most influential, and contradictory, art critics of the Victorian era.

Ruskin's *Modern Painters: Their Superiority in the Art of Landscape Painting to all the Ancient Masters proved by Examples of the True, the Beautiful, and the Intellectual from the Works of Modern Artists, especially from those of J.M.W. Turner, Esq., R.A.'* (1843) is in part a muddled and jingoistic platform attempting to prove the superiority of English artists in general and Turner in particular. But it was widely read. An extended section, 'Of Truth of Water', was devoted to marine painting; it contains some of the most eccentric criticism ever published.

Turner's *Dutch Boats in a Gale* was defended by Ruskin, who claimed that it was '...free from the Dutch infection...', although the subject and composition clearly derived from the Dutch tradition. Ruskin probably had in mind mediocre followers such as Monamy Swaine, and William

OPPOSITE ABOVE: ***Dutch Boats in a Gale: Fishermen endeavouring to put their Fish on Board*** (the Bridgewater Seapiece) , J.M.W. Turner. *Painted as a pendant to van de Velde the Younger's 'A Rising Gale', although the earlier picture is smaller. Turner received 250.guineas for this commission.*
OPPOSITE BELOW: ***The Battle of Trafalgar, 21 October 1805***, J.M.W. Turner. *Nelson's greatest and last naval action. The 'Victory' takes pride of place in the centre; to her right is the stricken 'Redoubtable', the ship from which a French sniper shot Nelson. A controversial image combining events that occurred hours apart.*
ABOVE: ***Gust of Wind***, Elisha Kirkall, *after Willem van de Velde the Younger. This is probably the '..green mezzotinto - an upright' that moved Turner to exclaim: 'Ah! That made me a painter.'*
BELOW: ***A Rising Gale***, Willem van de Velde the Younger. *This painting was the inspiration for Turner's 'Dutch Boats in a Gale'.*

John Huggins (1781-1845). He levelled scathing criticism at Huggins, who spent several years at sea with the East India Company before turning to marine painting full time.

Ruskin's scorn resulted in part from the unflattering comparisons seamen made in favour of Huggins over Turner. It has recently emerged that Turner himself found Huggins' pictures of whale-ships for their joint patron the whale-oil merchant Elhanan Bicknell, a useful source for his own powerful compositions. Huggins specialised in ship portraits, particularly of East Indiamen, general shipping scenes, sea battles and occasional public events such as George IV's voyage to Dublin in 1821 on board the *Lightning*.

John Constable (1776-1837) had first-hand seafaring experience on board an East Indiaman. In April 1803 he made a trip on the *Coutts*, where he '..was much employed in making drawings of ships in all situations'. The wash drawings he produced were reminiscent of the late work of van de Velde the Younger. Constable openly acknowledged the importance and influence of the Dutch tradition. He had met Turner at one of the Royal Academy's varnishing days in 1832. His *Opening of Waterloo Bridge* had been hung next to Turner's 'grey sea piece' *Helvoetsluys - the City of Utrecht, 64, going to sea*.

On balance Constable's picture received favourable reviews although his use of a palette knife rather than a brush did not go unnoticed. He called the picture his 'Harlequin's Jacket', a reference to the vibrant palette. Some critics thought it unfinished. The *Morning Chronicle* ridiculed his technique: '..if any plasterers were required, he might have been better employed in the erection of the bridge itself than in painting the subject'.

Constable was trained at the Royal Academy Schools. He copied Poussin, Claude and Salomon van Ruysdael. He approached painting as a science, making numerous sketches and drawings inscribed with the time of day, climatic conditions, and other data as references for creating paintings. But he pursued his own technique. His reputation as a marine artist rests on a handful of finished oil paintings of which *Brighton: Marine Parade and Chain Pier*, now in the Tate Gallery, London, is the best-known example. He produced a larger body of oil sketches of marines, mostly coastal subjects including *Shipping on the Orwell* and *Brighton Beach with Colliers*. These sketches are delightful atmospheric works. His spontaneous handling of pure unmixed paints and free brushwork convey an impression of the subject that anticipates the work of Eugène Boudin and the French Impressionists.

During the 1820s Constable's work was becoming well known abroad, and he exhibited at the French Salon with two other marine artists: A.V. Copley Fielding (1787-1855), who painted mostly in water-colours, and the francophile Richard Parkes Bonington (1802-1828) who specialised almost exclusively in highly atmospheric beach and shore scenes of northern France and whose crisp colour, lively handling of paint, and perfectly balanced compositions rank him as one of the most gifted, but sadly short lived, of all coastal painters. David Cox (1783-1859) shared Bonington's and Constable's fascination with the moods of nature. His beach scenes of Rhyl Sands in water-colour and oil sketches painted between 1854 and 1855, in their direct and spontaneous handling of paint are also precursors of the work of Boudin and the Impressionists. Constable and Bonington were certainly influential in the development of French landscape and marine painting.

Like Constable, the Norwich School, including John Crome (1768-1821), its founder, Robert Ladbrooke (1769-1842), John Berney Crome (1794-1842) and Joseph Stannard (1797-1830)

OPPOSITE ABOVE: *King George IV aboard the Steam Mail Packet 'Lightning', 11 August 1821*, William John Huggins. *The scene is off Holyhead where the sailing yacht 'Royal George' called with the King on board, on her way to Dublin. The wind being contrary, the King transferred to the new steam packet 'Lightning'.*
OPPOSITE BELOW: *Whitehall Stairs, June 18, 1817*, also known as *The Opening of Waterloo Bridge*, John Constable. *This picture was exhibited at the Royal Academy in 1832. It inspired Turner to re-touch his painting that hung nearby.*
ABOVE: *Fishermen upon a Lee Shore in Squally Weather*, J.M.W.Turner. *On 6 May the Star wrote: 'The drawing is spirited, the general touch masterly and the distribution of light and shade very effective, but the water has a stony appearance, and the colouring of the picture is cold and even dirty.'*

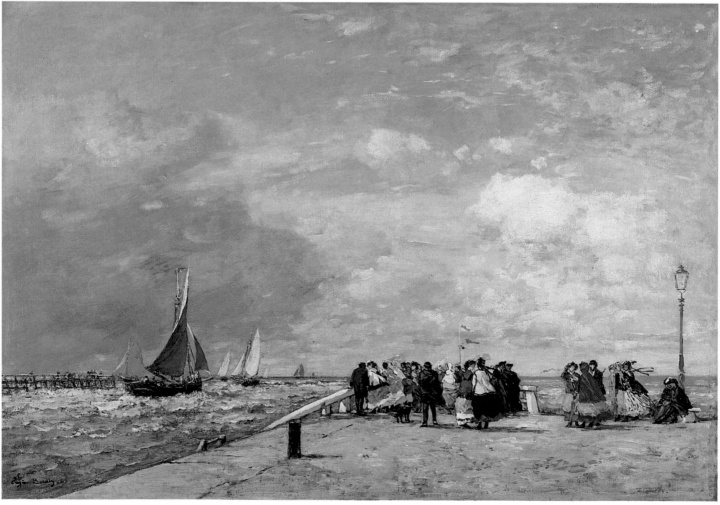

were all indebted to the compositions of the Dutch masters as can be seen in the expanse of sky, the attention to climatic conditions and cloud formations, the eye for nautical detail and the casual arrangement of figures in John Crome's *Yarmouth Jetty* and *The Fishmarket, Boulogne* or Ladbrooke's *Mackerel Market on the Beach at Yarmouth*. However, they were less concerned with views of shipping at sea and focused on maritime activity around the East Anglian coast.

Eugène Boudin (1824-1898) was one of the earliest to respond to Constable's painting. He had limited nautical experience and was largely self-taught but produced exceptional pictures of windswept beach scenes with fashionably dressed people. From an early age he was fascinated with the seashore and ships but in his mature work he was preoccupied with capturing movement and vibrancy.

In 1844 he established a stationery business in Le Havre selling artists' canvases and thus came into contact with some of the leading painters of the day, including Thomas Couture, (1832-1883), Constant Troyon, Jean-François Millet and Louis-Gabriel-Eugène Isabey (1803-1886), who encouraged him to paint beach scenes. In the 1850s he met Claude Monet (1840-1926), who was then known only for his caricatures. Boudin persuaded the embryonic and initially reluctant Monet to paint in the open air at Rouelles. He had a remarkable capacity for friendship and maintained close relationships with Monet, Charles-François Daubigny (1817-1878), Gustave Courbet (1819-1877) and the Dutch artist Johan Barthold Jongkind (1819-1891), who encouraged him to apply paint in a freer style to maintain the spirit and spontaneity of a rough sketch.

At the first Impressionist exhibition in 1874 the critics tried to come to terms with the broken brushwork and the radiant colours and light. But it was not just the technique of the Impressionists that baffled and outraged viewers. Many of the artists worked out of doors, and their subjects, which included picnics and prostitutes, ports, harbours, river scenes and railway stations, encompassed all aspects of modern life, thus challenging what was traditionally acknowledged as appropriate for painting. The Impressionists' experimentation with colour and the play of light on the surface of objects aimed at a new realism. It offered exciting possibilities for marine painters but the renewed emphasis on artistic technique and experimentation was not conducive to the accurate portrayal of ships.

Boudin was also acquainted with the American artist James Abbott McNeill Whistler (1834-1903). Before leaving for Europe, Whistler had already developed his celebrated etching skills working for the drawing division of the United States Coast and Geodetic Survey in Washington DC. In the summer of 1865, Boudin, Whistler, and Courbet worked together at Trouville. Whistler painted coastal sea pieces, devoid of shipping, with only the barest reference to human existence, inspired by the work of Courbet and executed in a similar realist style. They are among the most dynamic and powerful of all coastal marines.

Marine pictures focusing on the sea as the main subject of the picture became popular in the Victorian era. John Brett (1830-1902) and Henry Moore (1831-1895) were among the finest exponents. Almost every major Victorian collection had an example of their work.

When the Franco-Prussian War broke out in July 1870, Whistler was resident in London and other artists were encouraged to settle in England, including Monet and Camille Pissarro. All found inspiration in the Thames. Whistler published his *Sixteen Etchings of Scenes on the Thames* in 1871, and began painting luminous and atmospheric river scenes, called *Nocturnes*.

OPPOSITE ABOVE: ***Brighton Beach, with Colliers, 19 July 1824***, John Constable. *A delightful spontaneous sketch and one that is often cited as anticipating the work of Boudin and the Impressionists. But during Constable's lifetime his sketches were not generally available for study.*
OPPOSITE BELOW: ***The Pier at Trouville, 1869***, Eugène Boudin. *Boudin's atmospheric images of the seaside are remarkably convincing in their portrayal of climatic conditions. Here is his impression of a windy day and its effect on the sea and on the fashionably-attired people holding on to their hats.*
ABOVE: ***The Coast of Picardy***, Richard Parkes Bonington. *Bonington excelled at seashore pictures with beached vessels and figures. His 'Sea Piece', also in the Wallace Collection, is a rare example of a marine portraying vessels at sea.*
BELOW: ***Yarmouth Jetty***, John Crome. *John Crome is generally recognised as the founder of the Norwich School. Many of his compositions were inspired by the 17th-century Dutch painters.*

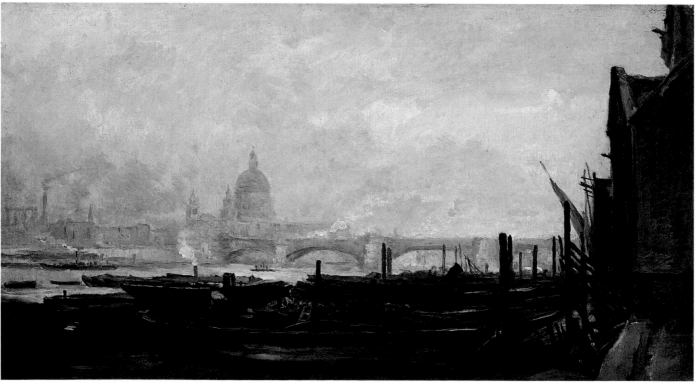

Monet and Pissarro painted various views on the upper reaches, including the Port of London. They visited museums and admired the work of Turner, Constable and John Crome although Pissarro later claimed that they had 'no understanding of the analysis of shadow, which in Turner's painting is simply used as an effect, a mere absence of light'.

An aged and outraged Ruskin publicly attacked Whistler's *Nocturne in Black and Gold: The Falling Rocket*, exhibited at the Grosvenor Gallery in 1877, accusing the artist of '..flinging a pot of paint in the public's face'. Why he took such offence is a mystery. The ensuing court case ruled in Whistler's favour, but awarded him derisory damages of a farthing and no costs.

The court ordered other paintings by the artist to be produced as evidence, including *Nocturne: Blue and Gold - Old Battersea Bridge, 1872-1873*. This powerful and harmoniously balanced composition derives from the Japanese woodcut prints of Hiroshige. The Attorney-General clearly had doubts about the picture. Whistler explained: 'As to what the picture represents, that depends upon who looks at it. To some persons it may represent all that I intended; to others it may represent nothing.' He stated categorically that the painting was not 'a correct portrait of the bridge, but only a painting of a moonlight scene'.

Whistler called his paintings symphonies, arrangements, and harmonies, consciously comparing them to music to underline their independence from any narrative meaning. He was adamant that 'Art should be independent of all clap-trap, should stand alone, and appeal to the artistic sense of eye or ear...'. He was not interested in imitation, and was vociferously opposed to all documentary painting. He believed that if a patron wanted imitation, he would do better to commission a photographer. Other artists followed his lead.

Whistler's compatriots developed their own school of marine painting with the assistance of English artists who settled in America. American artists travelled extensively in Europe and worked in London. Washington Allston (1779-1843), one of the first to respond to the Romanticism of de Loutherbourg and Turner, returned to America early in the century and was instrumental in breaking down the traditional accepted notions of marine painting as a documentary record. Like Whistler, he inspired successive generations of marine painters to explore creative avenues of expression.

OPPOSITE ABOVE: ***Impression: Sunrise, 1872***, Claude Monet. *Perhaps the most famous marine image in the world. Monet's marine painting gave rise to the name of the artists who first exhibited together in 1874.*
OPPOSITE BELOW: ***St. Paul's from the Surrey side***, Charles-François Daubigny. *In the foreground men are unloading sacks from barges. Some critics see a deliberate contrast of the dark colours of the 'materiality of the world of industry' with the lighter background featuring St. Paul's, 'a symbol of higher values'.*
LEFT: ***Britannia's Realm***, John Brett. *After a Pre-Raphaelite phase producing carefully observed and detailed pictures including 'The Stonebreaker', and 'Val d'Aosta', Brett specialised in rocky coastal scenes and images of the open sea characterised by the absence of shipping or other incident.*
ABOVE: ***Wapping***, James Abbott McNeill Whistler. *The background scene of spars, masts, and sails brings the picture to life. But the main focus of the picture is the relationship between the three figures. Robin Spencer has suggested that they are a prostitute, a pimp and a prospective client.*
BELOW: ***Nocturne: Blue and Gold - Old Battersea Bridge***, James Abbott McNeill Whistler. *Produced as evidence in the celebrated Whistler versus Ruskin court case, the elements of this painting derive from various woodcuts by Hiroshige.*

99

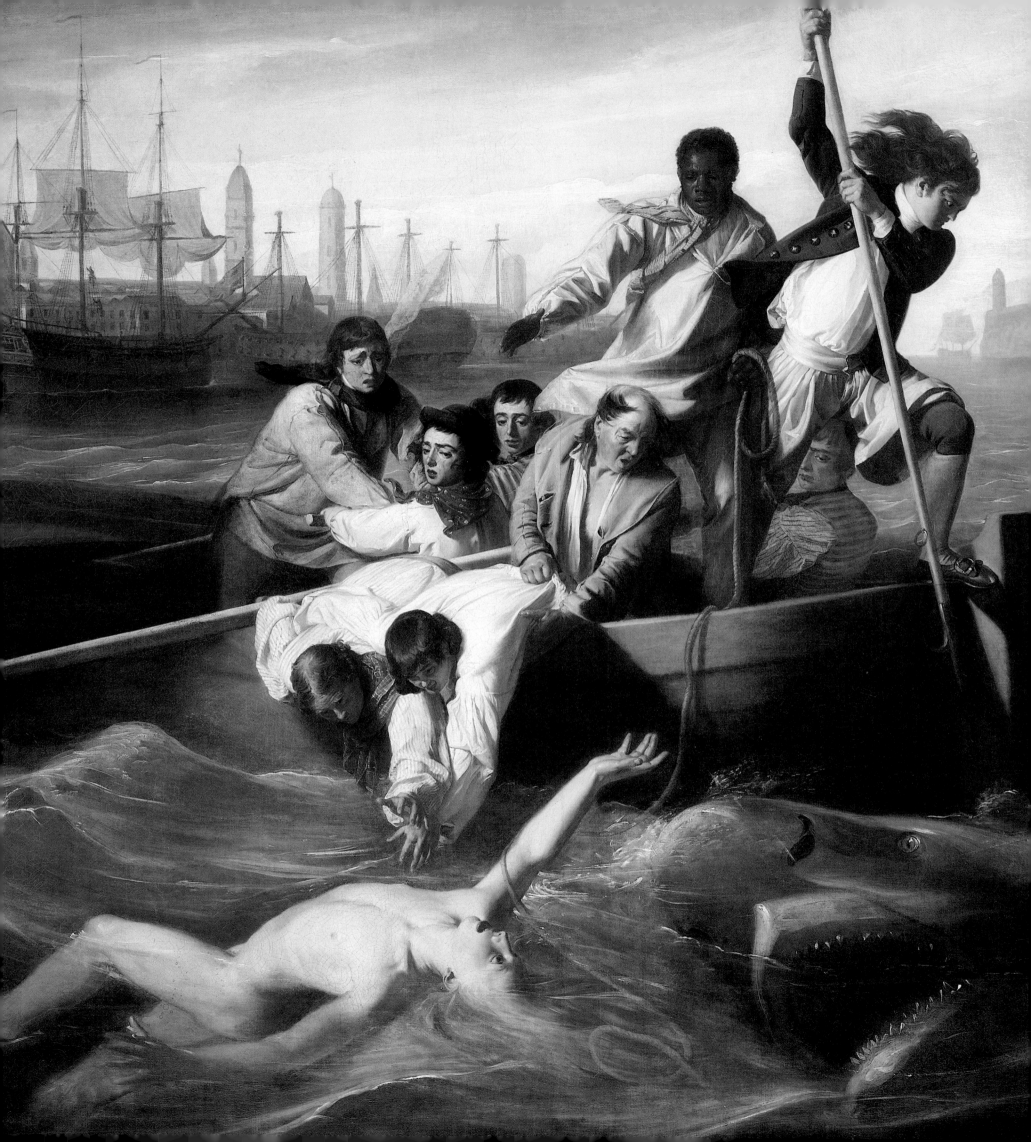

THE BIRTH OF AMERICAN MARINE PAINTING

Benjamin West (1738-1820) was the first significant link in the long and fruitful exchange of artistic talent across the Atlantic. He specialised in portrait, biblical, mythological and history subjects, and in the last category painted some of the most unconventional marine subjects, including *The Destruction of the French Fleet at La Hogue, 1692*.

The Death of General Wolfe, 1759 is West's masterpiece, and represents a watershed in the development of history painting. West did not dress his figures in antique costume, as was the tradition, but portrayed them in contemporary dress. Their dynamic poses, dramatic gestures, and restrained emotion evoke classical sources and place West at the forefront of Neoclassicism. His choice of focus on the death of Wolfe surrounded by his officers was novel, and elevated the picture from mere reportage to a heroic depiction of one of England's greatest soldiers. He used the format again for *The Death of Nelson, 1805* painted in 1808.

West was born in Springfield, Pennsylvania. His first painting lessons were from the English portrait and theatrical painter, William Williams (fl. 1758-1797) but he was largely self-taught, firmly believing in the supremacy of history painting. After studying in Italy, where he was influenced by Raphael, Guido Reni and Nicholas Poussin, he settled in London in 1763. In 1772 he was appointed Historical Painter to King George III, and in 1792 succeeded Sir Joshua Reynolds as president of the Royal Academy, beating de Loutherbourg in the final vote. He was a perceptive critic remembered for his advice to Constable: 'Always remember, Sir, that light and shadow never stand still.'

West was a successful painter and numerous prints were published after his work. His *Death of Wolfe*, exhibited at the Royal Academy in 1771, was purchased by Lord Grosvenor for £400. It was engraved and by 1790 had reputedly earned John Boydell, the publisher and artistic-patron, the sum of fifteen thousand pounds. West's studio in London became a popular attraction and he actively encouraged young American artists who left America at the time of the Revolutionary Wars including Copley, who arrived in England in 1774.

John Singleton Copley (1738-1815) was largely self-taught although he studied in Europe. He was a superb portraitist and painted many naval officers, although his reputation in England was made with a marine subject cleverly designed to attract public notice. *Brook Watson and the Shark* was commissioned by Watson as a reminder of a near fatal attack in Havana harbour when he was fourteen years old. Copley used engravings as a source for background details. The dramatic yet restrained tension of the picture, in keeping with neoclassical style, amplified the horror. Copley's picture excited and shocked the public, and inspired Winslow Homer's *The Gulf Stream* more than a century later.

OPPOSITE: ***Brook Watson and the Shark***, detail, John Singleton Copley. *Brook Watson lost a leg in the attack but went on to become Lord Mayor of London. There are versions of this picture in Boston, Washington, and Detroit.*
ABOVE: ***The Death of Nelson, 21 October, 1805***, Benjamin West. *Nelson is shown in the cockpit of his flagship 'Victory'. Exhibited at the Royal Academy in 1808, this picture was used as an illustration for Clarke and McArthur's biography of Lord Nelson (1809).*
BELOW: ***The Death of Wolfe, 1759***, after Benjamin West, engraved by William Woollett. *West's depiction of the dying Wolfe surrounded by his officers was re-used in his oil painting of the death of Nelson.*

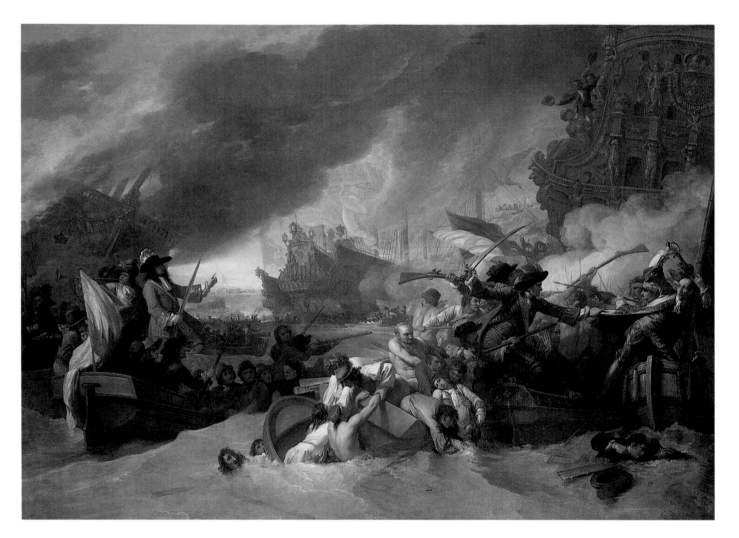

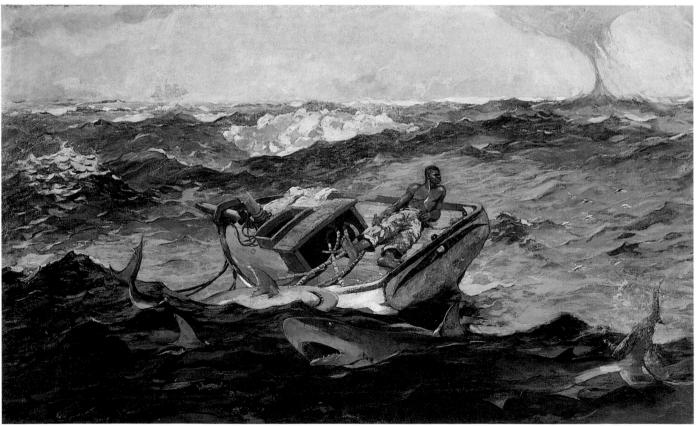

In 1783 the Corporation of London commissioned Copley to paint a large marine subject, *The Defeat of the Floating Batteries at Gibraltar, September 1782* to commemorate the British repulse of the Spanish at the end of the American War. Copley had beaten West to the commission. He laid out the design on a colossal canvas 18 by 25 feet, and produced numerous studies and drawings. His studio was described by the *Morning Post* as 'literally laying siege to Gibraltar, as he had models not only of the fortress, but of gun boats, ship-tackle, men, and every instrument of destruction arranged before him in all the stages of his progress'. The canvas had to be manipulated by means of a roller, and Copley painted from a raised platform.

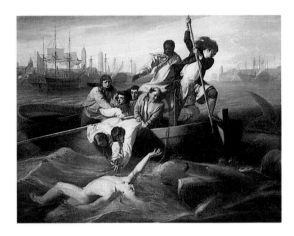

Copley's concern for accuracy prompted him to visit Germany to make oil sketches of senior Hanoverian officers. The group in the foreground was not part of Copley's original design but was added as a tribute to the garrison. He also decided to include the arrival of Admiral Lord Howe's relief fleet in a separate painting, and commissioned Dominic Serres to paint this *predella*. In 1791 both pictures were exhibited in a 'magnificent oriental tent' erected in Green Park, London. An estimated 60,000 people viewed them. The reception was lukewarm but Copley made a great deal of money from the admissions.

The changes to the initial design affected the composition. The original clarity was lost and the painting appeared overcrowded and lacking in cohesion. Contemporary critics were unhappy with the lack of perspective on the left-hand side and the eight years it had taken to complete. It was finally hung in the Common Council Chamber of the Guildhall in 1794.

Copley had few pupils as he preferred to work alone but Mather Brown (1761-1831), who left Boston for London in 1781, worked for him briefly. Brown later became a pupil of West who had greater influence on him. Brown's large-scale canvas *Lord Howe on the Deck of the 'Queen Charlotte'*, painted and exhibited in 1795, combined West's posing and gesturing figures with something of de Loutherbourg's theatricality. Admiral Lord Howe, the British commander-in-chief, stands on the deck of the *Queen Charlotte* holding his sword but Brown places equal emphasis on the group surrounding the dying Captain Neville of the Queen's Royal Regiment, an arrangement borrowed from West's *Death of Wolfe*. Brown also painted a remarkable, though unfinished, *Battle of the Nile*, 1798.

Washington Allston (1779-1843) was West's most versatile pupil and an important figure in the development of landscape and marine painting in America. He studied poetry at Harvard but was determined to become a painter, arriving in England in 1801. His initial scepticism of West's work soon gave way to admiration, and West encouraged him. In addition to historical and portrait subjects, Allston painted landscapes and coastal scenes sometimes adapted from the compositions of de Loutherbourg and Turner. He admired Claude's Italianate landscapes and the extraordinary melodramatic historical subjects of the English painter John Martin.

One of Allston's finest marines, *Rising of a Thunderstorm*, was painted in Paris in 1804, during his first European tour. Its composition closely relates to Turner's *Dutch Boats in Gale*, which Allston may have seen at the Royal Academy in May 1801. The emphasis on the vulnerability of the cutter, the small sailing vessel, and the ship of the line, is powerfully conveyed.

Allston was the first American Romantic painter. He was an intelligent, cultured and talkative man who shared West's passionate interest in encouraging young artists. His main focus was personal expression and moods conveyed by colour, which he compared to music, anticipating Whistler's 'arrangements' and 'symphonies'. On his return home in 1817, he inspired

OPPOSITE ABOVE: *The Battle of La Hogue, 23 May 1692*, Benjamin West. *A spirited portrayal of hand-to-hand combat at sea taken from the late 17th century.*
OPPOSITE BELOW: *The Gulf Stream*, Winslow Homer. *The shark's open jaws recall Copley's earlier image. Homer painted many marine subjects but his interest was in human activity associated with the sea.*
ABOVE: *Brook Watson and the Shark*, John Singleton Copley. *See page 101.*
BELOW: *Rising of a Thunderstorm at Sea*, Washington Allston. *Allston was the first American Romantic artist. Here he portrays a small sailing craft, perhaps a pilot vessel, struggling to make headway.*

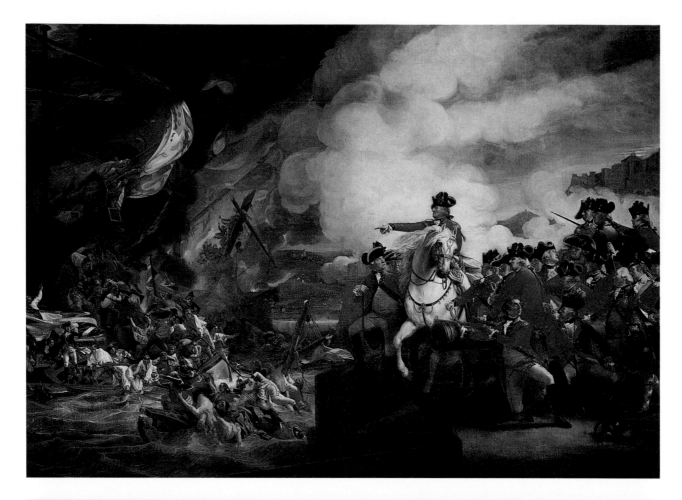

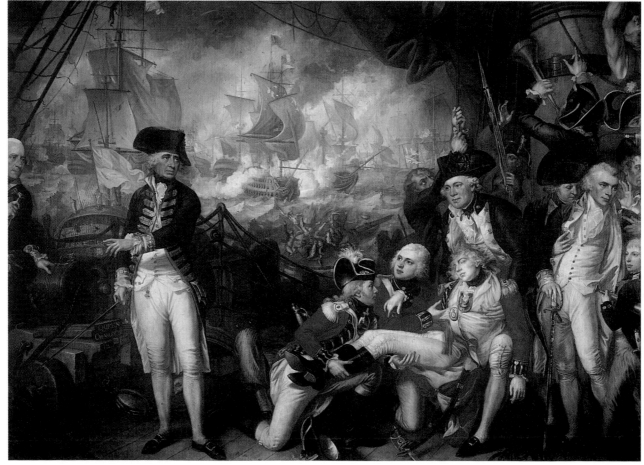

successive generations of painters including the British-born artist Thomas Cole (1801-1848), the father of the Hudson River School, which was fully established in the 1830s.

Cole and his followers expanded on Allston's legacy through their depictions of the American landscape north of New York, notably the Hudson River and Catskill mountains. Cole specialized in sweeping panoramic landscape and river views such as *North Mountain, Catskill Creek*. He also painted a series of metaphorical and visionary marine subjects, similar to the biblical subjects of John Martin, entitled *The Voyage of Life* (1839-1840). His followers John Frederick Kensett (1816-1872), Martin Johnson Heade (1819-1904), Frederick Edwin Church (1826-1900), Albert Bierstadt (1830-1902) and Alfred Thompson Bricher (1833-1908) painted mainly inshore and coastal subjects.

In the same year that Allston returned home, the English-born artist Joshua Shaw (b. c.1777) emigrated to America, settling in Philadelphia. Shaw graduated from sign-painting to become an artist of great charm and ability, although he remains an elusive figure. One of his finest pictures, the biblically-inspired marine *The Deluge*, of about 1813, was mistakenly attributed to Allston. Shaw also produced designs for John Hill's *Picturesque Views of American Scenery*, which was first published in 1820.

There was a growing interest in paintings of sea battles, ship portraits and general shipping scenes, spurred on by the desire of naval officers and others to record the Anglo-American War of 1812. Michele Felice Cornè (1762-1832), one of the earliest to treat these subjects, emigrated from France to Salem, Masachusetts, in 1799. He painted predominantly in watercolour in a style derived from the Roux family of Marseilles, and combined accuracy with an ability to create striking compositions in stimulating colours. His subjects were varied and he decorated the interior of the new building of the Salem East India Marine Society. In 1810 he settled in Boston. Some of his designs relating to the War of 1812 were engraved for the *Naval Monument* (1816), published by Abel Bowen in Boston.

The English-born artists Thomas Thompson (1776-1852) and Thomas Birch (1779-1851) settled in America and painted the major actions and events of the War in a style directly inherited from the Dutch School. Birch's naval encounters are reminiscent of Nicholas Pocock and Thomas Whitcombe; at first glance his *Battle of Lake Erie, 10 September 1813*, exhibited at the Pennsylvania Academy in 1814, could be mistaken for their work.

Thomas Birch was born in London and emigrated to Philadelphia with his father, who was a miniature painter and engraver. He helped his father make topographical prints, and maintained an interest in portraiture. He, too, was affected by Romanticism and responded to the wild, stormy coastal scenes of Vernet. His shipping views are lively and full of movement, in contrast to Thompson's more restrained arrangement of shipping and craft evident in the *U.S. Ship 'Franklin', with a View of the Bay of New York*. Thompson was a frequent exhibitor at the National Academy of Design in New York; he also painted landscapes including views of the Hudson River and exhibited at the Royal Academy in London from 1793 to 1810.

The fluid brush strokes of Thompson's pictures and his cluttered and somewhat awkward arrangement of vessels reveal the influence of the English painter Thomas Buttersworth (1768-1842), who also painted subjects of the War of 1812, and whose prints were widely available in aquatint, published by Joseph Jeakes. Copying prints was common during the nineteenth century. Thomas Chambers (1815-1866), another English-born artist working in

OPPOSITE ABOVE: *The Defeat of the Floating Batteries at Gibraltar, September 1782*, John Singleton Copley. *A small scale version. The original has survived and is still part of the Corporation of London art collection; but it is no longer on public view at the Guildhall.*
OPPOSITE BELOW: *The Glorious First of June, 1794: Lord Howe on the deck of the 'Queen Charlotte'*, Mather Brown. *The background encounter between the 'Brunswick' and the 'Vengeur' resembles an elaborate stage background. Brown boarded the ship to make sketches of officers and men.*
ABOVE: *North Mountain, Catskill Creek*, Thomas Cole. *Cole inspired contemporary artists to draw inspiration from the American landscape, especially the Hudson River Valley. The term Hudson River School, coined by a New York Tribune critic, was originally derogatory.*
BELOW: *Wreck of the 'Ancon' in Loring Bay, Alaska*, Albert Bierstadt. *The paddle-steamer 'Ancon' was rebuilt for the Pacific Coast Steamship Company in 1874. She ferried passengers from Tacoma, Washington, up the coast. On 28 August 1889 she broke her back in shallow water off Revillagigedo Island. Bierstadt was on board and made many sketches.*

America, copied the naval prints of Robert Dodd. His painting of *The 'Constitution' and the 'Guerrière'* was almost certainly taken from an engraving.

By far the most important marine artist to settle in America in the early nineteenth century was Robert Salmon (1775-c.1845). He shared Birch's dual interest in the documentary and Romantic traditions of marine painting, and effectively combined them to create accurate, animated representations of shipping in harbours and at wharves of great clarity and suffused with dramatic light.

Salmon (his family name was Salomon) was born in Cumbria and probably spent his early years working in his father's jewellery shop and at sea. As a painter he was self-taught. He copied the compositions of Turner, Julius Caesar Ibbetson and George Morland. In June 1806, he painted some of his finest harbour scenes in Liverpool. He worked in many British ports including Bristol, Glasgow, and Greenock, a Scottish coastal town on the Clyde with rugged and picturesque marine scenery.

By 1829 Salmon was in Boston. One of his earliest jobs was a backdrop for the Boston Theatre. He later painted three large panoramas that were shown at exhibitions for which he charged admission. Salmon's many harbour views include *Boston Harbour from Constitution Wharf*, and his patrons were almost all associated with seafaring or the seaport. He recorded harbour life and activities on wharves and quaysides, some based on studies from his boat; he also painted coastal and architectural views. His paintings constitute important historical documents.

Salmon's influence was considerable beginning with Fitz Hugh Lane (1804-1865). Lane was born in Gloucester, Massachusetts, and is acknowledged as 'the first native American marine painter of real stature'. He contracted polio as a child, was unable to move without the aid of crutches or a wheelchair, and was largely self-taught. Lane probably first met Salmon at William Pendleton's printing shop on Washington Street, where he served an apprenticeship, and where several of Salmon's drawings were lithographed. His lodgings were near by.

Lane openly copied Salmon's work. In 1845, he acknowledged on the back of the canvas that *The Yacht 'Northern Light' in Boston Harbour* was after a sketch by Salmon. He later painted original compositions that demonstrate a clear debt to Salmon in the general arrangement of shipping, and the placement of figures on the shore or harbour. He adopted Salmon's attention to detail, a similar articulation of wave forms, and the radiant diffusion of light. In addition to travel books, he produced designs for books, the covers of sheet music, and commercial business cards. Lane was an excellent lithographer and published many prints.

By 1842, Salmon's eye-sight was severely impaired and he returned to England. He influenced Albert van Beest, who was born in Holland and later emigrated to America, William Bradford (1827-1892), and later figures such as William James Bennett.

Albert van Beest (1820-1860) was an established artist when he emigrated. He shared Bradford's studio in Fairhaven and they occasionally collaborated. Initially their pictures were dominated by Salmon, but van Beest developed his own realist style and produced some of the most accomplished and spectacular American marines, many derived from his experiences sailing in the Arctic. He made seven sketching and painting trips to Labrador from 1861 to 1868, and in 1869 embarked on a 5,000 mile journey to Melville Bay on the Greenland Coast.

Martin Johnson Heade (1819-1904) was a gifted painter of panoramic coastal views, dominated but carefully balanced by an expanse of sky, a characteristic feature of the seventeenth-

OPPOSITE ABOVE: *Boston Harbour from Constitution Wharf*, Robert Salmon. *Salmon produced superb atmospheric marines contrasting human activity with carefully drawn ships and oared craft, often dramatically lit by golden light.*

OPPOSITE BELOW: *Sunset at Sea*, William Bradford. *In this lively, light-filled composition harbour pilots from New Bedford race out to meet the incoming sailing packet and the ocean steamer. A brigantine crosses astern of the steamer.*

ABOVE: *The U.S. Ship 'Franklin', with a View of the Bay of New York*, Thomas Thompson. *'Franklin' was a three-decker 74-gun ship-of-the-line, the first built in the Philadelphia Navy Yard in 1815. She visited New York on two occasions in 1820 and 1824.*

CENTRE: *The 'Constitution' and the 'Guerrière'*, Thomas Chambers. *The first naval encounter of the War of 1812. On August 19, the USS 'Constitution' defeated the British frigate 'Guerrière' and earned the name 'Old Ironsides'. Chambers' picture is a mirror image of Thomas Birch's composition; both probably taken from engravings.*

BELOW: *The Yacht 'Northern Light' in Boston Harbour*, Fitz Hugh Lane. *'Northern Light' was built by Whitmore Holbrook in East Boston in 1839, probably to the designs of Lewis Winde. She was one of the most successful schooners before the arrival of the 'America'.*

century Dutch school. He is generally associated with Lane through the similarity of their coastal compositions painted in the 1860s. He was also a close friend of Church. Heade was an inveterate traveller and in 1863 went to South America to paint natural history subjects. His pictures are highly atmospheric, and have a tendency to be formulaic. He favoured narrow horizontal canvases that emphasise the vastness of the coastalscape, and introduced scale by carefully placing sailing craft, and sometimes figures, on the foreshore. He was concerned about detail and his waves and reflections are carefully drawn.

James Edward Buttersworth (1817-1894), the son and pupil of Thomas, shared Bradford's interest in naval architecture, although he was no match for the American's rendering of light and atmosphere. He settled in West Hoboken near New York between 1845 and 1847. Like his father he produced many designs and paintings for the print trade and successfully collaborated with the engraver and publisher Nathaniel Currier. His style was similar to his father's and he painted battle scenes, yachting subjects, and especially portraits of clipper ships battling against the elements on the high seas. His paintings often have the appearance of being turned out rapidly, and his reputation has suffered, but he was capable of fine, sensitive work. With his contemporary James Bard (1815-1897), he was instrumental in popularising ship portraiture. Their followers include Antonio Jacobsen (1850-1921), who carried the tradition into the twentieth century.

James Hamilton (1819-1878) was one of the most imaginative of the émigré artists. He was of Irish origin and developed such a passion for Turner's work that during a tour of England in the 1850s, he was dubbed the 'American Turner'. He settled in Philadelphia but travelled widely. He was fascinated by arctic exploration, and produced designs for the explorer Elisha Kane's arctic publications of 1854 and 1856. In these dramatic designs, and in oil paintings such as *The Capture of the 'Serapis' by John Paul Jones*, he displays a close allegiance to the dramatic and Romantic vision of Vernet, Turner and de Loutherbourg. He painted historical subjects and was also a prolific illustrator.

The Moran brothers, Edward and Thomas were pupils of Hamilton and shared his interest in Turner. They combined accurate depictions of ships with vigorously executed seas and spectacular effects of light represented by bold strokes of vibrant colour.

Edward Moran (1829-1901) was born in Lancashire, England and emigrated to Philadelphia. On his return he enrolled at the Royal Academy Schools, and later studied in Paris. By 1876 he had settled permanently in New York, where his successful studio specialised in marines, landscapes, genre and historical subjects. His younger brother Thomas (1837-1926) was closely associated with the Hudson River School.

William Stanley Haseltine (1835-1904) was a native of Philadelphia. He painted excellent marine subjects, particularly coastal views. He left America in the 1840s for Düsseldorf and spent the rest of his life in Europe painting marines and landscapes similar in style to his American contemporary Alfred Thomson Bricher.

Haseltine was one of many American artists to exhibit in Europe during the mid-nineteenth century. These artists seemed reluctant to exhibit marines, and almost all exhibited either landscape or genre subjects at the Royal Academy. Church selected *Natural Bridge in Virginia, U.S.A.* (1852), and Bierstadt *Among the Sierra Nevada Mountains, California* (1869). During William Bradford's tour of Europe in 1875, Queen Victoria purchased one of his arctic views

OPPOSITE ABOVE: ***Approaching Storm: Beach near Newport***, Martin Johnson Heade. *Heade's horizontal canvases emphasise his skies and the vastness of the sea, as well as the vulnerability of the sailing vessels and beach people that inhabit his pictures. His work has a haunting quality.*
OPPOSITE BELOW: ***A U.S. Frigate attacking a French Privateer***, James Edward Buttersworth. *The vessels in this small panel picture have not been identified but the engagement occurred during America's undeclared war with France in 1799.*
ABOVE: ***S.S. 'Mississippi'***, Antonio Jacobsen. *Jacobsen specialised in ship portraiture. His ships are usually depicted at sea, crossing the Atlantic. He worked for many European ship owners and sea captains.*
BELOW: ***The Capture of the 'Serapis' by John Paul Jones***, James Hamilton. *The Scotsman John Paul Jones took the side of the Thirteen Colonies against England. He was given command of the 'Bonhomme Richard' and intercepted the 'Serapis' at the Battle of Flamborough Head, 23 September 1779. The 'Serapis' surrendered when she caught fire.*

The Steamer 'Panther' among the Field Ice in Melville Bay, and commanded that it be exhibited at the Royal Academy in that year.

Throughout the nineteenth century, with very few exceptions, American marine painting followed the Dutch and English documentary tradition. Two of the most famous American practitioners were Winslow Homer (1836-1910) and Thomas Eakins (1844-1916). Edward Hopper (1882-1967) also painted some notable marine subjects. Homer was responsible for some of the most original and stimulating of all marines, while Eakins introduced a new expressive realism. But they rarely focused on ships on the high seas. Both were predominantly maritime genre painters and most of their images were concerned with carefully observed human activity, expression and emotion in a maritime setting.

Albert Pinkham Ryder (1847-1917) defies categorisation. His highly personal and poetic vision of the sea allies him with the European Romantics, especially Turner. Ryder's earliest subjects were landscapes. He rarely painted from life but produced some of the most atmospheric, emotionally intense, and menacing of all marines, betraying a fascination with pattern-making and the expressive and emotional potential of paint. The artist's subjects and titles often reveal literary sources, including *Jonah* and the *Flying Dutchman*. His depictions of vulnerable ships or sailing craft tossed on the high seas appear as metaphors of the frailty of human existence, relating him directly to the Dutch and Flemish masters.

OPPOSITE ABOVE: ***America's Cup, 1871***, Edward Moran. *The schooners 'Livonia' and 'Sappho' are shown in New York Harbour racing in the 1871 America's Cup defence.*
OPPOSITE BELOW: ***The Life Line***, Winslow Homer. *The 'life-line', or jackstay, was a hemp rope or wire that could be rigged between two vessels at sea to assist the transfer of people or goods.*
LEFT: ***The 'Flying Dutchman'***, Albert Pinkham Ryder. *Ryder's highly personal interpretation of the classic ghost ship story.*
ABOVE: ***The Steamer 'Panther' among the Field Ice in Melville Bay***, William Bradford. *The 238 ton steam whaling bark 'Panther' was built at Miramichi, New Brunswick, in 1866, and was used for Bradford's voyage to the Arctic in 1869.*
BELOW: ***Starting out for Rail***, Thomas Eakins. *Eakins specialised in portraits and figure subjects. He painted only a few marine subjects, including rowing scenes.*

MASTERS OF VICTORIAN MARINE PAINTING

uring Queen Victoria's long reign the British Empire effectively doubled in size, although in terms of naval activity, with the exception of the Crimean War, it was a period of relative tranquillity. This extended period of peace, known as the *Pax Britannica*, was achieved by British supremacy at sea following the naval and military victories of the Napoleonic Wars. Exploration took the place of sea battles as the focus of marine interest, especially the search for the North-West Passage and the South Pole.

Retired naval officers took up painting. One of the most accomplished of these was Admiral Richard Brydges Beechey (1808-1895), son of the eminent portraitist Sir William Beechey. In 1825 he undertook a three-year voyage of discovery in the Pacific. His experiences on polar expeditions inspired various polar subjects, including *HMS 'Erebus' passing a Chain of Icebergs, 1842*. *Erebus* was commanded by Sir John Franklin on his search for the elusive North-West Passage in 1845. He failed to return and fifty international search expeditions were launched, ostensibly to find him, but many had orders to explore the arctic waters for their own ends.

The Queen regularly travelled in her own royal yachts and tenders. She enjoyed such voyages and coastal cruising but was unadventurous in her patronage of marine artists. She commissioned the amateur marine painters Henry Robins (1820-1892) and Algernon Yockney (1843-1912), a retired Royal Navy paymaster, to paint her yachts and formal occasions such as naval reviews, embarkations and arrivals. Marines by the Irish artist George Mounsey Wheatley Atkinson (1806-1884), William Adolphus Knell (c.1808-1875), an imitator of de Loutherbourg and the head of a large family of marine artists, and the obscure Joseph Miles Gilbert (fl.1825-1855) were acquired for the royal collection.

The Queen was more enamoured with military subjects, but her real passion was for portraiture, especially of her own family and animals. Her artistic taste was conservative. As Oliver Millar has pointed out, she distrusted anything original and was not stirred by exciting brushwork or new forms of artistic expression. She showed no interest in Turner and Whistler. As a child she expressed her views on art in a letter to a close friend: 'it only shows how wrong in fact it is not to paint things as they really are'. Her views on painting remained constant, and she reaffirmed in her subjects the demand for realism in painting.

Queen Victoria upheld and conferred the position of Marine Painter in Ordinary. In 1844 John Christian Schetky (1778-1874) was appointed, or rather succeeded to the post that he had held under George IV and William IV. His attendance was required on diplomatic and State occasions, and for reviews of the fleet at Spithead. The royal family delighted in his ability to make rapid on-the-spot sketches.

OPPOSITE: ***Pilot Cutters racing to a Ship***, *detail* Admiral Richard Brydges Beechey. *Pilot cutters are depicted racing to be the first to put a pilot aboard the incoming ship, which will pay for the service. Beechey was the most accomplished of the officer artists.*
ABOVE: ***Queen Victoria's Visit to Queenstown, 1849***, George Mounsey Wheatley Atkinson. *Atkinson painted several versions of this event. The Irish-born artist studied at the Royal Hibernian Academy.*

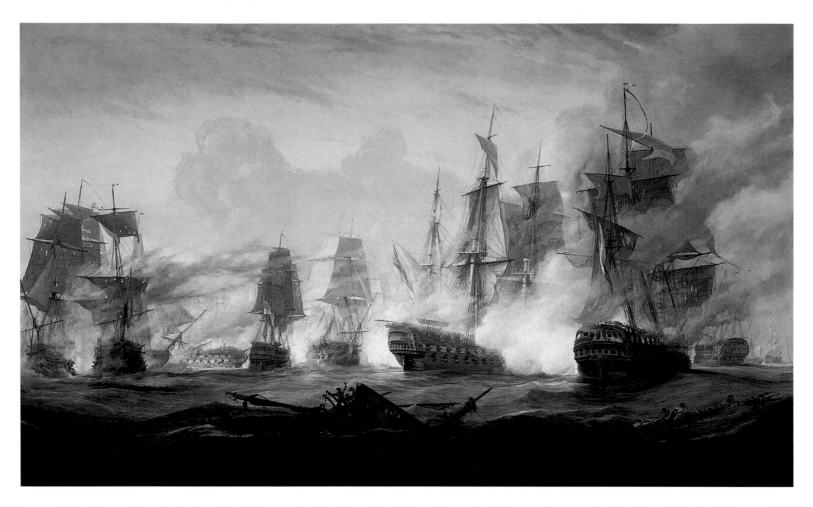

Schetky was born in Edinburgh. The family was of Hungarian origin, his father a musician and composer, his mother an amateur artist. He served briefly aboard the frigate HMS *Hind* before turning to marine painting. He made copies of Turner but remained interested in the Dutch masters. He owned many sketches and drawings after the van de Veldes and Ruisdael, a riverside view by Samuel Scott, a scene of vessels in a storm by Brooking, and engravings after Benjamin West's *Battle of La Hogue*, de Loutherbourg's *Battle of the Nile*, and Richard Wright's *The Fishery*, wrongly catalogued at auction as the work of Bakhuizen.

Schetky excelled as a teacher. His paintings tended to be overworked and lacking in colour - his nickname was 'Old Sepia'. He exhibited at the Royal Academy, and painted a wide range of subjects, including an unusual pair of pictures depicting the salvage of stores and treasure from the wreck of HMS *Thetis* at Cape Frio in Brazil. In 1864 he published a volume of photographs of his principal pictures, which he called *Reminiscences of the Veterans of the Sea*.

Oswald Walters Brierly (1817-1894) succeeded Schetky as Marine Painter in Ordinary. He attended Henry Sass's Academy, an art school in Bloomsbury. He made a number of notable voyages, settling for a time in Auckland, New Zealand, and circumnavigated the world. In 1854 he accompanied the Baltic fleet in the three decker *St. Jean d'Acre*, a First Rate of 101 guns and his many water-colours and on-the-spot sketches were later lithographed for *The English and French Fleets in the Baltic*, 1854. Brierly was equally skilled in water-colours, and although not a first-rate artist he was capable of producing dramatic marines such as *Man Overboard: Rescue Launch from HMS 'St. Jean d'Acre'*.

Brierly was succeeded by Eduardo Federico Martino (1838-1912), the last to hold the position. His appointment gave rise to various protests, including critics wanting a change from the predictable documentary style of marine painting approved by the Queen. The *Art Journal* lamented: 'Do courtiers never hear true artistic conversation, consideration, and discussion?'

Martino was born in Meta, then part of the Kingdom of Naples. He showed an early interest in maritime life, attended classes at the Naval Academy and served at sea as a pilot until 1868. For a time he painted in Brazil, and was commissioned to paint pictures of the Paraguayan War (1868-1869) from firsthand experience.

In 1876 he settled in London, and forged a lasting friendship with the royal family through his enthusiasm for yachting. In later life he suffered a series strokes that impaired his work but came up with a novel solution by subcontracting John Fraser (1858-1927) to paint pictures which, after minor finishing touches, he signed as his own. He refused to exhibit at the Royal Academy. His subjects were wide ranging, including *HMS 'Edinburgh' with anti-torpedo Nets out in a Mock Exercise against Torpedo Boats*, 1887.

Clarkson Stanfield (1793-1867), the leading painter of the first half of the Victorian era, never received official recognition, although the Queen acquired four of his pictures. She commissioned *The Royal Yacht passing St. Michael's Mount* as a Christmas present for Prince Albert, for which she paid £52 10s. It was an inspired choice as Stanfield had firsthand seafaring experience and could satisfy the exacting requirements of the nautical critics. He painted spirited and dramatic compositions, of which *A Market Boat on the Scheldt* is an early example.

Stanfield was born in Sunderland. He inherited a passion for the theatre from his father, an actor and author, and from his mother an ability to draw and paint. He was apprenticed briefly to an heraldic coach painter in Edinburgh and went to sea aboard a Shield's collier.

OPPOSITE ABOVE: ***The Battle of Trafalgar, 21 October 1805***, John Christian Schetky. *Schetky provided Turner with sketches for his famous version of the battle. Schetky's composition focuses on the less famous ships. The painting was exhibited at the Royal Academy in 1838.*

OPPOSITE BELOW: ***Man overboard: Rescue Launch from HMS 'St. Jean d'Acre'***, Oswald Walters Brierly. *In 1854 Brierly accompanied the Hon. Henry Keppel with the Baltic Fleet sailing in the three-decker HMS 'St. Jean d'Acre'. She is hove to and flying the Church pendant - usually the signal that divine service is in progress - but which here indicates 'man overboard'.*

ABOVE: ***HMS 'Edinburgh' with anti-torpedo Nets out in a Mock Exercise against Torpedo Boats***, Eduardo de Martino. *An unusual subject by a favoured Victorian artist. Martino also painted general shipping scenes and portraits of merchant sailing ships.*

BELOW: ***A Market Boat on the Scheldt***, Clarkson Stanfield. *This early atmospheric work in the 'Dutch style' was presented by the art collector John Sheepshanks to the Victoria & Albert Museum in 1857.*

a rather modest marine picture on millboard called *After a Storm*. His picture collection was typical in its combination of subjects and styles. There were landscapes and marines, historical, genre and sporting subjects; pictures by Turner and Constable hung alongside those by William Powell Frith, Edwin Landseer, Daniel Maclise and Thomas Gainsborough.

The Victorian obsession with realism elevated the status of many artists who, despite a recent Victorian revival, are little known today. Sir Augustus Wall Callcott (1779-1844) was regarded as one of the foremost artists of his day, and one of only two marine painters to be knighted. His real talent and his appeal to the Victorians lay in his ability to rework, and update, the compositions of the Dutch masters. The figures and their dress were normally of the Victorian age, but the composition was seventeenth century.

Callcott studied portraiture under John Hoppner but switched to landscape and coastal views. His most successful compositions, calm scenes often featuring small craft close to land, were exhibited at the Royal Academy. His contemporaries applauded his technique. In a publication entitled *Freaks of the Painters* (June 1827), a sailor lambasted Turner's painting of *Passengers going on Board - Now for the Painter (Rope)*, likening the artist's sea to a 'wash-hand basin with a good head of foul soap-suds on it'. Turner was advised that he 'may correct his fancy by studying the seas of Mr. Callcott..'.

George Chambers (1803-1840) was a talented artist who deserves to be better known. His promising career was cut short by ill health. William IV acquired four of his pictures including *A View of Dover*. Born in Whitby, he went to sea at an early age and sailed aboard various merchant ships. He earned his living by painting and lettering visiting ships, many from Greenland. He was given art lessons by a local amateur artist and copied prints borrowed from a local bookseller. He shared Constable's passion for painting from nature, an enthusiasm not without its dangers. One day he rowed out of Whitby harbour to observe the town from the sea, when a storm almost capsized his coble. At seventeen, he moved to London, where he was helped by Christopher Crawford, proprietor of the Waterman's Arms in Wapping.

Crawford had asked the marine painter William John Huggins, then a well-known exhibitor at the Royal Academy, to paint a view of Whitby on the walls of a conference room in his pub. Huggins had never seen Whitby, and wanted to charge a fee for the visit. The commission was given instead to Chambers. Chambers' pictures share Whitcombe's attention to nautical detail, although he surpassed him in his rendering of subtle atmospheric effects. He made two trips to Holland and probably composed *A Dutch Boeier in a Fresh Breeze* from sketches made on the spot. *HMS 'Britannia' entering Portsmouth* is his *chef-d'oeuvre* and one of the most popular images sold in print form today. In the last year of his life, he demonstrated that he was capable of exceptional work in the small-scale painting *A Fresh Breeze off Cowes*, now in the National Maritime Museum, Greenwich.

Chambers was commissioned by friends and associates of Admiral Pellew to paint *The Bombardment of Algiers, 27 August 1816*, as a tribute to the admiral's leadership. The painting was presented to Greenwich Hospital, but, despite Chambers' nautical training, it received hostile reviews. The critics, who were mostly sailors, were unhappy with the colour and character of the gunpowder smoke and the 'inky or purply haze'.

For much of his life, the renowned ability of Edward William Cooke (1811-1880) with the etching needle overshadowed his achievements as a painter. His collection of prints, *Shipping*

OPPOSITE ABOVE: *'Britannia' entering Portsmouth*, George Chambers. *The 120-gun 'Britannia' is returning to Portsmouth on 4 February 1835 after five and a half years in the Mediterranean. Various traditional boats are visible, including a ketch-rigged craft towing either a mast or bowsprit.*
OPPOSITE BELOW: *A Hay Barge off Greenwich*, Edward William Cooke. *This is one of the earliest examples of Cooke's work in oils. It was exhibited with a companion picture at the Royal Academy in 1835. Cooke's draughtsmanship is crisp and assured, his subject brilliantly composed and bathed in golden light. Spritsail barges carried hay and other goods to London and around the English coast.*
ABOVE: *E.W. Cooke*. Photograph. *Cooke took items from his own studio to that of Lake Price, the photographer, as props for this portrait sitting of 1857.*

and Craft, published in 1829, is an outstanding contribution to marine art with its vivid illustrations of barques, billy-boys and barges; anchors, boat huts, rope houses and men-of-war.

Cooke was an exemplary Victorian with wide-ranging interests. He was passionate about archaeology, architecture, botany, horticulture and ethnology. He collected pictures and decorative art, and owned an impressive collection of ship and boat models.

Cooke's father and uncle were prominent printmakers, who worked with a group of engravers to translate Turner's coastal sketches and drawings into the series of acclaimed etchings entitled *Picturesque Views of the Southern Coast of England, 1814-1826*. His father taught him to draw and etch, and as a teenager he made drawings of ship's gear to assist Clarkson Stanfield. One of his earliest oil paintings *A Hay Barge off Greenwich* is a superb demonstration of his knowledge of marine subjects and skill as a painter. His draughtsmanship is crisp and assured, his subject brilliantly composed and bathed in golden light.

An incessant traveller, Cooke visited Italy, Spain, Gibraltar, North Africa, France and Denmark. On sixteen trips to Holland, he made detailed drawings and sketches of boats, ships, and gear as a reference source for such pictures as *Beaching a Pink in Heavy Weather at Scheveningen*. As a tribute to the Dutch masters, he sometimes signed his work van Kook. He copied the van de Veldes' work, and owned a large collection of their drawings. He was also influenced by Turner, Stanfield, the topographical artist Thomas Shotter Boys (1803-1874), and the Norwich School artist Miles Edmund Cotman (1810-1858), whom he used to accompany on sketching excursions. He devoted most of his *oeuvre* to coastal craft and merchant shipping. Some critics saw his repeated subjects as mere 'prose', but one of his patrons, William Wells of Redleaf, probably had Turner in mind when he retorted, 'Dull prose, is it? I'd rather have dull prose than unintelligible poetry!'

Stanfield, Chambers and Cooke were the dominant forces of nineteenth-century documentary marine painting. They had numerous followers including several families of artists such as the Wilson, Callow, Knell, and Meadows families.

The market for marine painting in mid-Victorian England developed to such an extent that artists no longer had to gravitate towards London to exhibit and sell their work. Provincial schools developed in Staithes, Norwich, Ipswich, Bristol, Plymouth; and later at Newlyn and St. Ives, although many of the painters working in Cornwall specialised in maritime genre. The most important schools were Tynemouth, Hull and Liverpool. The main subject categories were ship portraits, general shipping and beach scenes; images of whaling and shipbuilding were also painted. Many artists were self-taught and of limited talent painting in a naive style. They have been called 'pierhead' painters because they would go down to the pier, or quayside, to seek business from visiting ships. Once a commission had been secured, the picture was sometimes produced overnight, depending on when the ship was due to sail. Pictures were painted to a formula and ships were normally portrayed broadside on, often framed by strips of headland and other vessels. In addition to the ship portraitists, there were other artists, often professionally trained, who sometimes surpassed their counterparts based in London.

John Wilson Carmichael (1799-1868) of the Tynemouth school had first-hand experience of the sea in a wide variety of craft. His *Recollection of Turner* (1857) was inspired by the Bridgewater sea piece, although stylistically he was far removed from Turner. He painted a pair of pictures commemorating the polar explorer Captain Sir James Clark Ross's expedi-

OPPOSITE ABOVE: *Beaching a Pink in Heavy Weather at Scheveningen*, Edward William Cooke. *Dutch herring boats, also called pinks, were broad and flat bottomed to assist stability and beaching. The 'Illustrated London News' described this picture as: '...a stirring scene rendered with exquisite life and motion'.*
OPPOSITE BELOW: *'Erebus' and 'Terror' in the Antarctic*, John Wilson Carmichael. *The antarctic landscape is largely fantastic and imaginary. Carmichael painted a companion picture depicting the ships with native craft in New Zealand.*

tion to the Antarctic in 1839-1843. *HMS 'Erebus' and 'Terror' in the Ice*, was an imaginative reconstruction inspired by Ross's *A Voyage of Discovery and Research in the Southern and Antarctic Regions* (1847). The dramatic and largely fanciful light, and the vulnerability of the ships in the swelling sea make it a Romantic evocation.

Carmichael wrote two painting guides published by Winsor & Newton: *Marine Painting in Water Colours* (1859), and *The Art of Marine Painting in Oil Colours* (1864), which ran to several editions. In 1855 he was employed by the *Illustrated London News* to cover naval events and went aboard some of the most powerful ships of the Victorian navy.

By the 1840s Carmichael had moved to London. He exhibited at the Royal Academy from 1835 and his work sold well. He painted a wide range of subjects and could produce a picture in a day. His straightforward documentary style was widely imitated but rarely equalled.

John Ward of Hull (1798-1849) learned his craft through painting and decorating houses and ships. He accompanied the Hull whaling fleets on a voyage to the arctic fishing grounds. The resulting polar scenes are among his finest work and prints of them sold well. Ward recorded day-to-day maritime activities, the return of the fleet, quayside activity, and general shipping subjects, usually on a small scale and in a precise and carefully delineated style, with a limited but lively range of colour. He exhibited at the Royal Academy from 1840 to 1847. His nephew, William John Settle (1821-1897) painted well crafted pictures, full of detail and on a small scale; Queen Victoria commissioned him to design nautical Christmas cards.

Ward's contemporaries, Robert Willoughby (1768-1843) and Thomas Binks (1779-1851) were inferior painters but their pictures of whaling subjects are important historical records. John Warkup Swift (1815-1869) was capable of competent work, and often painted contrasting pairs of calm scenes and stormy subjects. Henry Redmore (1820-1887) excelled at atmospheric shipping scenes painted in a calm or swell with well-drawn ships and craft.

Thomas Somerscales (1842-1927) was invalided out of the navy at Valparaiso in Chile, where he established a drawing school. On his return to Hull he exhibited at the Royal Academy in 1893. He excelled at paintings of merchant ships under sail, his most famous being *Off Valparaiso* (1899). His seas were invariably blue and his ships boldly but accurately painted. He stands at the head of a long line of ship portraitists who excelled at paintings of deepwater merchant sailing ships, the most popular being Jack Spurling (1870-1933) and Montague Dawson (1895-1973). Spurling also painted steamships.

Samuel Walters (1811-1882), son of artist Miles Walters and one of the most accomplished and prolific of nineteenth-century ship portraitists, raised the standard of ship painting from the naive style of the 'pierhead' painters to new heights, where the ship became part of a harmonious picture and satisfied the exacting requirements of masters and ship owners. He was capable of fine work, and occasionally produced a masterpiece such as *The Indiaman 'Euphrates'*. He painted ship portraits, harbour scenes, yacht races, shipwrecks, and coastal subjects.

Liverpool prospered with the increasing Atlantic trade and by the 1860s was the largest centre for ship portraits. But these were not painted exclusively by native artists. The Yorke family left New Brunswick in America for Liverpool in about 1850. William Gay Yorke (1817-c.1886) and his son William Howard Yorke (1847-1921) were accomplished painters who attracted many American clients. William Gay Yorke painted yacht races and harbour views, sometimes from his 'floating studio'. He returned to Brooklyn, New York, in 1870.

OPPOSITE ABOVE: *The Barque 'Columbia'*, John Ward of Hull. *A talented draughtsman Ward's pictures are characterised by an appealing stillness. He specialised in general shipping scenes and whaling subjects.*
OPPOSITE BELOW: *Merchantmen and other Vessels off the Spurn Light Vessel*, Henry Redmore. *One of the most collectable marine artists today. Redmore's calm scenes are invariably superior to his other subjects.*
ABOVE: *The 'Great Western' riding a Tidal Wave, 11 December 1844*, Joseph Walter. *The 'Great Western' was the first regular transatlantic steamship and Brunel's only commercially successful ship.*
BELOW: *A New Bride for the Sea*, Thomas Danby. *Foreshore building at Portishead, outside Bristol. The pilot cutters of the area were built by the 'skeleton' method. The frames were erected first and then the planking nailed on.*

ABOVE: ***A Ship running before a Gale***, Thomas Somerscales. *The ship is a four-master with foul weather rig. Somerscales has produced a late depiction of a merchant sailing vessel, not long before their demise. For economic reasons sail gave way to steam.*

CENTRE: ***The Indiaman 'Euphrates' off Capetown***, Samuel Walters. *The Liverpool ship 'Euphrates' of 617 tons arriving off Cape Town is one of Walter's finest paintings. She was built at Liverpool and traded to India initially, and later to China.*

BELOW: ***The Barque 'Queen Bee'***, Joseph Heard. *The Whitehaven-born artist was a prolific painter of ship portraits. He ranks second only to Samuel Walters as Liverpool's most accomplished marine painter.*

ABOVE: *The 'A.J. Allaire' Off Long Island*, William Gay Yorke. *Yachtsmen of the Harlem Yacht Club put the sandbagger through her paces.*
CENTRE: *View of San Sebastian*, James Webb. *Webb deserves to be better known today. He painted dramatic coastal scenes ranging from large exhibition pieces to small-scale cabinet pictures.*
BELOW: *Shipping in the Sound, Kronborg Castle in the Distance*, Vilhelm Melbye. *In the foreground is a Dutch merchant dogre, with two barques beyond and another in the right background. Melbye is the best known Danish marine painter. He was inspired by the artists' community of Skagen.*

Among the West Country artists, Joseph Walter (1783-1856) painted some of the earliest images of the revolutionary ships designed by Isambard Kingdom Brunel (1806-1859) notably the *Great Western* (1837) the largest wooden paddle steamer of her day. The Danby family: Francis (1793-1861), James Francis (1816-1875) and Thomas (c.1818-1886) all painted marine subjects, some in a Romantic style.

Nicholas Condy the Elder (1799-1857) and his son Nicholas Matthew Condy (c.1818-1851) were the best marine painters in Plymouth. The Elder also painted genre and interior scenes. His son was a professional painter of talent who favoured fluid seas, shipping, harbour scenes and yachting subjects. He exhibited at the Royal Academy and his *Royal Yacht in Plymouth Sound, 30 August 1843* was purchased by Queen Victoria. It was lithographed by Louis Haghe and issued by E. Fry of Plymouth with a dedication to Prince Albert.

The Dubliner Stanhope Forbes (1857-1947) was the first marine painter of note to settle in Newlyn. The success of his busy beach scene *A Fish Sale on a Cornish Beach* first drew attention to the Newlyn School. It is full of detail with a frieze-like arrangement of fishing vessels in the background and carefully observed studies of the foreground figures. Other artists drawn to the Cornish coastline were Henry Scott Tuke (1852-1929), Walter Langley (1852-1922), Julius Olsson (1864-1942), 'Lamorna' Birch (1869-1955) and Harold Harvey (1874-1941). They excelled at harbour views and maritime genre subjects.

In 1864 Charles Napier Hemy (1841-1917) completed his coastal masterpiece *Among the Shingle at Clovelly*, painted according to the principles of the Pre-Raphaelites and the theories of John Ruskin. He lived aboard a floating studio in Falmouth, and would follow the fishing fleet in search of subjects. *Pilchards* (1897), now in the Tate Gallery, London, is his *chef-d'oeuvre* and ranks as one of the masterpieces of maritime genre.

William Lionel Wyllie (1851-1931), who was strongly influenced by Hemy, witnessed and painted Queen Victoria's funeral cortege afloat in 1901. The Queen's coffin aboard the Royal Yacht *Alberta* was escorted through the fleet from the Isle of Wight to Portsmouth. *The Passing of a Great Queen, 1901*, is now in the Walker Art Gallery in Liverpool. Wyllie never received royal patronage but he was one of the most widely admired of all marine artists.

He shared the van de Veldes' passion for the sea and all activities associated with it. He lived by the sea in the Tower House in Portsmouth, and at Hoo Lodge on the Medway, and painted on his French yawl *Ladybird*. A versatile artist equally adept in oils and water-colour, he was also a skilful printmaker, designer and illustrator working for numerous newspapers.

His subjects encompassed battleships, submarines and seaplanes, passenger liners powered by steam; and images of shipboard life, beach scenes and landscapes. He also painted historical subjects and was an unofficial war artist during World War I.

Wyllie was born into a family of artists and received formal instruction at Heatherlys Art School and the Royal Academy Schools. He was influenced by Turner, Boudin, Whistler and Impressionism but his concern for accuracy sometimes obscured the atmospheric qualities of his work. He was author and co-author of various art guides and books, including one on Turner. Turner's influence can be seen in *Storm and Sunshine: a Battle with the Elements*.

During the 1880s the working life of the river held a particular fascination for Wyllie, and his lively depictions of the Thames and Medway are arguably his most important work. He recorded the transition from sail to steam; many of the vessels and coastal craft he painted

OPPOSITE ABOVE: *An Extensive View out through the Entrance of Grand Harbour, Valletta, Malta on a Stormy Day*, G. Gianni. *An excellent painting by an obscure artist. He painted Maltese scenes and ship portraits for naval officers but was probably born in southern Italy.*
OPPOSITE BELOW: *The Shipwreck*, Ivan Aivazoffski. *Aivazoffski's marines often focus in close-up on the sea. His waves are well observed and painted with great skill emphasising the transparency and luminosity of the sea.*
ABOVE: *The Yacht 'Alarm' in Plymouth Sound*, Nicholas Matthew Condy. *A rare subject by an elusive artist. Condy exhibited three marines at the Royal Academy from 1842-1845.*
BELOW: *A Fish Sale on a Cornish Beach*, Stanhope Forbes. *Forbes' most famous oil painting that helped focus attention on artists outside London.*

have long since vanished. One of his most powerful river compositions *Toil, Glitter, Grime and Wealth on a Flowing Tide* shows in close-up and carefully-observed detail, the physical labour involved in working the lighters to move cargo. The subject is human activity, a type of picture called maritime genre that was greatly loved by the Victorian public.

Wyllie's influence on his contemporaries and successive generations was considerable. He influenced the style of Charles John De Lacy (c.1860-1956), Frank Watson Wood (1862-1953), and Charles Dixon (1872-1934) and taught Lieutenant Commander Rowland Langmaid (1897-1956). Wyllie was also important in the development of the art of Alma Claude Burlton Cull (1880-1931) and the American-born William Minshall Birchall (1884-1941).

Many of the finest European and American practitioners exhibited in London including the Dutch families Koekkoek, Hulk and Dommersen; also the Danish painter Vilhelm Melbye, the fashionable French genre painter and portraitist James Tissot, and the Russian artist Aivazoffski. Winslow Homer worked in the north-east and exhibited coastal scenes at the Royal Academy. Victorian England had become the centre of marine painting.

OPPOSITE ABOVE: ***Fisherfolk and Ships by the Coast***, Abraham Hulk Senior. *Hulk's often small-scale pictures are highly sought after. He is admired for his bright and breezy marines, usually showing coastal craft in a calm.*
OPPOSITE BELOW: ***Flat-bottomed Fishing Pinks and Fisherfolk at Scheveningen***, Hendrik Willem Mesdag. *Mesdag's subject follows in the footsteps of his 17th-century forbears.*
LEFT ABOVE: ***Among the Shingle at Clovelly***, Charles Napier Hemy. *A Pre-Raphaelite maritime masterpiece. The focus of this remarkable image is literally the sea-side shingle.*
LEFT BELOW: ***Henley Regatta***, James Tissot. *An uncharacteristic work by the French artist who is better known for his elegant portrayals of fashionable Victorian women. The first regatta was held at Henley on the River Thames in 1839.*
ABOVE: ***Storm and Sunshine: a Battle with the Elements, 1885***, William Lionel Wyllie. *This picture depicts the 'Leonidas' (1807), which was used to store gun cotton. The hulk was moored close to Wyllie's house 'Hoo Lodge'.*

TWENTIETH-CENTURY WAR ARTISTS

War artists have painted marine subjects for almost four hundred years. The concept of an official war artist, commissioned by the State, was pioneered in Holland with the appointment of the van de Veldes. The Elder followed the Dutch fleet sketching sea-battles in progress from his galliot from the Dutch viewpoint. Later, he worked for Charles II, taking his instructions from the English. Such pictures were thus an early form of pictorial propaganda. In the eighteenth century marine painters recreated sea-battles from drawings, notes and precise instructions from their patrons, who were usually naval officers. Sometimes the officers themselves painted the action.

Brierly and Carmichael were invited to cover the Crimean War in the Baltic where Carmichael was a roving visual journalist for the *Illustrated London News*, as was Charles John De Lacey during the Boer War and World War I. Wyllie was too old for active service, but was familiar with Portsmouth and his extensive contacts with senior naval officers resulted in several oils and many sketches and water-colours, some of which he engraved.

World War I provided the inspiration for the first official government art schemes. In 1916 the British Liberal politician Charles F.G. Masterman conceived the idea of using artists as illustrators to supplement the dearth of photographic material for new propaganda publications such as *War Pictorial*. Artists were sent to witness the war at first hand, to draw and record the landscape, the everyday life of the men, actual fighting, and portraits of officers and men.

Muirhead Bone (1876-1953) and Francis Dodd (1871-1949) were the first to be sent to France. Bone's reputation as a draughtsman - his soubriquet was the 'London Piranesi' - enabled him to record the bomb-scarred landscape but he recommended Dodd for the portraits. Bone worked with great speed and intensity providing drawings for numerous publications. In 1917 he was dispatched to work with the Grand Fleet at Rosyth in Scotland, where he recorded daily routine aboard ship, with practical exercises, drills and recreations including *A Cinema on Board a Battleship, HMS 'Repulse'*.

The first art scheme that encouraged artists to capture their own experiences on canvas and paper was initiated by the Canadian Sir Max Aitken, later Lord Beaverbrook, who had settled in England and was a Member of Parliament. By 1917 he was Officer in charge of War Records, which included newspapers, books, magazines, films and photographs. He formed a committee to acquire a commemorative record of the Canadian war effort. The terms of reference were fairly liberal, and were the inspiration for similar schemes during World War II. Artists were to paint what they experienced at first hand but the resulting work had to be a 'balance between the historical and aesthetic aspects'.

OPPOSITE: ***Masters of the Sea: First Battle Cruiser Squadron, 1915***, *detail*, William Lionel Wyllie. *Battle-cruisers were conceived as a complement to the dreadnought battleship. Carrying similar sized guns they achieved greater speeds by compromising on the thickness of their armour and could take swift evasive action.* ABOVE: ***Repairing a Torpedoed Ship in an English Harbour***, *Sir Muirhead Bone. Bone's superb draughtsmanship is well illustrated here. He portrays the workers of the Salvage Section of the Admiralty working in Southampton Docks. The vessel was formerly the German merchantman, the 'Armenia' of Hamburg.*

The majority of artists commissioned were English and Irish, including Paul Nash, William Roberts, Percy Wyndham Lewis and Sir William Orpen. Arthur Lismer (1885-1969) was commissioned to paint the war from the Canadian viewpoint. His most visually arresting compositions are portraits of the 'dazzle-camouflaged' White Star liner *Olympic* .

Lismer's bizarre patterned ship was conceived as a practical device to protect shipping from U-boats by the British-born marine artist Norman Wilkinson (1878-1971). It did not attempt to make ships invisible but the reverse. The bold abstract patterns broke up their constructional lines, so that when viewed through an enemy periscope the range, course and speed were difficult to estimate. When 'dazzle painting' was combined with a zig-zag course and air-cover, the ship stood a far greater chance of survival.

'Dazzle-painting' departments were established in London, principally at Burlington House, home of the Royal Academy today. New designs were tested on ship models. Wilkinson went to America to supervise the painting of several thousand ships. Many artists passed their war years dazzle-painting and dazzle designs became the main subject of some prints and paintings. The Scottish artist John Duncan Ferguson (1874-1961) made dazzle the main feature of *Dockyard, Portsmouth, 1918*, now in the Imperial War Museum, London.

Wilkinson was an artist, illustrator and poster designer. Before becoming a full-time painter, he worked for the *Illustrated London News*, and in 1901 was sent to cover Sir Thomas Lipton's attempt to recover the America's Cup. He was selected by the Admiralty to paint marine subjects for a permanent exhibition gallery in what would become the Imperial War Museum. Artists were given honorary commissions and either a set fee per canvas or variable salaries.

Wilkinson recorded his first-hand experiences of the Dardanelles campaign in 1915, and one of his main tasks for the Admiralty in 1917 was to duplicate the water-colours done shortly after the action, but this time in oils.

Ambrose McEvoy (1878-1927) and Glyn Philpot (1884-1937) painted portraits, an activity that McEvoy, who was a society portrait painter, especially loathed as he had to recreate images of men who had been awarded the Victoria Cross from faded and tinted photographs.

The most successful war images were created by John Lavery (1856-1941) and Charles Pears (1873-1958). Lavery painted panoramic views of ships from airships. Pears was one of the most gifted of twentieth-century marine artists, but is better known today as a poster designer. He was assigned to Rosyth where he made careful studies of ships, and provided a wealth of illustrations for the press. The career of Philip Connard (1875-1958) as a war artist was less successful because he was a poor sailor. But the works he did complete, including *The Guns of HMS 'Caesar'* and *Twenty-seven Knots: HMS 'Melampus'*, are direct and forceful compositions. High hopes for the work of Philip Wilson Steer (1860-1942) faded with *Dover Harbour* (1918), which was uninspiring, drab and largely sepia in tone although he was known for his vibrant and colourful subjects.

Frank Henry Mason (1876-1965), who was commissioned as a lieutenant in the Royal Naval Volunteer Reserve, recorded and reconstructed actions and operations in the Mediterranean. He painted mainly in water-colour and was a gifted illustrator and designer. Montague Dawson was sent to Gibraltar to undertake similar work. Donald Maxwell (1877-1936) painted Mediterranean subjects as an official war artist for the Admiralty. He produced an extensive body of naval subjects for the *Graphic* and also recreated events. Leonard Campbell Taylor

OPPOSITE ABOVE: ***A Convoy, North Sea, 1918***, Sir John Lavery. *Lavery is better known as a portrait painter. He was one of the first artists to paint naval activity from the air. In this scene, witnessed from the airship SN7, he portrays a convoy of ships near the Norwegian coast.*
OPPOSITE BELOW: ***Dover Harbour***, Philip Wilson Steer, *1918. Steer was celebrated for his use of vibrant colour but this painting of Dover, the castle and the white cliffs is essentially a drab sepia image.*
ABOVE: ***'Olympic' with Returned Soldiers***, Arthur Lismer. *The 'Olympic' is shown here in Halifax, Novia Scotia. Lismer ran an art school there and was a member of the the Group of Seven, who drew inspiration from the Canadian landscape*
BELOW: ***A Cunarder converting to a Merchant Cruiser***, John Everett. *'Dazzle' fascinated many artists not only marine painters. Everett painted a series of pictures in which its rhythmic effects are the main focus.*

(1874-1969) and John Wheatley (1892-1955) painted portraits and maritime genre subjects. Stanhope Forbes contributed one of his familiar genre subjects, and one of the few images portraying the prominent role played by the Women's Royal Naval Service (WRNS) during World War I. He depicted Wrens sailmaking aboard HMS *Essex* at Devonport in 1918.

Muirhead Bone was the only official artist commissioned to commemorate the arrival of the surrendered German fleet at Inchkeith on 21 November 1918 but John Lavery was concealed aboard Admiral Beatty's flagship HMS *Queen Elizabeth* to record the meeting with senior German officers to discuss the terms of the surrender. Charles Dixon was not affiliated to any of the art schemes but was also afloat to witness and record the historic event at first hand, and later worked up his sketches and drawings into oils. His depiction of the arrival of German fleet led by HMS *Cardiff*, now in the National Maritime Museum, Greenwich, is one of his largest and most impressive works.

Arthur James Wetherall Burgess (1879-1957), an Australian war artist based in England, worked as an illustrator for the *Illustrated London News*, the *Graphic*, and the *Sphere*, painting a wide range of subjects. His portraits of merchant vessels adapted for war service include *A Standard Merchantman of World War I*. A close inspection reveals that two guns for defence are mounted on her stern, while the steel wires running from bow to stern act as radio. These vessels, mass produced to a standard design, were used to enforce blockades and for patrol duties.

German marine artists were given some encouragement to paint war subjects from the German point of view but there was no official scheme. The large-scale images of Claus Bergen (1885-1964) are painted in a vigorous semi-impressionist style. His subjects, which include empty seas and solitary figures looking out to sea, recall Caspar David Friedrich. *Nazi Wreath in the North Sea in Memory of the Battle of Jutland* and *On the Deck of a German U-boat* are cases in point. The Berlin artist Carl Saltzmann (1847-1923) painted marines on a similar scale and in an equally vigorous style. He studied at the Academy in Berlin and was awarded medals in Berlin, Paris and Chicago.

During World War II (1939-1945) the War Artists' Advisory Committee (WAAC), chaired by Kenneth Clark under the auspices of the Ministry of Information, was created to establish an historical record of the war in all its aspects. Clark justified the budget by emphasising its importance as a propaganda tool but was more interested in art than propaganda. Abstract painting was not approved of because of its predominant concern for individual expression rather than factual record, and sensitive subjects could be censored in the name of national security. Otherwise, artists were free to record their own experiences, were given commissions and encouraged to witness the war at first hand. The three main categories were: actions and events, documentary scenes of everyday life afloat and ashore, and portraits.

The WAAC's inaugural meeting was held on 23 November 1939. Because of opposition from both the War Office and the Admiralty, a compromise gave each body its own artists, although the WAAC had some say in their selection and destination.

Muirhead Bone, an experienced war artist, joined the Committee and was the first to be commissioned. Artists received honorary commissions, normally for a six-month period. They were paid for their work although the fees were far less than they could expect in peacetime. The going rate for oils varied from £150 to £200, and occasionally £300. Prices below ten pounds were not unusual for water-colours and drawings.

OPPOSITE ABOVE: *HMS 'Cardiff' leading the surrendered German Fleet into the Firth of Forth, 18 November 1918*, Charles Dixon. *On 21 June 1919, Admiral Ludwig von Reuter scuttled 11 battleships, 5 battle-cruisers, 8 light cruisers and 50 destroyers rather than let them fall into enemy hands.*
OPPOSITE BELOW: *The Brotherhood of Seamen: Rescue of a Motor Vessel by the Steamship 'Glengyle'*, Arthur James Weatherall Burgess. *Burgess worked as a war artist in both World Wars. This incident is fictitious but the ship is real. She was a cargo liner built for the Glen Line in 1939.*
ABOVE: *The Guns of HMS 'Caesar'*, Philip Connard. *HMS 'Caesar' was a Majestic-class battleship dating from 1896 and mounting 12-inch guns.*
BELOW: *Commander Rose on the Deck of a German U-Boat, 1917*, Claus Bergen. *The lonely figure looking out to sea is reminiscent of pictures by the German Romantic painter Caspar David Friedrich.*

As a full-time artist working for the Admiralty, Bone received a commission as an honorary Major in the Royal Marines. He drew a wide range of subjects from images of life afloat on mine-sweepers, to parades in Whitehall. Many were reproduced in the illustrated weekly newspapers with appropriate captions to maintain morale.

Muirhead Bone's *Winter Mine-Laying off Iceland* was a rare attempt at oil painting, and part of a series he made aboard HMS *Southern Prince*. It took almost a year to finish and the result is overworked and disappointing. By spring 1943 Bone had effectively retired and was succeeded by his son Stephen, one of a group of artists who were less gifted as draughtsmen but superior and more imaginative painters.

Stephen Bone (1904-1958) studied at the Slade School of Art. As a Lieutenant in the Royal Naval Volunteer Reserve, he had access to majestic naval vessels whose power and scale attracted his most vigorous work. By 1943 he was an established artist. His matter-of-fact realism was also highly atmospheric: the finest work depicts seamen below decks, in the engine-room, mess-room and conning towers of ships and submarines. Stephen Bone's work was published in the *Illustrated London News* alongside that of regular contributors, Bryan de Grineau and Charles E. Turner, who drew and painted naval subjects but were not official war artists. He shared his father's obsessive interest in detail. For several months during 1944, he made a comprehensive record of the activities and day-to-day life aboard the escort carrier HMS *Pursuer*.

In 1940 John Nash (1893-1977) was appointed to cover naval subjects. He was a landscape painter and unhappy with his role as a war artist, not finding subjects he wanted to paint. He worked in oils and water-colours, and painted subjects ashore and afloat including flying boats. The work of the war artists was exhibited at the National Gallery in London, and elsewhere in England and abroad, to bolster morale.

John Worsley (b.1919) survived the sinking of HMS *Laurentic* in 1940 and three years later was appointed by the WAAC on behalf of the Admiralty to record shipboard life and other subjects in the Mediterranean. He was captured during a rescue operation but continued to paint in Marlag O at Westertimke, the German naval P.o.W. camp, with materials supplied by the Red Cross. His more clandestine activities were as camp forger, producing black and white identity photographs in pencil and creating the dummy naval officer 'Albert RN' who helped cover for escapees. His drawings and paintings were smuggled out in tubes made of Red Cross KLIM tins that originally contained dried milk.

Charles Pears and Norman Wilkinson were employed again during World War II to reconstruct notable maritime actions and events. Pears painted some of the finest war paintings characterised by a visually exciting style derived from his work as a poster designer. His subject matter included part of the artificial harbour, code-named Mulberry, used in Operation Overlord, better known as the Normandy Landings, on D-Day.

Wilkinson was a camouflage adviser to the Royal Air Force but resigned in order to paint an ambitious series of fifty-four canvases covering all aspects of the work of the Royal Navy. entitled *The War at Sea*. In 1944, he presented it to the nation via the WAAC. All except one went to the National Maritime Museum, Greenwich. In 1945 the series was exhibited in New Zealand and Australia but its reception was far from complimentary.

Charles Cundall (1890-1971) and Richard Eurich (1903-1992) both painted dramatic scenes of the withdrawal from Dunkirk in June 1940. Cundall's picture, which was derived from first-

OPPOSITE ABOVE: ***Convoy to Russia***, Charles Pears. *The convoy to Russia was the most hazardous and arduous of the convoy routes.*
OPPOSITE BELOW: ***Landing Craft approaching the Normandy Beaches, 6 June 1944***, Norman Wilkinson. *Operation Neptune was an attempt to land in France and confront the German army in the field. Wilkinson was on board the destroyer 'Jervis'.*
ABOVE: ***Up the Conning Tower: on board an S-Class Submarine, 1944***, Stephen Bone. *One of Bone's most dynamic compositions in which he contrasts artificial and natural light. S-class submarines carried the first radar sets for surface and air search.*
BELOW: ***Moonpath Attack on a U-boat by a Halifax Bomber in the Bay of Biscay, March 1944***, Charles E.Turner. *The pilot was a pioneer of 'moonpath' tactics, a method of framing a submarine in the moon's reflection and then swooping down on it from the darkness.*

hand experience, was well received. But Eurich's reconstructed version was preferred by the navy and used as their Christmas card. Eurich had written to the WAAC in June 1941: 'Now the epic subject I have been waiting for has taken place. The Dunkirk episode. This surely should be painted and I am wondering if I would be considered for the job! It seems to me that the traditional sea painting of van de Velde and Turner should be carried on to enrich and record our heritage'.

Eurich based his painting on eye-witness accounts, aerial photographs and sketches he had made from a cargo boat the previous summer. It was completed in less than three weeks. Eurich was one of the most successful war artists whose strength lay in his ability to combine diverse sources into a powerful and imaginative whole, convincing to those who had been there. His subjects include images of survival at sea. He updated Géricault's famous image, portraying with disturbing realism the survivors in a ship's boat. Not surprisingly the Wartime Censorship Office feared a detrimental effect on recruitment, and withdrew it from public exhibition.

In 1945 Muirhead Bone had to chivvy Stanley Spencer (1891-1959) into completing a series of shipbuilding scenes entitled *The Furnaces* commissioned by the WAAC in 1940. Spencer had spent two years in Glasgow making extensive studies and notes at Lithgow's yard at Port Glasgow on the Clyde. The resulting images are not marine paintings but unique genre scenes in Spencer's highly imaginative style. The pressure placed on Spencer caused him to complain that he could have painted a better image. To placate the Director of Merchant Shipbuilding, Sir James Lithgow, the WAAC commissioned Henry Rushbury to make three drawings of the yard in a matter-of-fact style.

The official scheme to paint Canada's role in the war received Canadian Cabinet approval only in 1943. Fortunately war artists, especially Henry Lamb (1885-1960), were encouraged to record events involving the Canadian army before the official scheme was launched. The National Gallery of Canada sent Michael Forster (b.1908) and Jack Nichols (b.1921) to record daily activities and shipboard life on merchant ships.

Thomas Harold Beament (1898-1985) selected a subject rarely found in painting - burial at sea. The Ottawa-born artist served as an official war artist from 1943 until 1947 with the rank of Commander. Thomas Charles Wood (b.1913), also a native of Ottawa, enlisted in the Royal Canadian Naval Volunteer Reserve in 1943. He was present at the Normandy landings and served in motor torpedo boats (MTBs). Mine sweeping off Normandy, and aircraft carriers were painted by the London-born artist Frank Leonard Brooks (b.1911). He settled in Canada in 1912, and was an official war artist from 1943 until 1946 with the rank of Lieutenant.

By the end of 1944, Canadian war art had been exhibited at the National Gallery in London, at Campobasse, Piedmont d'Allfe and Rome in Italy, and in Paris and Brussels. Almost four thousand items were produced and are now housed in the National Gallery of Canada in Ottawa.

There was no official programme to encourage American war art during World War I. Henry Reuterdahl (1870-1925) worked as an unofficial correspondent for *Collier's Weekly*. By 1941, Combat Art, as it was then called, had been devised by Griffith Baily Coale (1890-1950), a landscape and mural painter. He convinced navy officials to send artists to sea, and was the first to be commissioned in August 1941. He recorded the sinking of USS *Reuben James*, and visited Pearl Harbour after the raid. He was one of eight artists to receive commissions. Dwight C. Shepler (1905-1972), Mitchell P. Jamieson (1915-1976), and Alexander P. Russo

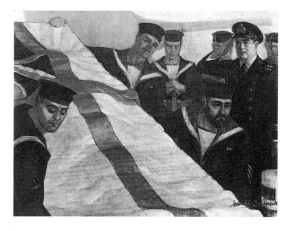

OPPOSITE ABOVE: *Withdrawal from Dunkirk, 27 May - 3 June 1940*, Richard Eurich. *An armada of assorted vessels, largely manned by amateurs, and British destroyers brought back almost 300,000 men pinned down on the coast by the German army in 1940.*
OPPOSITE BELOW: *A Ship's Boat at Sea*, Richard Eurich. *Eurich was fascinated by the theme of survival at sea but the official Wartime Censorship Office feared a detrimental effect on recruitment to the Merchant Navy and withdrew the painting from display.*
ABOVE: *Six-inch Gun Cruisers*, Norman Wilkinson. *Wilkinson was on board the ship in the foreground and has incorporated the twin gun-turrets into a visually striking composition.*
BELOW: *Burial at Sea (during World War II)*, Thomas Harold Beament. *Few artists have painted this subject. The name of the ship and of the deceased have not been recorded.*

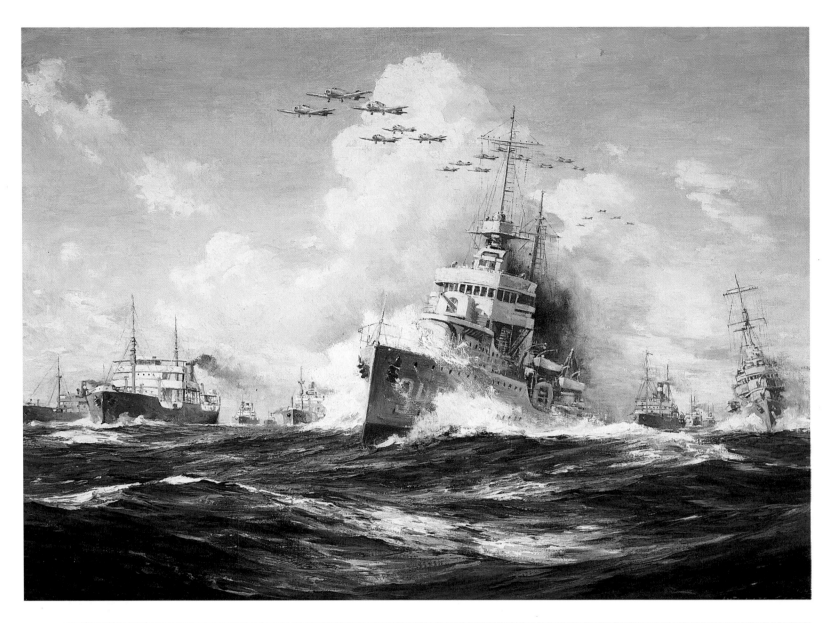

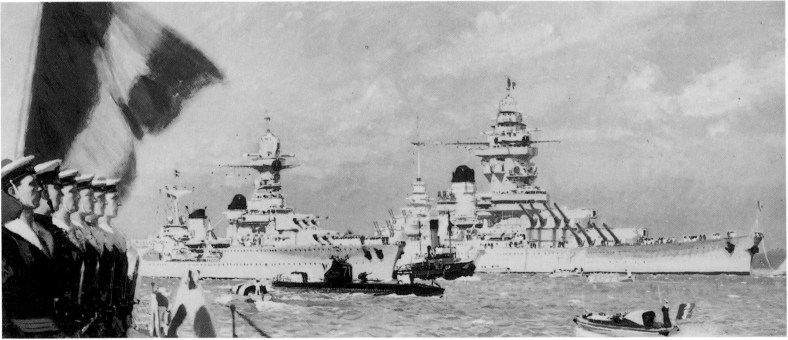

(b.1922) witnessed the allied invasion of Normandy. Standus Backus Jr (1910-1989) and William F. Draper (b.1912) served in the South Pacific. Edward Millman (1907-1964) painted the retaking of Manila and other islands, while Albert K. Murray (1906-1992) painted portraits of senior naval officers.

Anton Otto Fischer (1882-1962) was not part of the Combat Art programme but in 1942 became official painter for the U.S. Coast Guard. He accepted a commission as a Lieutenant-Commander and painted lively and dramatic images in a vigorous style. Although German-born, Fischer became an American citizen in 1916. He was a successful painter and illustrator, and designed war posters. He was also an experienced sailor making many deep sea passages and wrote and illustrated a book entitled *Fo'c'sle Days* (1947).

Others painted naval and merchant subjects. Thomas Hart Benton (1889-1975) one of the American Regionalist artists inspired by rural life and landscape became fascinated with submarines. In 1943 he painted a series of pictures aboard the USS *Dorado*, which, in their matter-of-fact realism, are comparable to the work of Stephen Bone.

In the 1960s, the Salmagundi Club of New York City, an organisation promoting the interests of artists, formed the Navy Art Co-operation and Liaison Committee (NACAL) to recruit civilian artists to cover naval subjects for what is now called the Navy Art Collection at the Navy Yard in Washington DC. Striking post-World War II images were painted by Robert G Smith (b.1909), Walter Brightwell (b.1919), Frank Zuccarelli (b.1921) John Charles Roach (b.1943), and many others.

No other European country matched the WAAC and the British Admiralty in the acquisition of war art. Germany had no official art programme, although Germans serving at sea during World War II, including Rudolf Ressel (b.1921) and his contemporary Captain Gerhardt Ulpts, painted marines. Ressel was a naval radio operator in Norwegian waters.

French marine painters are first recorded as being 'attached to the Ministry of the Navy' in 1830, although almost three centuries earlier, the French Navy had established the tradition of commissioning its own painters and printmakers. During World War I Charles Fouqueray (1872-1956) produced designs for illustrated newspapers, especially *La Guerre Documentaire*. After studying at the *Ecole des Beaux-Arts* in Paris, he made several sea voyages to the French colonies. Albert Brenet (b.1903) painted some of the most accomplished naval scenes of World War II. He also studied in Paris and made numerous voyages on merchant sailing ships. He was appointed a *Peintre officiel de la Marine, Titulaire*, in 1935.

Marin-Marie (1901-1987) and Roger Chapelet (b.1903) are two of the most popular and accomplished French marine artists. Chapelet is still working today. Their depictions of clipper ships, yacht races and historical scenes, executed in a lively and realistic style, are painted with an intense passion sometimes absent from their war work.

From the late 1940s the nostalgia for sailing subjects made them the most popular category of marine art, and they have remained so to this day. Commissions from naval officers and seamen eager to commemorate a successful action had become comparatively rare as seamen and officers possessed photographs of their ships and crews.

Since 1945 the dearth of major naval actions has resulted in the decline of naval war art. Of the few official artists commissioned to cover the Falklands War, and more recently the war in the Gulf, none was a marine painter.

OPPOSITE ABOVE: ***America Delivers, 1942***, Anton Otto Fischer. *Fischer depicts either USS 'Farragut' or 'Dewey' manoeuvring at high speed in the formation of a North Atlantic convoy beneath an air cap of pursuit planes from USS 'Enterprise'.*
OPPOSITE BELOW: ***Marine***, Albert Brenet. *The armour plated cruiser 'Strasbourg' is featured to the far right, another cruiser the 'Georges Leygues' is portrayed on the left, and the submarine 'La Vestale'. All were painted by the artist from the stern of a torpedo boat.*
ABOVE: ***Up the Hatch***, Thomas Hart Benton. *Benton made studies onboard submarines in 1943. During the war the names of the actual vessels were suppressed, as this information was regarded as sensitive.*
BELOW: ***Home to Roost***, William F.Draper. *Aircraft return to the carrier before dark, as landing operations become more hazardous in artificial light.*

David Cobb (b.1921) is one of the few marine painters to paint war subjects today. He was invited to the Falkland Islands immediately after the Argentine surrender in 1982, and with the co-operation of the military, recreated paintings of the main events of the war. He had painted a similar series of World War II pictures now in the Royal Naval Museum, Portsmouth. Cobb attended the naval school at Pangbourne College, and served in MTBs from 1943 to1945. He is self-taught and became a professional marine painter in 1946.

In 1991, determined to witness the Gulf War for himself, Cobb persuaded the Admiralty to fly him out in exchange for an oil painting. For a month he worked as a volunteer with the Royal Navy and the United States Navy, drawing all aspects of their work by day and night. The Friends of the National Maritime Museum, Greenwich, commissioned two marines based on his experiences in the Gulf. He chose to depict the activities of the Mine-Counter-Measure Vessels or MCMVs.

Cobb also paints sailing ships and steamers, power boats, yachts, and historical subjects. He is a past president of the Royal Society of Marine Artists, one of the earliest to actively encourage marine painting, established in Britain just before the outbreak of World War II.

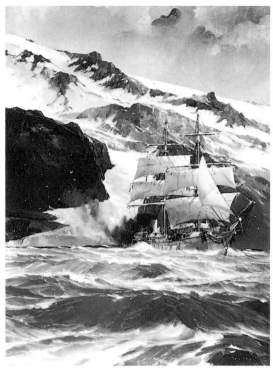

OPPOSITE ABOVE: *'Gloucester''s Lynx attacking Iraqi Patrol Boats with Sea-dart Missiles, 1991,* David Cobb. *The Commanding Officer of the helicopter was David Livingstone whose successful sorties against Iraqi ships earned him a Distinguished Service Cross.*
OPPOSITE BELOW: *Loss of HMS 'Coventry' off the Falklands, 25 May 1982,* David Cobb. *This painting was commissioned by HMS 'Broadsword' which came to 'Coventry''s rescue. A bomb damaged 'Broadsword''s helicopter flight deck preventing the rescue helicopters from landing. The event was recreated with the assistance of officers from the 'Broadsword'.*
LEFT: *Commander of a French Submarine looking through a Periscope during World War I,* Charles Fouquerary. *Fouquerary's draughtsmanship is similar to that of Sir Muirhead Bone. In addition to his work as an illustrator, he painted in oils.*
ABOVE: *Merchant Ship under Sail,* Marin-Marie. *Widely acknowledged as the leading French marine painter of the first half of the 20th century, Marin-Marie was an enthusiastic yachtsman.*

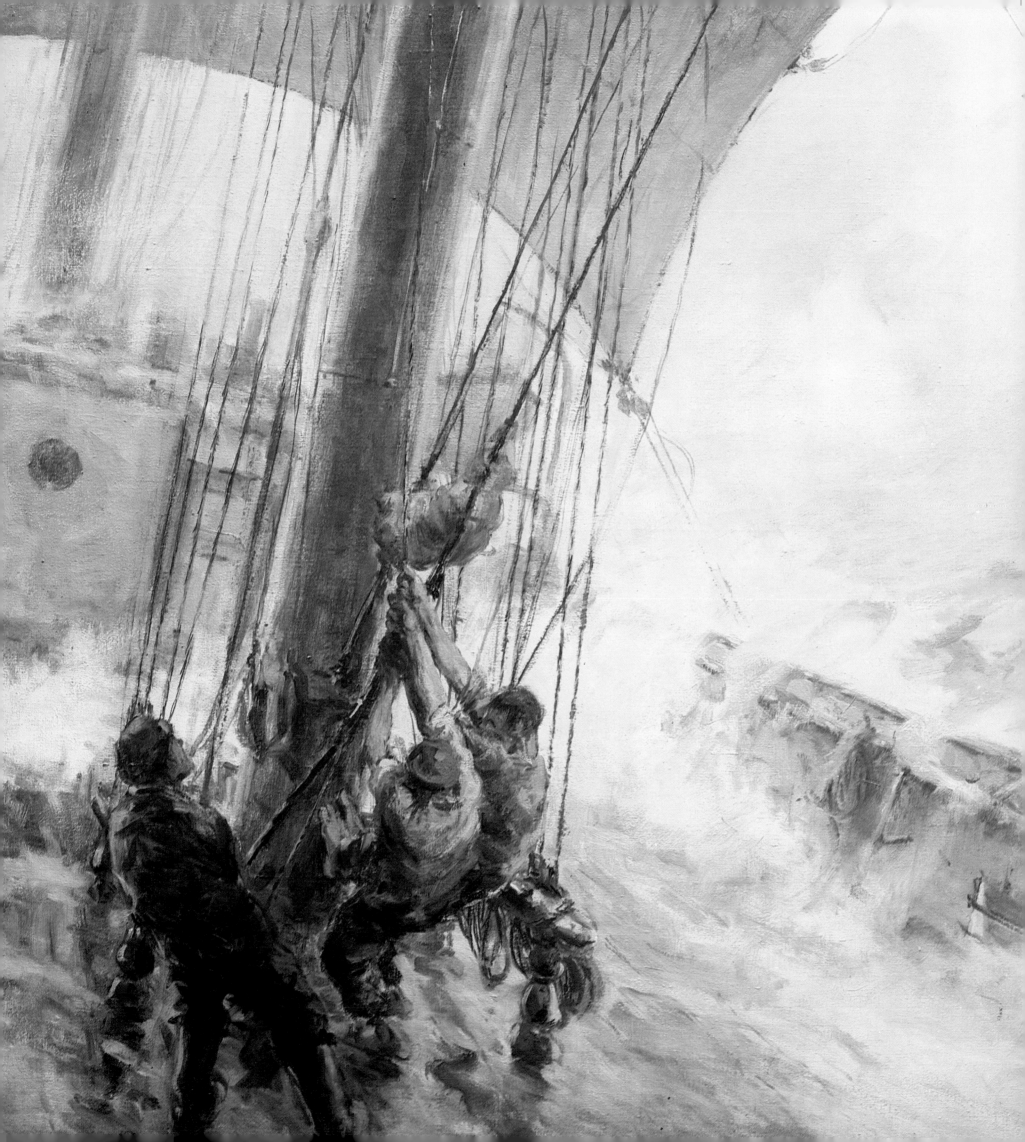

'NEW HORIZONS'

Today Britain is a leader in the encouragement of modern marine painting. Surprisingly there are no active organisations advancing the interests of Dutch or Flemish marine artists. While those in Germany and America derive from an English organisation established before World War II - the Royal Society of Marine Artists. The RSMA held its inaugural exhibition at the Guildhall, London, in 1946. Between the wars, William Lionel Wyllie, Charles Pears, Montague Dawson, Arthur Briscoe and others attempted to establish an organisation to promote the interests of marine artists. Their efforts, and especially those of Pears, the Society's first President, led to the foundation of the RSMA which received its royal prefix in 1966. The Society is still active and its original aims remain unchanged: 'to encourage, develop and maintain the highest standards of marine art'. For more than a decade the Mall Galleries in London have hosted an annual exhibition of members' work, and the Society has helped establish the preeminence of Britain as a centre of marine painting.

Charles Pears is underrated as a painter, illustrator, and designer. His poster designs advertising sea-side resorts were a common sight on the London Underground and British Rail stations. After his war service he continued to paint marines but also produced a large body of designs for the *Illustrated London News*, the *Graphic*, and *Punch*; and also illustrated books including yachting books, a sport for which he always maintained a great enthusiasm.

Harry Hudson Rodmell (1896-1984), who was invited to join as a founder member in 1939, designed the Society's logo. He was a professional illustrator and poster designer, who had worked for many leading shipping companies. A native of Hull, he left a selection of his work to the Hull Museums and Art Gallery.

Lieutenant-Colonel Harold Wyllie (1880-1973), the eldest son of William Lionel, was fascinated by the history and development of the sailing ship and became an international authority on marine archaeology. He was was a member of the committee for the restoration of Nelson's flagship *Victory* with special responsibility for the re-rigging. In addition to painting he was a printmaker and ship modeller. Arthur J. W. Burgess and Norman Wilkinson were enthusiastic members during the Society's formative years, but their energies were largely directed towards creating war art.

John Worsley, a past president, recorded work on the oil fields of America for Esso. He later spent several years drawing the 'strip' story PC 49 for the Eagle comic and working as an illustrator for children's television. But marine painting has remained his mainstay.

The Wapping Group was founded in 1947 after the Chairman of the Port of London Authority had mooted the idea of holding an exhibition of images of the London River. The

OPPOSITE: *Clewing Up the Mainsail in Heavy Weather*, detail, Arthur Briscoe. *Briscoe studied at the Slade School of Art in London. He is a superb draughtsman known for his etchings of scenes aboard deep water merchant sailing ships.*
ABOVE: *The Critics: R.M.S 'Queen Mary' arriving at Southampton on 27 March 1936*, Charles Pears. *The 'Queen Mary' set new standards of luxury and speed. She is arriving at Southampton before going into drydock. John Brown's fitters and joiners - the 'Critics' - featured in the foreground are waiting to board her.*

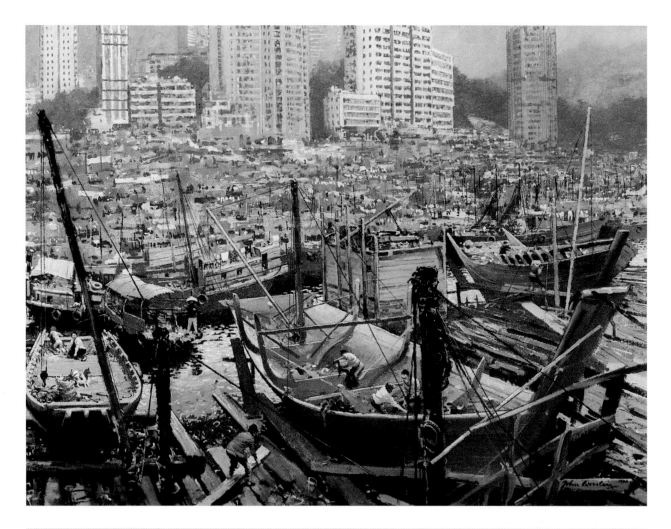

Group was originally limited to twenty-five members. Among the more familiar names today are: Arthur Bond (1885-1958), W. Eric Thorp (b.1901), Jack Merriot (1901-1958), Josiah Sturgeon (b.1919), Vic Ellis (b.1921), Bert Wright (b.1930) and Trevor Chamberlain (b.1933). They carried on the tradition of William Lionel Wyllie and Charles Dixon who focused on the day-to-day life and views of the Thames - once the world's busiest waterway.

The organisation of a body of marine artists in France predates the RSMA. Since the seventeenth century there have been marine painters in France supported by the government. Jean-Baptiste de la Rose (c.1612-1687) is the earliest recorded marine artist.

By 1901 the number had expanded to fifty but thirty years later was reduced to twenty. At the same time an annual exhibition was inaugurated, the *Salon annuel de la Marine*, held at the Musée de la Marine in Paris. The exhibition has in fact been held every two years. In 1953 painters were joined by sculptors, printmakers, illustrators and decorators, all of whom were formally recognised as *Peintres du Département de la Marine*. A 1981 decree established a new category of '*peintre des armées*', assigning artists to paint for the army, navy and airforce.

Serge Michel Henry Marko (b.1926) was until recently the Secretary-General of the Association. A gifted draughtsman, he has exhibited widely in France and Antwerp, and in New York and Japan. Other members include Georges-Jean-Clément Fouille (b.1909), Leon Gambier (b.1917), Gaston Sebire (b.1920), Jean Elie Le Merdy (b.1928) and Michel King (b.1930). Since 1992 Michel Bernard has been Secretary-General.

The RSMA and the official French painters were catalysts in the foundation of other societies in Europe and America. The American Society of Marine Artists was founded in 1978 with similar aims to the RSMA - 'to recognise and promote marine art and history, and to encourage cooperation among artists, historians, marine enthusiasts and others engaged in activities related to marine art and maritime history'.

Of the six founder members Frederick Freeman (1906-1987), Robert Oliver Skemp (b.1910), and Thomas Maclay Hoyne (b.1923) are probably the best known in Europe today. Freeman was born in Boston and worked for the U.S. Navy during World War II. He was a painter, designer and illustrator. Skemp is based in Westport, Connecticut and in addition to painting is a yachting enthusiast and model maker. Hoyne was born in Chicago and was largely self-taught. After service as the gunnery officer of a landing ship tank, he specialised in a wide range of illustration work.

The ASMA has no permanent home or regular exhibition venue. Past shows have been held in collaboration with major American maritime museums, such as Mystic Seaport in Connecticut. There are currently members in forty states and one, Mark R. Myers, currently resident in south-west England. He is self-taught and works in watercolour, oils, acrylics and inks. His subjects draw upon extensive practical deep water sailing experience. Myers is the current President of the RSMA.

In 1985 Peter Tamm, whose collection of maritime art and ship models rivals those of many national maritime museums, and Franz Zeithammer, conceived the idea of 'Art Maritim', an exhibition devoted to promoting foreign marine art in Germany. German artists were also encouraged to exhibit and sell their work. France (1987), the Soviet Union (1989), Argentina (1991), Italy (1992), the USA (1993) and Japan (1994) have already participated. The aim is a representative selection of artists and painting styles. Uniforms, ship models, historical

OPPOSITE ABOVE: ***Chinese Boat Building, Hong Kong, 1990***, John Worsley. *The inspiration for this subject derived from an earlier commission for the Hong Kong and Shanghai Banking Corporation to paint 'Chinese New Year in Aberdeen Harbour, Hong Kong'.*
OPPOSITE BELOW: ***Brest 92 - Les Grands Voiliers***, Jean Rigaud. *Rigaud's breezy quayside composition, broken brushwork and vivid palette recall the work of Eugène Boudin.*

charts, scientific and navigational instruments, arms and armour are also displayed. 'Art Maritim' is a regular part of the annual International Boat Exhibition (Hanseboot) in Hamburg.

The 'Forum of German Marine Artists' (*Forum der Deutschen Marinemaler*) was established in 1991, spearheaded by Peter Hagenah (b.1928) who shared a general concern about the future of marine art in Germany. He encouraged the artists exhibiting at the 'Art Maritim' exhibition to form a group on the lines of the RSMA. It aims to revive and promote classical marine painting, to encourage living artists to paint marine subjects, and to foster international contacts. The Forum currently has fifteen members and holds an annual exhibition of the group's work on board the ship *Rickmer Rickmers*, which is also a meeting place for artists and a venue for workshops.

Members include: Rudolf Ressel (b.1921), who paints detailed portraits of modern merchant vessels; Peter Hagenah and Uwe Lutgen (b.1944) who specialise in the realistic representation of modern and historic sailing ships; Alwin Grohn (b.1928) who paints ship portraits; Gerhard Geidel (b.1925) who paints historical scenes; Jochen Sachse who tackles a broader range of subjects in a realistic photographic style. Fred Muller (b.1933) and Karl-Heinz Schrader (b.1925) paint coastal and beach scenes, as well as harbour subjects. Hans-Peter Jurgens' Impressionist-style paintings are known internationally. Kurt Schmischke is an illustrator.

Modern marine painting offers a broad range of subjects including super tankers, oil rigs and supply vessels, light-ships, container ships and port scenes. But most artists have avoided them. Oil and shipping companies generally commission professional photographers and videomakers to record their activities and marine artists specialising in these subjects are rare. For the majority of modern collectors portraits of sailing ships are more appealing than super ships, although these floating giants are not wholly lacking in aesthetic appeal.

Stuart Beck (b.1903) paints super-tankers and oil rigs. He also paints naval vessels, square-riggers, river craft and motor yachts. From 1941 to 1946 he served in the special branch of the Royal Naval Volunteer Reserve, and afterwards became a painter and illustrator of marine and aeronautical subjects. His autobiography 'A Dash of Salt' was published in 1993.

The American artist Rick Klepfer (b.1948) is almost alone in his passion for painting portraits of commercial shipping. He is self-taught with the express purpose of painting ships. Most galleries in America regard modern commercial ships as 'industrial art' and are wary of it. He therefore works almost exclusively for ship owners and agents, although photography has robbed him of many potential commissions. His paintings are testimony to the fact that there is beauty in the lines of modern shipping. Klepfer believes that 'the working vessel has evolved from a somewhat graceful and well-crafted form into a highly specialised, mass-produced tool - but so much the better; the overwhelming physical presence of such a massive artifact, whose whole being is built to a single purpose, is a magnificent thing.'

Grenville Cottingham (b.1943) painted a whole range of subjects, including deck scenes of supertankers. Geoff Hunt (b.1948) has tackled marine subjects for oil companies, notably the oil support vessel *Balblair*. He is a freelance artist and designer. In 1979-1980 he and his family sold their house and cruised their yacht *Kipper* to the Mediterranean. Since returning he has devoted himself to marine painting and illustration.

Terence Storey (b.1923) contrasts a light-ship of fairly recent construction with an older type of craft - a spritsail barge, in his painting of *St. Katharine's Dock, London*. These cargo

OPPOSITE ABOVE: ***'Rickmer Rickmers' after the Storm in 1906***, Peter Hagenah. *The vessel is shown drifting out of Cape Town. Hagenah, son of a Merchant Navy Captain, is entirely self-taught. He is inspired by the late Johannes Holst.*
OPPOSITE BELOW: ***Trouble on Bideford Bar***, Mark Myers. *The full-rigger 'Louisa' after leaving Appledore in Devon on her way to Cardiff in Wales, is accompanied by the tugs 'Ajax' and 'Iron Duke' shortly after they collided on New Year's Day, 1863.*
ABOVE: ***St. Katharine's Dock, London, 1991***, Terence Storey. *Vessels belonging to the Maritime Trust, founded in 1969 to preserve sea-going vessels, were on display at St. Katharine's Dock until 1986. The 'Nore' No.86 was a light vessel formerly owned and operated by the Corporation of Trinity House, London.*
BELOW: ***The Thirteen Gun Salute***, Geoff Hunt. *Designed as a book cover for Patrick O'Brian's book of the same title, published in 1989.*

ABOVE: ***RMS 'Britannia' departing after being freed from the Icebound Harbour, February, 1844,*** John Stobart. *At the time, the Royal Mail paddle-driven steamship 'Britannia' was owned by the Canadian, Samuel Cunard. The view looking south shows the Cunard dock in East Boston. Stobart trained at the Derby and Royal Academy Art Schools before settling in America.*

carriers were once a common sight on the Thames and Medway and around the British coasts but few have survived. Storey studied in Sunderland, and at Derby College of Art. He paints a wide variety of subjects including wildlife, landscape and still-life.

Colin Verity (b.1924) is interested in all forms of marine painting. He is drawn to ocean-going ships and associated dockland craft, particularly in dockland settings, depicting arrival, loading and departure techniques. He undertakes detailed research using drawings and photographs, believing, as did the Dutch masters, that without an intimate knowledge of technical marine matters it is not possible to be plausible on canvas.

Historical subjects are popular in modern marine painting, many of them carefully researched. Some are designed as illustrations, for example Geoff Hunt's book jackets for maritime novelist Patrick O'Brian. Hunt also painted a series of twelve paintings depicting the various activities of the Royal Navy during the Napoleonic Wars, now in the Royal Naval Museum at Portsmouth.

Others including Leslie Wilcox (b.1904), Derek Gardner (b.1914), Chris Mayger (b.1918), Roy Cross (b.1924), John Chancellor (1925-1984), John Stobart (b.1929), and the Americans John Barber (b.1947), Christopher Blossom (b.1956), and Donald Demers (b.1956) have gone to great pains to reconstruct ports, harbours, wharves, coastal views, and shipping scenes of

the seventeenth, eighteenth and nineteenth centuries. The American artist and art dealer William Davis (b.1932) and Louis Dodd (b.1943) paint historical pictures evocative of eighteenth and nineteenth-century artists.

David Thimgan (b.1955) is a leading marine artist working in California. A self-taught artist working in oils and water-colour, he has specialised in historical subjects since 1979. His painting *'Galatea' and 'Sea Foam' at Mendocino* reveals his eye for a visually engaging composition, and his concern for accuracy and nautical detail. Another west-coast artist, Ken Marschall (b.1950) specialises in accurate reconstructions of the ill-fated White Star Liner *Titanic*, on and below the water, and of other historic ships, which have been used extensively for book covers and illustrations.

After sailing ships, yachts are the most popular category of 'portraiture'. In addition to modern yacht races, artists have depicted the famous yachts of history, those used for ceremonial and State occasions, and others - notably *Gipsy Moth IV* - that have circumnavigated the world. Some artists paint only yacht races, and their work appears regularly in the London auction rooms, where it has recently started to fetch high prices.

Stephen Dews (b.1949) is one of an informal group that specialises in yachting subjects. He studied at Hull Regional College of Art and has branched out to paint other historical

ABOVE: ***Warping In: The 'Ardnamurchan', Port Blakely, 1903***, Christopher Blossom. *The British steel ship is seen here 'warping in' to a berth. Ships took on cargo through stern hatches, or 'Lumber Ports', either in the bow or stern of the vessel. Blossom is one of the most gifted marine painters working today. He studied at the Parsons School of Design, New York, and later as an industrial designer. He is preoccupied with new ways of representing marine subjects and constantly experiments with lighting effects. He is a keen sailor.*

ABOVE: ***The Yacht 'Gipsy Moth' IV running before a heavy quartering Sea***, Peter MacDonagh Wood. *Sir Francis Chichester's yacht was built in 1966, designed by Messrs Illingworth and Primrose. He set off in August 1966 and took nine months and a day to complete his circumnavigation, the first man to accomplish this single-handed in a small vessel. Wood studied at the Slade School of Art, was a keen yachtsman and produced numerous illustrations for yachting magazines.*
CENTRE: ***'Balblair', 1989***, Geoff Hunt. *The British Petroleum support vessel, is portrayed in the Forties Field. Few modern artists have focused on these subjects.*
BELOW: ***Annapolis, circa 1900***, John Morton Barber. *The side-wheel steamer 'Emma Giles' is landing at the steamboat wharf. The artist is concerned with preservation and has painted Chesapeake Bay and the few remaining oyster dredgers, known as skipjacks, on which he sails.*

ABOVE: ***The 'Philmac Venturer' in the Queen Elizabeth II Dock of the Manchester Ship Canal***, Colin Verity. *This vessel is a Panamanian tanker carrying crude oil between England and South America. She was built by Mitsubishi in Nagasaki in 1982.*
CENTRE: ***Summer Racing off Cowes***, Stephen Dews. *The 'Canterbury', a Davidson 40-foot yacht was built in New Zealand for the New Zealand Admirals Cup team.*
BELOW: ***Kenwood Cup, Hawaii, 1990***, Michael Vaughan. *Originally a graphics artist, Vaughan paints motor racing, eventing, wildlife and golfing subjects in addition to marines.*

themes. His marines approach photographic realism. Others working in a similar style are Deryck Foster (b.1924), Frank Wagner (b.1931), David Brackman (b.1932), Michael Whitehand (b.1941), Stephen Renard (b.1947) and Tim Thompson (b.1951). They have been compared with Montague Dawson but their brushwork and application of paint are quite distinct.

Michael Vaughan (b.1940) is one of the most exciting artists to emerge in recent years. He combines an interest in graphics, photography and painterly effects to create yachting scenes of remarkable originality, characterised by vigour and vitality. He captures the excitement, speed and grace of ocean racing in close-up detail, from above and below his subject. His pictures include detail that may derive from photographic sources, but his means of expression is through paint, and certainly not film.

Images of ports and harbours, coastal and shore scenes, and of the sea continue to have a broad appeal. Today, they are attractive subjects for landscape, topographical and architectural artists painting in styles ranging from photorealism to the vivid colours and broken brushwork associated with Impressionism. Hugh Boycott Brown (1909-1990) drew upon the legacy of Impressionism to produce attractive pictures, usually on a small scale, of the coast and shore of East Anglia. He was the informal leader of the modern school of artists there.

Sonia Robinson (b.1927), John Ambrose (b.1931) and John Michael Groves (b.1937) also paint delightful beach and harbour subjects. The first two are attracted to the light and colour of Cornwall; both live and work there. Ambrose acknowledges the influences of Boudin, Edward Wesson (b.1910) and Edward Seago (1914-1974). Seago painted many scenes in his native East Anglia and is now a sought after coastal painter.

David Curtis (b.1948) is known for his shore scenes. His draughtsmanship is assured and handling of colour and light superb - evident in *Late Afternoon Light, Mykonos*, painted in 1992. The sea and waves continue to fascinate artists such as Sheila MacLeod Roberston (b.1927) who delights in windswept and rugged coastalscapes.

The American painter and illustrator Frank Handlen (b.1916) demonstrates a passion for the sea in his many 'portraits' of waves breaking over rocks, and occasional forays on board ship to recreate conditions aboard a merchant sailing ship in a gale; he also paints landscapes, and is a talented sculptor of maritime subjects.

Keith Shackleton (b.1923), a self-taught artist and past president of the RSMA, excels at antarctic and arctic subjects that focus on the sea and seabirds, mountains, rocks and icebergs.

In the sixties and seventies, the profile of marine painting was probably at its lowest ebb, and the market for work by earlier artists was also weak. But the last decade has witnessed a revival of interest in marine painting. There is an expanding market and the major auction houses have for the last few years held specialist sales devoted to maritime art and antiquities. Many painters working today are aware of the importance of the early Dutch masters, and their knowledge, like that of the van de Veldes, derives from firsthand experience of sailing and cruising, and from sketching, drawing and studying models. Today there are more sophisticated resources to hand including aerial photography, technical magazines and computer technology. But these modern aids do not make a better painter. Colin Verity is not alone in believing that, like the Dutch masters, 'it is essential to be able to observe and draw, because ships are particularly unforgiving to indifferent draughtsmen and no amount of arty verbosity can disguise this fact'.

OPPOSITE ABOVE: ***Boats on the Hard, Pinmill, Suffolk***, Edward Seago. *Seago excelled at atmospheric beach scenes in a style indebted to the French Impressionists.*
OPPOSITE BELOW: ***Evening Light, Mykonos***, David Curtis. *A superb study of light in a carefully balanced seascape/rockscape. Curtis paints marines and landscapes with equal ability, in a loose style reminiscent of Sir Alfred Munnings.*
ABOVE: ***Idling, Newlyn, 1993***, Sonia Robinson. *Robinson focuses in close-up on two moored dinghies. These working boats are used by one or two men for fishing. The detail and stillness of the composition recall the work of Richard Eurich.*

LIST OF ILLUSTRATIONS

London, Thomas Rowlandson (1756-1827) and Augustus Pugin (1762-1827), Hand-coloured aquatint, originally published 1808-1810, facsimile edition Wordsworth Editions, London
- *The 'Victory' underway*, Monamy Swaine (b.c.1750), Oil on canvas, 89 x 124.5cm, National Maritime Museum, Greenwich
- *Fishing Scene, with a Yacht becalmed near the Shore*, Francis Swaine (c.1715-82), Oil on canvas, 95.5 x 165cm, dated 1768, National Maritime Museum, Greenwich
- *Chatham Dockyard in 1777*, Robert Wilkins (c.1740-c.1799), Oil on canvas, 74.3 x 137cm, Richard Green Galleries, London
- *Mausoleum of Sher Shar, Sasaram, Bihar*, Captain Francis Swain Ward (1736-1794), Oil on canvas, 81 x 130cm, c.1770, The India Office Collection, British Library
- *A Sixth-Rate on the Stocks*, John Cleveley the Elder (c.1712-1777), Oil on canvas, 67.5 x 129.5cm, dated 1758, National Maritime Museum, Greenwich
- *Forcing a Passage of the Hudson River, 9 October 1776*, Thomas Mitchell (1735-1790), Oil on canvas, 71 x 117cm, dated 1780, National Maritime Museum, Greenwich
- *Jared Leigh and his Family*, George Romney (1734-1802), Oil on canvas, 185.8 x 202cm, National Gallery of Victoria, Melbourne, Australia

VI Eighteenth-century Sea Battles and Shipping Scenes
- *Princess Charlotte arriving at Harwich, 6 September 1761*, Dominic Serres (1722-1793), Oil on canvas, 81.5 x 129.5cm, dated 1763, National Maritime Museum, Greenwich
- *A Lieutenant with his Cutter in the background*, Dominic Serres (1722-1793), Hand-coloured aquatint, engraved and published in November 1777, National Maritime Museum, Greenwich
- *The British Fleet entering Havana, 21 August 1762*, Dominic Serres (1722-1793), Oil on canvas, 119.5 x 180.5cm, dated 1775, National Maritime Museum, Greenwich
- *The Thames at Shillingford, near Oxford*, John Thomas Serres (1759-1825), Oil on canvas, 104 x 137cm, National Maritime Museum, Greenwich
- *Captain Philip Affleck (1726-1799)*, Edward Penny (1714-1791), Oil on canvas, 94 x 66cm, National Maritime Museum, Greenwich
- *Dutch Boats in a Calm*, William Anderson (1757-1837), Oil on canvas, 48.2 x 73.5cm, Richard Green Galleries, London
- *Swedish and Russian Fleets engaging in 1789*, Johan Tietrich Schoultz (c.1750-1807), Oil on canvas, 57 x 88cm, Sjohistoriska Museet, Sweden
- Plate XVII from Vol.1 of *Liber Nauticus*, Drawn by John Thomas Serres (1759-1827) and aquatinted by Swain and Harraden, National Maritime Museum, Greenwich
- *The Battle of Cuddalore*, Capitaine le Marquis de Rossel de Cercy (1736-1804), Oil on canvas, 72.5 x 105.5cm, Musée de la Marine, Paris, France
- *Relief of Gibraltar by Earl Howe, 11 October 1782*, Richard Paton (1717-1791), Oil on canvas, 72.5 x 105.5cm, National Maritime Museum, Greenwich
- *A Fleet of East Indiamen at Sea*, Nicholas Pocock (1740-1821), Oil on canvas, 61 x 92.5cm, dated 1803, National Maritime Museum, Greenwich
- *A Dutch Frigate and a Pilot Vessel in a Rough Sea*, Petrus Johannes Schotel (1808-1865), Oil on canvas, 112 x 142cm, Nederlands Scheepvartmuseum, Amsterdam, Netherlands
- *'Charlotte of Chittagong' and other Vessels in the River Hoogli*, Franz Balthazar Solvyns (1760-1824), Oil on panel, 53.5 x 61cm, dated 1792, National Maritime Museum, Greenwich
- *An English Brig with captured American Vessels*, Francis Holman (1729-1784), Oil on canvas, 86.5 x 150cm, dated 1778, National Maritime Museum, Greenwich
- *The Battle of the Nile, 1 August 1798*, Nicholas Pocock (1740-1821), Oil on canvas, 71 x 101.5cm, dated 1808, National Maritime Museum, Greenwich
- *Action Between the 'Quebec' and the 'Surveillante', 6 October 1779*, Robert Dodd (1748-1715), Oil on canvas, 61 x 89cm, 1781, National Maritime Museum, Greenwich
- *From Leghorn towards London in the ship 'Betsey' 1770*, Nicholas Pocock (1740-1821), Extract from log book, National Maritime Museum, Greenwich
- *George III in the 'Southampton' reviewing the fleet of Plymouth, 18 August 1789*, Lieutenant William Elliott (fl.1784-1791), Oil on canvas, 112 x 171.5cm, dated 1789, National Maritime Museum, Greenwich
- *The Wreck of the 'Dutton' at Plymouth, 26 January 1796*, Thomas Luny (1759-1837), Oil on canvas, 76 x 112cm, National Maritime Museum, Greenwich
- *The Inshore Blockading Squadron off Cadiz, April-July 1797*, Thomas Buttersworth (1768-1842), Oil on canvas, 63.5 x 99cm, National Maritime Museum, Greenwich
- *The Cutter 'Mary Ann' and the 'Sylph'*, Thomas Whitcombe (1763-1824), Oil on canvas, 106.7 x 162.2cm, dated 1795 National Maritime Museum, Greenwich

VII Towards a New Vision
- *Battle of the Glorious First of June, 1794*, Philippe-Jacques de Loutherbourg (1740-1812), Oil on canvas, 214.5 x 278cm, detail, dated 1795, National Maritime Museum, Greenwich
- *Battle of the Glorious First of June, 1794*, Philippe-Jacques de Loutherbourg (1740-1812), Oil on canvas, 214.5 x 278cm, dated 1795, National Maritime Museum, Greenwich
- *Battle of Trafalgar, 21 October 1805*, J.M.W. Turner (1775-1851), Oil on canvas, 261.5 x 368.5cm, detail, National Maritime Museum, Greenwich
- *The Raft of the Medusa*, Jean Louis André Théodore Géricault (1791-1824), Oil on canvas, 488 x 712.5cm, painted in 1819, Louvre, Paris, France
- *A View of Cape Stephens in Cook Strait, New Zealand, with Waterspout*, William Hodges (1744-1797), Oil on canvas, 136 x 193cm, Admiralty House Collection, NMM, Greenwich
- *Arctic Shipwreck*, Caspar David Friedrich (1774-1840), Oil on canvas, 98 x 128cm, 1823-1824, Kunsthalle, Hamburg, Germany
- *A Party from the 'Resolution' shooting Sea-horses (walruses)*, John Webber (1752-1793), Oil on canvas, 124.5 x 157.5cm, Admiralty House Collection, NMM, Greenwich
- *Salcombe, Devon*, Hand-coloured aquatint from *A Voyage Round Great Britain*, published between 1814 and 1826, by Longman, Hurst, Rees and Orme in London, National Maritime Museum, Greenwich
- *Fishermen at Sea*, J.M.W.Turner (1775-1851), Oil on canvas, 91.5 x 122.4cm, Trustees of the Tate Gallery, London
- *The Fighting 'Temeraire', tugged to her Last Berth to be broken up, 1838*, J.M.W.Turner (1775-1851), Oil on canvas, 91 x 122cm, exh. RA1839, Trustees of the National Gallery, London
- *Sun rising through Vapour; Fishermen cleaning and selling Fish*, J.M.W.Turner (1775-1851), Oil on canvas, 134.5 x 179cm, exh. RA1807, Trustees of the National Gallery, London
- *Dutch Boats in a Gale: Fishermen endeavouring to put their Fish on Board* (*The Bridgewater Seapiece*), J.M.W.Turner (1775-1851), Oil on canvas, 162.5 x 222cm, exh. RA.1801, National Gallery, London, on loan from a private collection
- *The Battle of Trafalgar, 21 October 1805*, J.M.W.Turner (1775-1851), Oil on canvas, 261.5 x 368.5cm, National Maritime Museum, Greenwich
- *Gust of Wind*, Elisha Kirkall, after Willem van de Velde the Younger (1633-1707), Mezzotint, National Maritime Museum, Greenwich
- *A Rising Gale*, Willem van de Velde the Younger (1633-1707), Oil on canvas, 132.2 x 191.9cm, 1671-1672, Toledo Museum of Art, Toledo
- *King George IV aboard the Steam Mail Packet 'Lightning', 11 August 1821*, William John Huggins (1781-1845), Oil on canvas, 94 x 152.5cm, National Maritime Museum, Greenwich
- *Whitehall Stairs, June 18, 1817*, also known as *The Opening of Waterloo Bridge*, John Constable (1776-1837), Oil on canvas, 138 x 218cm, Trustees of the Tate Gallery, London
- *Fishermen upon a Lee Shore in Squally Weather*, J.M.W.Turner (1775-1851), Oil on canvas, 91.4 x 122cm, Southampton Art Gallery, Great Britain
- *Brighton Beach, with Colliers, 19 July 1824*, John Constable (1776-1837), Oil on paper, 14.9 x 24.9cm, Victoria and Albert Museum, London
- *The Pier at Trouville, 1869*, Eugene Boudin (1824-1898), Oil on canvas, 65 x 93cm, Burrell Collection, Glasgow, Scotland
- *The Coast of Picardy*, Richard Parkes Bonington (1801-1828), Oil on canvas, 36,5 x 51cm, Trustees of the Wallace Collection, London
- *Yarmouth Jetty*, John Crome (1768-1821), Oil on canvas, 44.8 x 58.3cm, c.1810, Norwich Castle Museum, Great Britain
- *Impression: Sunrise, 1872*, Claude Monet (1840-1926), Oil on canvas, 50 x 62cm, Musée Marmottan, Paris, France
- *St. Paul's from the Surrey Side*, Charles-François Daubigny (1817-1878), Oil on canvas, 44.5 x 81.3cm, 1873, Trustees of the National Gallery, London
- *Britannia's Realm*, John Brett (1830-1902), Oil on canvas, 105 x 212cm, Trustees of the Tate Gallery, London
- *Wapping, 1860-1864*, James Abbott McNeill Whistler (1834-1903), Oil on canvas, 71.1 x 101.6cm, painted 1860-1864, National Gallery of Art, Washington, USA
- *Nocturne: Blue and Gold - Old Battersea Bridge*, James Abbott McNeill Whistler (1834-1903), Oil on canvas, 66.6 x 50.2cm, painted 1872-1873, Trustees of the Tate Gallery, London

VIII The Birth of American Marine Painting
- *Brook Watson and the Shark*, John Singleton Copley (1738-1815), Oil on canvas, 183 x 229cm, detail, dated 1778, Museum of Fine Arts, Boston
- *The Death of Nelson, 21 October, 1805*, Benjamin West (1738-1820), Oil on canvas, 87.5 x 72.5cm, dated 1808, National Maritime Museum, Greenwich
- *The Death of Wolfe, 1759*, After Benjamin West (1738-1820), Hand-coloured engraving by William Woollett, published London, 1776, National Maritime Museum, Greenwich
- *The Battle of La Hogue, 23 May 1692*, Benjamin West (1738-1820),

Oil on canvas, 164 x 244cm, dated 1778, National Gallery of Art, Washington, USA
- *The Gulf Stream*, Winslow Homer (1836-1910), Oil on canvas, 71 x 125cm, 1899, Metropolitan Museum of Art, New York, USA
- *Brook Watson and the Shark*, John Singleton Copley (1738-1815), Oil on canvas, 183 x 229cm, dated 1778, Museum of Fine Arts, Boston, USA
- *Rising of a Thunderstorm at Sea*, Washington Allston (1779-1843), oil on canvas, 98 x 129.5cm, painted in 1804, Museum of Fine Arts, Boston, USA
- *The Defeat of the Floating Batteries at Gibraltar, September 1782*, John Singleton Copley (1738-1815), Oil on canvas, 134.6 x 189.9cm, Trustees of the Tate Gallery, USA
- *The Glorious First of June, 1794: Lord Howe on the Deck of the 'Queen Charlotte'*, Mather Brown (1761-1831), Oil on canvas, 259 x 366cm, National Maritime Museum, Greenwich
- *North Mountain, Catskill Creek, c.1838*, Thomas Cole (1801-1848), Oil on canvas laid on panel, 71x 96.5cm, Yale University Art Gallery, USA
- *Wreck of the 'Ancon' in Loring Bay, Alaska*, Albert Bierstadt (1830-1902), Oil on paper mounted on panel, 35.5 x 50cm, painted in about 1889, Museum of Fine Arts, Boston, USA
- *Boston Harbour from Constitution Wharf*, Robert Salmon (1775-c.1845), Oil on canvas, 68.5 x 104cm, US Naval Academy Museum, Annapolis, USA
- *Sunset at Sea*, William Bradford (1823-1892), Oil on canvas, 81 x 122cm, dated 1860, Vallejo Gallery, California, USA
- *The U.S. Ship 'Franklin', with a View of the Bay of New York*, Thomas Thompson (1776-1852), Oil on canvas, 76 x 165cm, Metropolitan Museum of Art, New York, USA
- *The 'Constitution' and the 'Guerrière'*, Thomas Chambers (1808-c.1866), Oil on canvas, 62.9 x 87.2cm, c.1845, Metropolitan Museum of Art, New York, USA
- *The Yacht 'Northern Light' in Boston Harbour*, Fitz Hugh-Lane (1804-1865), Inscribed verso: 'Painted by F H Lane from a sketch by Salmon 1845', Oil on canvas, 47.5 x 66cm, dated 1845, Shelburne Museum, Shelburne, Vermont, USA
- *Approaching Storm: Beach near Newport*, Martin Johnson Heade (1819-1904), Oil on canvas, 71 x 148cm, c.1860s, Museum of Fine Arts, Boston, USA
- *A U.S. Frigate attacking a French Privateer*, James Edward Buttersworth (1817-1894), Oil on panel, 20.3 x 25.4cm, dated 1860, Vallejo Gallery, California, USA
- *S.S. 'Mississippi'*, Antonio Jacobsen (1850-1921), Oil on canvas, 56 x 92cm, Private Collection
- *The Capture of the 'Serapis' by John Paul Jones*, James Hamilton (1819-1878), Oil on canvas, 147.3 x 221.6cm, dated 1854, Yale University Art Gallery, USA
- *America's Cup, 1871*, Edward Moran (1829-1901), Oil on canvas, 56 x 94cm, dated 1882, Vallejo Gallery, California, USA
- *The Life Line*, Winslow Homer (1836-1910), Oil on canvas, 73 x 114.3cm, 1884, Philadelphia Museum of Art, USA
- *The 'Flying Dutchman'*, Albert Pinkham Ryder (1847-1917), Oil on canvas, 35x 142cm, 1880s, Smithsonian Institution, Washington DC, USA
- *Starting out for Rail*, Thomas Eakins (1844-1916), Oil on canvas, 70 x 50.8cm, dated 1874, Museum of Fine Arts, Boston, USA
- *The Steamer 'Panther' among the Field Ice in Melville Bay*, William Bradford (1823-1892), Oil on millboard, 45.7 x 76.2cm, dated 1873, The Royal Collection 1994/ Her Majesty Queen Elizabeth II

IX Masters of Victorian Marine Painting
- *Pilot Cutters racing to a Ship*, Admiral Richard Brydges Beechey (1808-1895), Oil on canvas, 92.5 x 138.5cm, dated 1873, National Maritime Museum, Greenwich
- *Queen Victoria's Visit to Queenstown, 1849*, George Mounsey Wheatley Atkinson (1806-1884), Oil on canvas, 86.5 x 133.5cm, National Maritime Museum, Greenwich
- *The Battle of Trafalgar, 21 October 1805*, John Christian Schetky (1778-1874), Oil on canvas, 108 x 181cm, dated 1838, Richard Green Galleries, London
- *Man overboard: Rescue launch from HMS 'St. Jean d'Acre'*, Oswald Walters Brierly (1817-1894), Oil on canvas, 61 x 104cm, National Maritime Museum, Greenwich
- *HMS 'Edinburgh' with anti-torpedo Nets out in a Mock Exercise against Torpedo Boats*, Edouardo de Martino (1838-1912), Oil on canvas, 52 x 91.5cm, National Maritime Museum, Greenwich
- *A Market Boat on the Scheldt*, Clarkson Stanfield (1793-1867), Oil on panel, 82.9 x 124.4cm, dated 1826, Victoria and Albert Museum, London
- *Shakespeare Cliff, Dover*, Clarkson Stanfield (1793-1867), Oil on canvas, 58.5 x 91.5cm, dated 1862, National Maritime Museum, Greenwich
- *Dead Calm: Fishing Boats off Cowes Castle*, Sir Augustus Wall Callcott

(1779-1844), Oil on canvas, 90 x 117cm, National Maritime Museum, Greenwich
- *'Britannia' entering Portsmouth*, George Chambers (1803-1840), Oil on canvas, 57 x 77.5cm, dated 1835, National Maritime Museum, Greenwich
- *A Hay Barge off Greenwich*, Edward William Cooke (1811-1880), Oil on panel, 35.5 x 53.5cm, 1855, National Maritime Museum, Greenwich
- *E.W. Cooke*, Photograph, National Maritime Museum
- *Beaching a Pink in heavy Weather at Scheveningen*, Edward William Cooke (1811-1880), Oil on canvas, 106.5 x 167.5cm, dated 1855, National Maritime Museum, Greenwich
- *'Erebus' and 'Terror' in the Antarctic*, John Wilson Carmichael (1799-1868), Oil on canvas, 122 x 183cm, dated 1847, National Maritime Museum, Greenwich
- *The Barque 'Columbine'*, John Ward of Hull (1798-1849), Oil on panel, 15.2 x 23cm, Courtesy of Sotheby's
- *Merchantmen and other Vessels off the Spurn Light Vessel*, Henry Redmore (1820-1887), Oil on canvas, 61 x 95cm, dated 1873, Richard Green Galleries, London
- *The 'Great Western' riding a Tidal Wave, 11 December 1844*, Joseph Walter (1783-1856), Oil on canvas, 45.5 x 76cm, National Maritime Museum, Greenwich
- *A New Bride for the Sea*, Thomas Danby (c.1818-1886), Oil on canvas, 86.4 x 122cm, c.1865, National Maritime Museum, Greenwich
- *A Barque running before a Gale*, Thomas Somerscales (1824-1927), Oil on canvas, 40.5 x 56cm, dated 1910, National Maritime Museum, Greenwich
- *The Indiaman 'Euphrates' off Capetown*, Samuel Walters (1811-1882), Oil on canvas, 96.5 x 152.5cm, dated 1835, National Maritime Museum, Greenwich
- *The Barque 'Queen Bee'*, Joseph Heard (1799-1859), Oil on canvas, 49.5 x 75cm, dated 1852 , National Maritime Museum, Greenwich
- *The 'A.J. Allaire' off Long Island*, William Gay Yorke (1817-c.1886), Oil on canvas, 61 x 91.5cm, dated 1870, Vallejo Gallery, California
- *View of San Sebastian*, James Webb (1825-1895), Oil on canvas, 101.5 x 167.5cm, National Maritime Museum, Greenwich
- *Shipping in the Sound, Kronborg Castle in the distance*, Vilhelm Melbye (1824-1882), Oil on canvas, 70 x 103cm, dated 1873, Richard Green Galleries, London
- *An Extensive View out through the Entrance of Grand Harbour, Valletta, Malta on a Stormy Day*, G. Gianni (fl.1870-1880), Oil on canvas, 50.8 x 101.6cm, dated 1879, Richard Green Galleries, London
- *The Shipwreck*, Ivan Aivazoffski (1817-1900), Oil on canvas, 58 x 87cm, Bridgeman Art Library, London
- *The Yacht 'Alarm' in Plymouth Sound*, Nicholas Matthew Condy (c.1818-1851), Oil on panel, 33 x 45.5cm, National Maritime Museum, Greenwich
- *A Fish Sale on a Cornish Beach*, Stanhope Forbes (1857-1947), Oil on canvas, 121.3 x 155cm, dated 1885, Plymouth City Museum and Art Gallery
- *Fisherfolk & Ships by the Coast*, Abraham Hulk Senior (1813-1897), Oil on panel, 33 x 50cm, Sotheby's, London
- *Flat-bottomed Fishing Pinks and Fisherfolk at Scheveningen*, Hendrik Willem Mesdag (1831-1915), Oil on canvas, 43 x 53cm, Christie's, London
- *Among the Shingle at Clovelly*, Charles Napier Hemy (1841-1917), Oil on canvas, 43.5 x 72.1cm, dated 1864, Laing Art Gallery, Tyne & Wear Museums Service
- *Henley Regatta, 1877*, James Tissot (1836-1902), Oil on canvas, 46.5 x 94.5cm, dated 1877, The Leander Club, Henley-on-Thames
- *Storm and Sunshine: a Battle with the Elements, 1885*, William Lionel Wyllie (1851-1931), Oil on canvas, 106.5 x 183cm, National Maritime Museum, Greenwich

X Twentieth-Century War Artists
- *Masters of the Sea: First Battle Cruiser Squadron, 1915*, William Lionel Wyllie (1851-1931), Oil on canvas, 152 x 274cm, National Maritime Museum, Greenwich
- *Repairing a Torpedoed Ship in an English Harbour*, Sir Muirhead Bone (1876-1953) Black chalk and pastel, 64.8 x 98cm, dated 1918, Imperial War Museum, London
- *A Convoy, North Sea 1918 from N.S.7*, Sir John Lavery (1856-1941), Oil on canvas, 172.7 x 198cm, Imperial War Museum, London
- *Dover Harbour, 1918*, Philip Wilson Steer (1860-1942), Oil on canvas, 106.7x 152.4cm, Imperial War Museum, London
- *'Olympic' with Returned Soldiers*, Arthur Lismer (1885-1969), Oil on canvas, 123.1 x 163.1cm, dated 1918 , Canadian War Museum, Ottawa
- *A Cunarder converting to a Merchant Cruiser*, John Everett (1876-1949), Oil on canvas, 73 x 98.5cm, National Maritime Museum, Greenwich
- *HMS Cardiff leading the surrendered German Fleet into the Firth of Forth, 18 November 1918*, Charles Dixon (1872-1934), Oil on canvas, 157.5 x 330cm, dated 1919, National Maritime Museum, Greenwich

- *The Brotherhood of Seamen: Rescue of a Motor Vessel by the Steamship 'Glengyle'*, Arthur James Weatherall Burgess RSMA (1879-1957), Oil on canvas, 105 x 165cm, National Maritime Museum, Greenwich
- *The Guns of HMS 'Caesar'*, Philip Connard (1875-1958), Oil on canvas, 50.8x 70cm, painted in 1918, Imperial War Museum, London
- *Commander Rose on the Deck of a German U-Boat, 1917*, Claus Bergen (1885-1964), Oil on canvas, 160 x 229cm, dated 1918, National Maritime Museum, Greenwich
- *Convoy to Russia*, Charles Pears (1873-1958), Oil on canvas, 81.5 x 127cm, National Maritime Museum, Greenwich
- *Landing Craft approaching the Normandy Beaches, 6 June 1944*, Norman Wilkinson (1878-1971), Oil on canvas, 101.5 x 152.5cm, dated 1944, National Maritime Museum, Greenwich
- *Up the Conning Tower: on Board an S-Class Submarine, 1944*, Stephen Bone (1904-1958), Oil on canvas, 77.5 x 65cm, National Maritime Museum, Greenwich
- *Moonpath Attack on a U-boat by a Halifax Bomber in the Bay of Biscay, March 1944* , Charles E.Turner (1883-1965), Monochrome gouache, 52.7 x 41.3cm, N.R. Omell Gallery, London
- *Withdrawal from Dunkirk, 27 May-3 June 1940*, Richard Eurich RSMA (1903-1992), Oil on canvas, 76 x 101.5cm, National Maritime Museum, Greenwich
- *A Ship's Boat at Sea*, Richard Eurich (1903-1992), Oil on canvas, 35.5 x 62cm, dated 1941, National Maritime Museum, Greenwich
- *Six-inch Gun Cruisers*, Norman Wilkinson RSMA (1878-1971), Oil on canvas, 76 x 101.5cm, National Maritime Museum, Greenwich
- *Burial at Sea (during World War II)*, Thomas Harold Beament (1898-1985), Oil on canvas, 60.5 x 76cm, Canadian War Museum, Ottawa
- *America Delivers, 1942*, Anton Otto Fischer (1882-1962), Oil on canvas, 66 x 91cm, dated 1942 , Vallejo Gallery, California, USA
- *Marine, 1939*, Albert Brenet (b.1903), Oil on canvas, 184.5 x 79cm, Musée de la Marine, Paris
- *Up the Hatch*, Thomas Hart Benton (1889-1975), Oil on canvas, 92 x 66.3cm, US Navy Art Collection, Washington DC, USA
- *Home to Roost*, William F.Draper (b.1912), Oil on canvas, 250.8 x 61cm, US Navy Art Collection, Washington
- *'Gloucester''s Lynx attacking Iraqi Patrol Boats with Sea-dart Missiles, 1991*, David Cobb (b.1921), Oil on panel, 40.6 x 25.4cm, Admiralty Board Collection
- *Loss of HMS 'Coventry' off the Falklands, 25 May 1982*, David Cobb (b.1921), Oil on canvas, 66 x 45.7cm, Collection of HMS 'Broadsword'
- *Commander of a French Submarine looking through a Periscope during World War I*, Charles Fouquerary (1872-1956), Lithograph, Musée de la Marine, Paris
- *Merchant Ship under Sail*, Marin-Marie (1901-1987), Oil on canvas, 61 x 51cm, Musée de la Marine, Paris

XI 'New Horizons'
- *Clewing Up the Mainsail in Heavy Weather*, Arthur Briscoe RSMA (1873-1943), Oil on canvas, 66 x 101.5cm, dated 1925, National Maritime Museum, Greenwich
- *The Critics: R.M.S. 'Queen Mary' arriving at Southampton on 27 March 1936*, Charles Pears PPRSMA (1873-1958), Oil on canvas, 101.5 x 127cm, National Maritime Museum, Greenwich
- *Chinese Boat Building, Hong Kong, 1990*, John Worsley PPRSMA (b.1919), Oil on board, 101.5 x 76.2cm, The Artist's Collection
- *Brest 92*, Jean Rigaud (b. 1912), Oil on canvas, 116x81cm, By courtesy of the artist
- *'Rickmer Rickmers' after the Storm in 1906*, Peter Hagenah (b.1928), Oil on canvas, 80 x 60cm, The Artist's Collection
- *Trouble on Bideford Bar*, Mark Myers PRSMA (b.1945), Acrylic on canvas, 50.8 x 61cm, The Artist's Collection
- *St.Katharine's Dock, London, 1991*, Terence Storey PPRSMA (b.1923), Oil on board, 50.8 x 76.2cm, The Artist's Collection
- *The Thirteen Gun Salute*, Geoff Hunt RSMA (b.1948), Oil on panel, 36.8 x 54.6cm, The Artist's Collection
- *HMS 'Britannia' departing after being freed from the icebound Harbour, February, 1844*, John Stobart (b.1929), Oil on canvas, 61 x 101.5cm, The Artist's Collection
- *Warping In: The 'Ardnamurchan', Port Blakely, 1903*, Christopher Blossom ASMA (b.1956), Oil on canvas, 55.8 x 95.5cm, The Artist's Collection
- *The Yacht 'Gipsy Moth IV' running before a heavy quartering Sea*, Peter MacDonagh Wood RSMA (1914-1982), Oil on canvas, 61 x 91.5cm, National Maritime Museum, Greenwich
- *'Balblair', 1989*, Geoff Hunt RSMA (b.1948), Oil on panel, 45.7x 61cm, The Artist's Collection
- *Annapolis, circa 1900*, John Morton Barber ASMA (b.1947), Oil on canvas, 53.3 x 87cm, painted in 1991, Reproduced courtesy of the Artist
- *The 'Philmac Venturer' in the Queen Elizabeth II Dock of the Manchester Ship Canal, 1986*, Colin Verity RSMA (b.1924), Oil on canvas, 61 x 91.5cm, The Artist's Collection

- *Summer Racing off Cowes*, Stephen Dews (b.1949), Oil on canvas, 51x 76.2cm, Courtesy of Felix Rosenstiel's Widow & Son Ltd.
- *Kenwood Cup, Hawaii, 1990*, Michael Vaughan (b.1940), Oil on canvas, 58.4 x 76.2cm, The Artist's Collection, courtesy of Essential Art
- *Boats on the Hard*, Edward Seago (1914-1974), Oil on canvas, 50.8 x 76.2 cm, Richard Green Galleries, London
- *Evening Light, Mykonos*, David Curtis RSMA (b.1948)Oil on canvas, 74 x 60cm, Courtesy of the Artist
- *Idling, Newlyn, 1993*, Sonia Robinson RSMA (b.1927), Oil on canvas, 51 x 43cm, Courtesy of the Artist

SOURCES

I and II
- Russell, J., *Visions of the Sea, Hendrick C. Vroom and the Origins of Dutch Marine Painting*, Leiden, 1982
- Goedde, Lawrence Otto, *Tempest and Shipwreck in Dutch and Flemish Art, Convention, Rhetoric, and Interpretation*, Pennsylvania State University Press, 1989
- Keyes, George S., *Mirror of the Empire, Dutch Marine Art of the Seventeenth Century*, Cambridge University Press, 1990
- Groot, Irene de and Vorstman, Robert, *Maritime Prints by the Dutch Masters*, Gordon Fraser, London, 1980
- White, Christopher, *The Dutch Pictures, The Pictures in the Collection of Her Majesty the Queen*, Cambridge University Press, 1982
- Lloyd Williams, Julia, *Dutch Art and Scotland, A Reflection of Taste*, National Gallery of Scotland Exhibition Catalogue, 1992
- *Art in Seventeenth Century Holland*, Exhibition Catalogue of the National Gallery, London, 1976
- *Van de Velde Drawings, A Catalogue of Drawings in the National Maritime Museum*, Cambridge University Press, 1974
- *The Art of the van de Veldes*, Exhibition Catalogue, National Maritime Museum, 1982
- Robinson, M.S., *The Paintings of the Willem van de Veldes*, National Maritime Museum, Greenwich, 1990
- Russell, Margarita, *Jan van de Capelle*, F. Lewis, Leigh-on-Sea, 1975
- Public Records Office Works 5/25 (in section relating to Greenwich). Outlines the division of labour of the Willem van de Veldes
- Mahon, Denis, 'Notes on the Dutch Gift to Charles II', *Burlington Magazine*, 91 (1949) and 92 (1950)

III
- *The Universal Magazine of Knowledge and Pleasure*, published by John Hinton, at the King's Arms in St. Paul's Churchyard, London, 1748
- Rouquet, André [M], *The Present State of the Arts in England*, 1755, facsimile edition, Cornmarket Press, 1970
- Walpole, Horace, *Anecdotes of Painting in England with some account of the Principal Artists*, new edition, Swan Sonnenschein, Lowrey & Co., London, 1888
- Edwards, Edward, *Anecdotes of Painters who have resided or been born in England*, London, 1808
- Mortimer, Thomas, *The Universal Director; or Nobleman's and Gentleman's True Guide to the Masters and Professors of the Liberal and Polite Arts and Sciences, and of the Mechanic Arts, Manufactures established in London and Westminster*, 3 Vols., London, 1763
- Tomlin, Maurice, *Ham House*, Her Majesty's Stationery Office, London, 1982
- Société Jersiaise, Extract from the Annual Bulletin, *Peter Monamy*, The Jersey Museum, 1981
- *Peter Monamy 1681-1749 Marine Artist*, Exhibition Catalogue, Pallant House Gallery, Chichester, 1983
- Russett, Alan, 'Peter Monamy's Marine paintings for Vauxhall Gardens', *The Mariner's Mirror*, Vol. 80, February 1994
- Smith, John Thomas, *Nollekens and his Times*, 1828, reprinted by Century Hutchinson, 1986
- Farington, Joseph, *The Farington Diary*, Hutchinson & Co., London 1922-1928
- *Samuel Scott c.1702-1772*, Exhibition Catalogue, Guildhall Art Gallery, 1955
- Kingzett, Richard, *A Catalogue of the Works of Samuel Scott by the Walpole Society Journal*, 1982
- Minutes of the Society of the Company of Painter-Stainers, The Guildhall, London, MSS 5667-9
- Christie's Auction Records, King Street, London
- Englefield, W.A.D., *The History of the Painter-Stainers Company of London*, Hazell, Watson & Viney, London, 1950

IV
- McClure, Ruth, *Coram's Children, The London Foundling Hospital in the Eighteenth Century*, Yale University Press, 1981
- Nicholson, B., *The Treasures of the Foundling Hospital*, Oxford, 1972

- Charles Brooking 1723-1759, Paintings, Drawings and Engravings, Exhibition Catalogue, 1966
- The Minutes of the Foundling Hospital
- The Court and Committee Minutes of the Royal Society of Arts
- Allan, D.G.C., The Houses of the Royal Society of Arts, A History and a Guide, RSA, 1974
- Allan, D.G.C., William Shipley, Founder of the Royal Society of Arts, London, 1968
- Allan, D.G.C., and Abbott, John L., The Virtuoso Tribe of Arts and Sciences. Studies in the Eighteenth-Century Work and Membership of the London Society of Arts, University of Georgia Press
- Wood, S. Henry Trueman, The History of the Royal Society of Arts, 1913
- Luckhurst, Kenneth W., The Story of Exhibitions, The Studio Publications, 1951
- Hayes, John, Gainsborough Paintings and Drawings, Phaidon,1975
- Allen, Brian, Francis Hayman, Yale University Press, 1987
- Dibdin, E. Rimbault, Liverpool Art and Artists in the Eighteenth Century, The Walpole Society Journal (No. 6), 1918
- Fagan, Louis, A Catalogue raisonné of the Engraved Works of William Woollett, Fine Art Society, London, 1885
- Millar, Olivar, The Later Georgian Pictures in the Collection of Her Majesty the Queen, Phaidon
- Archer, Mildred, The India Office Collection of Paintings and Sculpture, The British Library, London, 1986
- Pears, Iain, The Discovery of Painting, Yale University Press, 1993
- Solkin, David H., Painting for Money, The Visual Arts and the Public Sphere in Eighteenth-Century England, Yale University Press, 1993
- Whitley, William T., Artists and their Friends in England 1700-1799, Medici Society, London
- William T. Whitley, Art in England, 1800-1828, Cambridge, 1921
- Graves, Algernon, The Society of Artists of Great Britain 1760-1791, The Free Society of Artists 1761-1783, A Complete Dictionary of Contributors, Kingsmead Reprints, Bath, 1969
- Manners and Morals, Hogarth and British Painting 1700-1760, Exhibition Catalogue, Tate Gallery, London
- Pye, J., Patronage of British Art, An Historical Sketch, London, 1845

V and VI
- Cordingly, David, Nicholas Pocock 1740-1821, Conway's Marine Artists, 1986
- Greenacre, Francis, Marine Artists of Bristol, Nicholas Pocock, Joseph Walter, Exhibition Catalogue, City of Bristol Museum and Art Gallery, 1982
- Philip Conisbee, Claude-Joseph Vernet 1714-1789, Greater London Council Exhibition Catalogue, 1976
- Claude-Joseph Vernet 1714-1789, Exhibition Catalogue, Musée de la Marine, Palais de Chaillot, Paris, 1977
- Liversidge, Michael and Farrington, Jane, ed., Canaletto and England, Exhibition Catalogue, Birmingham Museums and Art Gallery, Merell Holberton, 1993
- Ross, Nicholas, Canaletto, Studio Editions, London, 1993
- Constable, W.G., Canaletto, Giovanni Antonio Canal 1697-1768, Oxford, 1976
- Steed, Michael; Holman Sayers, Joyce; and Taylor, James, The Life and Work of Francis Holman, unpublished.

VII
- Joppien, Rudiger, Philip-Jacques de Loutherbourg, RA, 1740-1812, Exhibition Catalogue, Greater London Council
- Butlin, Martin and Joll, Evelyn, The Paintings of J.M.W. Turner, Yale University Press, 1977
- Shanes, Eric, Turner, Studio Editions, London, 1990
- Bachrach, Fred G.H., Turner's Holland, Tate Gallery Exhibition Catalogue, 1994
- Thornbury, Walter, The Life and Correspondence of J.M.W. Turner, Ward Lock Reprints, 1970
- Reynolds, Graham, Turner, Thames & Hudson, 1980
- Joppien, Rudiger and Smith, Bernard, The Art of Captain Cook's Voyages, Yale University Press, 1985
- Honour, Hugh, Romanticism, Pelican, 1981
- Vaughan, William, Romanticism and Art, Thames & Hudson, 1994
- Vaughan, William; Borsch-Supan, Helmut; and Neidhardt, Hans Joachim, Caspar David Friedrich 1774-1840, Tate Gallery Exhibition Catalogue, 1972
- Pointon, Marcia, Bonington, Francia and Wyld, B.T. Batsford, 1985
- Hemingway, Andrew, The Norwich School of Painters 1803-1833, Phaidon, Oxford, 1987
- Kauffmann, C.M., Sketches by John Constable in the Victoria and Albert Museum, Her Majesty's Stationery Office, London, 1981
- Lucas, E.V., John Constable, Halton, Truscott and Smith, London, 1924
- Pool, Phoebe, Impressionism, Thames & Hudson, 1981
- Aubrey, G. Jean, Eugène Boudin, New York Graphic Society, 1968

- Spencer, Robin, Whistler, Studio Editions, London, 1990
- Dorment, Richard, and MacDonald, Margaret F., James McNeill Whistler, Tate Gallery Publications, 1994

VIII
- Evans, Dorinda, Benjamin West and his American Students, Smithsonian Institution Press, Exhibition Catalogue, National Portrait Gallery, London, 1980
- Prown, Jules David, John Singleton Copley, Harvard University Press, 1966
- Wilmerding, John, A History of American Marine Painting, Peabody Museum of Salem, Massachusetts, 1968
- Wilmerding, John, Robert Salmon, Painter of Ship and Shore, Peabody Museum of Salem, 1971
- Wilmerding, John, Fitz Hugh Lane, Praeger Publishers, 1971
- Wilmerding, John, American Light, the Luminist Movement 1850-1875, Princeton University Press, 1989
- Michele Felice Cornè, Versatile Neapolitan Painter, Foreword and Notes by P.C.F. Smith, Peabody Museum of Salem, 1972
- Stein, Roger B., Seascape and the American Imagination, Clarkson N. Potter, New York, 1975
- Knight, Vivien, The Works of Art of the Corporation of London, A Catalogue of Paintings, Watercolours, Drawings, Prints and Sculpture, Woodhead-Faulkner, Cambridge, 1986
- Schaefer, Rudolph J., J.E. Buttersworth 19th Century Marine Painter, Mystic Seaport, 1975
- Brewington, Dorothy E.R., Marine Paintings and Drawings in Mystic Seaport Museum, Mystic Seaport Museum, 1982
- Schweizer, Paul D., Edward Moran 1829-1901, American Marine and Landscape Painter, Delaware Art Museum, 1979
- Martin, Constance, James Hamilton, Arctic Watercolours, Glenbow Museum, Calgary, Alberta, 1984
- Hoopes, Donelson F., Eakin Watercolours, Watson-Guptill, New York, 1985
- Winslow Homer, All the Cullercoats Pictures, Exhibition Catalogue, Northern Centre for Contemporary Art, Sunderland, 1988

IX
- Brown, David Blayney, Augustus Wall Callcott, Exhibition Catalogue, Tate Gallery, 1981
- Van de Merwe, Pieter, The Spectacular Career of Clarkson Stanfield 1793-1867, Seaman, Scene-Painter, Royal Academician, Tyne and Wear County Council Museums, 1979
- Watkins, John, Life and Career of George Chambers, London, 1841
- E.W. Cooke 1811-1880, Guildhall Art Gallery Exhibition, 1970
- John Wilson Carmichael 1700-1868, Exhibition Catalogue, Laing Art Gallery, 1982
- Hall, Marshall, 'John Wilson Carmichael, the Missing Years at Scarborough', Art and Antiques, October 15, 1977
- Davidson, A.S., Marine Art and Liverpool, Painters, Places and Flag Codes, 1760-1960, Waine Research Publications, 1986
- Davidson, A.S., Samuel Walters - Marine Artist, Fifty Years of Sea, Sail, and Steam, Jones-Sands Publishing, 1992
- Credland, A.G., John Ward of Hull, Marine Painter, 1798-1849, Ferens Art Gallery, Queen Victoria Square, Hull, 1981
- Hamlyn, Robin, Robert Vernon's Gift, British Art for the Nation 1847, Tate Gallery, 1993
- Chapel, Jeannie, Victorian Taste, the Complete Catalogue of Paintings at the Royal Holloway College, Royal Holloway College, 1982
- Fox, Caroline, Painting in Newlyn 1900-1930, Newlyn Orion, Penzance, Cornwall, 1985

X and XI
- Quarm, Roger and Wyllie, John, W.L. Wyllie, Marine Artist, 1851-1931, Chris Beetles, 1981
- Wyllie, M.A., We Were One, A Life of W.L. Wyllie, London, G. Bell and Sons Ltd., 1935
- The War at Sea, Exhibition Catalogue of Norman Wilkinson's Oil Paintings, National Gallery, 1944
- Wilkinson, Norman, A Brush with Life, Seeley Service & Co., London, 1969
- Viney, Nigel, Images of Wartime, British Art and Artists of World War I, Pictures from the Collection of the Imperial War Museum, David and Charles, 1991
- Harries, Meirion and Susie, The War Artists, Michael Joseph, 1983
- Foss, Brian, 'Message and Medium: Government Patronage, National Identity and National Culture in Britain, 1939-1945', Oxford Art Journal, February 1991
- Wodehouse, R.F., A Check List of the War Collections of World War I and World War II, National Gallery of Canada, Ottawa
- Fischer, Katrina Sigsbee, Anton Otto Fischer Marine Artist: His Life and Work, Toledo Books, Brighton, 1977
- Worsley, John and Giggal, Kenneth, John Worsley's War, an Official

War Artist in World War II, Airlife, Shrewsbury, 1993
- Usherwood, Nicholas, Richard Eurich, from Dunkirk to D-Day, Imperial War Museum Exhibition Catalogue, 1991
- Cobb, David, The Making of a War Artist, the Falkland Paintings, Conway Maritime Press, 1986
- Hurst, Alex A., Arthur Briscoe Marine Artist, His Life and Work, Teredo Books, Brighton, 1974
- Schiffart und Kunst aus den USA, Schiffarts-Verlag Hansa, Hamburg, 1993

SELECTED BIBLIOGRAPHY

- Archibald, E.H.H., Dictionary of Sea Painters, Antique Collectors' Club, Woodbridge, Suffolk, 1989
- British Marine Painting, special number of The Studio, 1919, with articles by A.L. Baldry
- Brook-Hart, Denys, 20th Century British Marine Painting, Antique Collectors' Club, 1981
- Brook-Hart, Denys, British 19th Century Marine Painting, Antique Collectors' Club, 1992
- Clowes, William Laird, The Royal Navy, Sampson, Low, Marston and Co., London, 1897
- Cordingly, David, Marine Painting in England, 1700-1900, Studio Vista, London, 1974
- Cordingly, David, Painters of the Sea, Lund Humphries, London, 1979
- Finch, Roger, The Pierhead Painters: Naive Ship-Portrait Painters 1750-1950, Barrie and Jenkins, London, 1983
- Gaunt, William, Marine Painting, Secker and Warburg, London, 1975
- Graves, Algernon, The Royal Academy of Arts, A Complete Dictionary of Contributors 1769 to 1904, Henry Graves & Co. Ltd., 1905
- Hemming, Charles, British Painters of the Coast and Sea: A History and Gazetteer, Victor Gollancz Ltd., London, 1988
- Kemp, Peter and Ormond, Richard, The Great Age of Sail, Phaidon, Oxford, 1986
- Preston, Harley, London and the Thames: Paintings of Three Centuries, Exhibition at Somerset House, London, 1977
- Quarm, Roger and Wilcox, Scott, Masters of the Sea: British Marine Watercolours, Phaidon, Oxford, 1987
- Redgrave, Richard and Samuel, A Century of British Painters, Phaidon, 1947
- Roe, Gordon F., Sea Painters of Britain, Leigh-on-Sea, 1947
- Warner, Oliver, An Introduction to British Marine Painting, London, 1948.
- Waterhouse, Ellis, British 18th Century Painters, Antique Collectors' Club, 1991
- Wood, Christopher, Dictionary of Victorian Painters, Antique Collectors' Club, 1992
- Great Victorian Pictures, an Arts Council of Great Britain Exhibition, 1978, introduction by Rosemary Treble
- The Image of London: Views by Travellers and Emigrés, 1550-1920, catalogue for exhibition at the Barbican, London, 1987
- Concise Catalogue of Oil Paintings in the National Maritime Museum , compiled by the staff of the NMM, Antique Collectors' Club, 1988

INDEX OF ARTISTS